MW01030595

Film Distribution in the Digital Age

Film Distribution in the Digital Age

Pirates and Professionals

Virginia Crisp
Coventry University, UK

palgrave
macmillan

First published 2015 by
PALGRAVE MACMILLAN

Palgrave Macmillan in the UK is an imprint of Macmillan Publishers Limited, registered in England, company number 785998, of Houndmills, Basingstoke, Hampshire RG21 6XS.

Palgrave Macmillan in the US is a division of St Martin's Press LLC, 175 Fifth Avenue, New York, NY 10010.

Palgrave Macmillan is the global academic imprint of the above companies and has companies and representatives throughout the world.

Palgrave® and Macmillan® are registered trademarks in the United States, the United Kingdom, Europe and other countries.

ISBN 978–1–137–40660–6

This book is printed on paper suitable for recycling and made from fully managed and sustained forest sources. Logging, pulping and manufacturing processes are expected to conform to the environmental regulations of the country of origin.

A catalogue record for this book is available from the British Library.

A catalog record for this book is available from the Library of Congress.

This book is dedicated to Anna, John and Thea

Contents

Figures and Tables

Figures

Tables

Acknowledgements

There are many individuals that I would like to thank for their ongoing support and encouragement throughout the development of this book. Those omitted should not be offended; they have doubtless enriched my life in other ways but perhaps not directly in the production of this particular book. In alphabetical order they are: Feona Attwood, Sarah Baker, Chris Berry, Billy Clark, James Crisp, Lynne Crisp, Tony Crisp, Rayna Denison, Vivienne Francis, Roddy Gibson, Andrew Goffey, Janet Harbord, Ed Higgs, Katie Johnson, Janet Jones, Sneha Kamat Bhavnani, Ben Little, Jo Littler, Ramon Lobato, Paul McDonald, Farah Mendelsohn, Sarah Pearse, Chris Penfold, Jim Pipkin, Pam Pipkin, Felicity Plester, Sylvia Shaw, Lynne Shepherdson, Mafalda Stasi, Pasi Väliaho, Ellie Walker and Alison Winch.

Particular thanks go to those who kindly read draft chapters: Gemma Commane, Gary Hall, Shaun Hides, James Graham, Gabriel Menotti Gonring and Gavin Singleton. Extra special thanks go out to all of my interviewees: Andy Bale, Jane Giles, Phillip Hoile, Ben Stoddart, Adam Torel and all of the members of the *Chinaphiles* and *Eastern Legends* forums.

Extra special thanks, as always, go to my partner, Gavin, without whose love and support (and excellent book cover designing skills) none of this would have been possible.

Introduction

This book is about film distribution. In more specific terms, it is about the interactions between informal and formal networks for the dissemination of films. Various gatekeepers are able to influence how films circulate globally and arguably film distributors are the most powerful of these intermediaries. As Julia Knight and Peter Thomas eloquently express, distribution is 'the largely invisible link in the chain' between production and exhibition, and it has hitherto attracted surprisingly little academic attention (2008, p. 354). However, through their 'acquisitions policies, their promotional and marketing practices, and their links with production and exhibition, distributors play a crucial role in determining what we as audiences get to see and hence in helping to shape our film culture' (Knight and Thomas 2008, p. 354).

However, as Alisa Perren proposes, there is not so much a 'shortage' of research on distribution as a 'lack of certainty about what exactly constitutes distribution today' (2013, p. 171). With this in mind, any discussion of film distribution should rightly begin with an acknowledgement that the term 'distributor' when applied to the international film industry is at best misleading and at worst a complete misnomer. As Paul McDonald suggests, while the term is commonly used to designate those who own the intellectual property rights to film texts, 'these companies do not usually handle the physical transportation of units to retailers and rentailers' and so he prefers Harold Vogel's (2001, p. 467 cited in McDonald, 2007, p. 5) proposition that these companies are in effect 'publishers' and not simply distributors in the logistical sense. In the film industry, distributors do far more than facilitate the movement of the producer's creation to the intended audience. Often, distributors define 'who gets to watch films, under what circumstances, and why' (Lobato, 2007, p. 113).

Considering the influence that distributors have on what films get seen, where, when and by whom, the lack of a coherent body of work in this area is both surprising and worrying. Furthermore, although distribution takes many forms (formal and informal) and although these methods of dissemination are inextricably connected, there is a lack of research that directly examines the nature of the relationship *between* professional film distribution and film piracy. While existing literature has focused on professional distribution and piracy as distinct phenomena, this book considers both in conjunction with each other and in doing so uncovers the distinctly social contexts of each environment.

On the one hand, the small amount of literature on distribution tends to focus on the dominance of Hollywood and often ignores the role of 'independent' distribution companies. On the other hand, previous studies of media piracy have been too narrow; often preoccupied with establishing once and for all whether such practices are ultimately damaging or beneficial to the creative industries. However, what the latter body of work fails to acknowledge is that informal methods of film distribution are not homogenous activities underpinned by a unified set of motivations that result in a similarly predictable set of outcomes. The field is also weighted towards studies that attempt to establish what motivates 'pirates' so that they can be forced or persuaded to halt their activities.[1] These dual preoccupations dominate the discussion, leaving a need for more work on the social and cultural aspects of 'filesharing' and 'piracy', which have hitherto been examined in some interesting, but regrettably scarce, studies.[2] Finally, many academic and popular discussions surrounding piracy focus on the supposedly antagonistic relationship between the 'pirates' and the cultural industries; within such discourse the positions and priorities of each group are repeatedly constructed as unequivocally distinct and oppositional. This book seeks to go beyond such a narrow and polarised discussion by questioning whether this construction is an accurate portrayal of either the 'pirates' or the 'professionals'. Unlike many considerations of film piracy (and indeed piracy of any cultural commodity), this book is not concerned with establishing or disproving the economic costs of the illegal circulation of these goods. Instead, this book considers 'pirate' activities as part of the wider social and cultural processes of film distribution.

The fact that the role of the distributor in the process of bringing films to audiences has been largely ignored within academic circles is particularly problematic when we consider the power that distributors wield. Indeed, as Ramon Lobato suggests:

Thousands of features are produced each year, but only a small number of these will play to large audiences. Distributors, formal and informal, determine which films win and lose in this game of cultural consumption. In the process, they shape public culture by circulating or withholding texts which have the potential to become part of shared imaginaries, discourses and dreams.

(2012, p. 2)

What this quote illustrates is that distribution acts as a gatekeeper, separating producers from potential audiences. That is not to say that other tastemakers, such as film critics, journalists, historians and academics, do not have a role to play in shaping what we understand as our film heritage. Indeed, even audiences are able to make a contribution to what constitutes the canon of cinema. However, those judgements on the quality and worth of certain films are ultimately restricted by what films have been made, and also which films have been lucky enough to get a distribution deal.

Global distribution is an increasingly important revenue stream for the Hollywood studios. Hollywood is now making 50% of its revenues from exports and since the 1990s the returns from the domestic market have not even covered basic production costs (Scott, 2004, p. 78). In such a financially precarious environment, the major studios and the larger independents organise output arrangements with associated distributors so that one third of production costs will be returned no matter how well the film actually performs at the box office (Miller et al., 2004, p. 296). Furthermore, the vertical integration of the Hollywood system allows the US majors to maintain their dominance over the global film industry and is one of the main reasons that independent filmmakers have trouble getting their films exhibited at all (Doyle, 2002, p. 113). While the UNESCO Institute for Statistics (2012) shows that every year India and Nigeria produce more films than the US, Hollywood still manages to bring in more dollars through worldwide box office receipts. This is particularly alarming when we note the domination of a handful of companies. For instance, if we look at the UK as an example, in 2010, 'The top 10 distributors[3] had a 94% share of the market' (BFI Statistical Yearbook, 2011, p. 71). This share of the market has fluctuated between 92% and 97% from 2004 to 2010 (BFI Statistical Yearbook, 2011, p. 78). Thus, this dominance is not a flash in the pan but a consistent trend. What this suggests is that a few multinational corporations control decisions over which films are distributed and which are not. Indeed, there is fierce competition to maintain control over formal distribution

channels. This leads theorists like Sean Cubitt to suggest that associating piracy with forms of criminality such as terrorism and people trafficking is all part of 'the extremism with which privileged access to the means of distribution is protected' (2005, p. 207). Indeed, anti-piracy wars are at their very core not about control of revenue, but control over the channels of distribution that lead to that revenue.

Piracy and the changing face of film distribution

Arguably Hollywood's pre-eminence within the channels of film distribution is being challenged by piratical practices the world over, from the counterfeit DVDs bought and sold in street markets to the film files that circulate through 'filesharing' networks online. All these activities are said to threaten the health and profitability of the film industry. But more significantly such practices also raise questions about what constitutes film distribution and whom we identify as the film distributors. While the Hollywood studios are undoubtedly incredibly influential, their control over the circulation of film is not now, and arguably never has been, absolute.

So, in this changing digital context, what is film distribution and how do we define the distributor in an era when the boundaries between producers, distributors and consumers are arguably being blurred? In the most basic terms, film distribution might be understood as the space between production and exhibition where negotiations are made to secure the release of films in cinemas and/or organise the production of a physical consumer copy of the film on DVD, or more latterly, Blu-ray. However, such a straightforward definition only gives part of the story. Although an everyday understanding of film distribution automatically brings to mind the companies that operate within a particular sector of the film industry, a more critical definition must examine a wealth of other activities to which the term might apply. This situation raises the question, should film distribution simply refer specifically to a particular arm of the film industry or should it describe more generally the process by which films are disseminated across the globe?

This book takes the position that film distribution is far more than a part of an institutional chain that facilitates the delivery of product from producer to consumer. Furthermore, just as exhibition is more than viewing the latest blockbuster at the local multiplex, distribution must be viewed as a varied activity within the film industry itself. Commercial distribution can include, but is not reduced to, the activities of sole traders, small independent distribution companies, quasi-autonomous 'independent' distributors with links with major

studios, formerly independent distributors that (although owned by larger corporations) continue to trade under their own brands, and the distribution arms of the major Hollywood studios themselves. Furthermore, film distribution is more than a professional and commercial activity. If one considers the manner in which films actually circulate globally, then any examination of film distribution companies alone will only tell part of the tale. Distribution is also facilitated through a multitude of alternative distribution networks that serve to circulate copies of films around the world. Such networks might include organised global piracy of DVDs, online filesharing networks, sharing DVDs within film societies and even individuals lending films to friends. While all of these activities might come under the banner of 'distribution', they themselves are vastly differing practices and must be treated as distinct yet interconnected entities.

However, deciding upon terms that adequately describe the overall nature of the particular types of distribution discussed within this book is not straightforward. For instance, what term should be used when describing those who purchase the rights to films as part of their employment within a professional and commercially recognised film distribution company? In one sense, the term 'commercial' might seem appropriate, but it also implies that financial gain is necessarily at the forefront of the activity of these distributors. In this respect, the term 'professional' seems like a better alternative, except if one considers its natural binary, the 'amateur'. While the term 'professional' is used within the title of this book to provide a pithy alliteration, the term is otherwise rejected for a number of reasons. For a start, to use the term professional would problematically suggest that those on the other side of the coin, the 'amateur' distributors, are in some way *un*professional. This book intends to avoid the trap of positioning those engaged in amateur distribution practices as somehow less professional or knowledgeable than their paid counterparts. Secondly, to contrast 'professional' practices with those of the 'amateur' would also be problematic because of the associations attached to the latter term. Just as the word 'fan' has 'never fully escaped its earlier connotations of religious and political zealotry, false beliefs, orgiastic excess, possession and madness' (Jenkins, 1992, p. 12), the word 'amateur' is constructed as a pejorative term within popular discourse. Distinct from the aficionado or the connoisseur, the amateur is often constructed as someone who is, by definition, not good enough to be a professional; for, it is implied, surely someone who is a leader in their field would reap financial reward for their knowledge and expertise. Finally, the binary of the professional

and the amateur still positions the discussion within an arena that is primarily concerned with finance. In other words, the choice of these terms leads one to position the activities of the distributors in relation to whether or not they receive financial remuneration for their labour, an opposition that is worth avoiding.

Due to the weight attached to these preceding terms and following on from the work of Ramon Lobato (2007, p. 113), the labels 'informal' and 'formal' distribution will be used within this book. Such terminology, while by no means perfect, reflects the fact that certain channels of distribution are recognised and validated while others are not. In the sense outlined by Lobato, 'the formal lies with the legally sanctioned, formal economy on which distribution data and trends are routinely based, while the informal encompasses grey (secondary markets, household-level peer-to-peer exchange)' (2007, p. 33). Thus, formal, in this case, is used to refer to 'traditional' distribution where 'studios control box office revenues by releasing films for coordinated showing in a system of theatres and then direct them through an inflexible succession of hierarchically ordered windows of exhibition' (Iordanova, 2012, p. 1). This chain of release typically begins in a cinema, moves to retail sale and DVD/Blu-ray rental before filtering down to pay-per-view (PPV) and subscription-based satellite or cable until the film is finally available on terrestrial television (Hennig-Thurau et al., 2007, p. 63). Within the Hollywood studio system of production, the distributor is typically attached at the outset and plays a part in funding the film. In this respect, the distributor wields vast amounts of power, and so we can understand that 'more than just a sector of the film industry or a set of technical procedures, distribution is also about the regulation, provision and denial of audiovisual content – it is about cultural power and cultural control' (Lobato, 2007, p. 170).

However, such a definition of formal distribution is far removed from the sort of independent distribution examined within this book. The formal distributors here typically secure the rights to distribute films in non-domestic markets long after each film has been completed and shown theatrically in its country of origin. Thus, formal distribution in this context might be better defined as 'where the producers of a film enter a contract with distributors for certain territories' (Iordanova, 2012, p. 4). Some of the films distributed this way will enjoy a limited theatrical release but quite often they will only ever appear on DVD (and occasionally Blu-ray). Thus, formal distribution in this context is the legal acquisition of rights to show a film theatrically and/or produce DVD/Blu-ray copies for retail sale within a given territory.

Informal distribution is even more difficult to define as we see a proliferation of means of disseminating film facilitated by rapid technological developments in the audio-visual industries. As such, Lobato has attempted to provide a more inclusive definition of distribution that encapsulates such changes when he describes distribution 'as the movement of media through time and space' (Lobato, 2007, p. 114). However, while certainly inclusive, such a definition is too vague and nebulous to be practically useful. Lobato further refers to informal distribution channels as 'subcinema', that is 'a loose way of *conceptualising* certain forms of film culture, which are incompatible with more familiar paradigms' (2007, p. 114, original emphasis). Within such a category, we might find 'straight-to-video releasing, telemovies, cult movie markets, diasporic media, ... "Nollywood", pornography, special interest cinema' and also piracy (Lobato, 2007, p. 114). As such, further clarification is needed on the particular *type* of informal distribution under discussion here.

For instance, in Chapter 6, two types of informal online distribution are discussed: autonomous and intermediary distribution. Autonomous distribution involves an individual acquiring a copy of a film (legally or illegally) that is then (generally) encoded and/or subtitled so that it might be shared through a specific forum-based 'filesharing' community via a peer-to-peer network. Intermediary distribution refers to when Scene[4] releases (those sourced, encoded and distributed by loosely connected 'release groups') are shared by individuals who did not play a part in the production of the 'release' but are members of particular forums and thus act as 'intermediaries' between the Scene and certain 'filesharing' communities. Both forms of distribution would come under Lobato's definitions of 'informal' distribution channels, certainly come under the technical definition of 'filesharing' and would widely be considered to be 'piracy'.

However, this in turn highlights the problematic and confusing associations of these two terms: 'filesharing' and 'piracy'. Within the context of the cultural industries and intellectual property, the term 'piracy' is enthusiastically wheeled out to support a particular corporate agenda and worldview. The connotations of the term are resoundingly negative and serve to support the claims of the film industry that both their livelihood and the future of creativity are put at risk by the pirates who profit from the labour of others. Furthermore, the term does not adequately describe the type of appropriation and sharing of digital material that takes place in online communities.

The term 'filesharing', on the other hand, places the emphasis on the 'sharing' aspect of the re-distribution of copyright protected content on

the Internet and as such does not encapsulate the differences between how varying *types* of media circulate online. While 'filesharing' may be easily applied to the online circulation of music files, it is not as applicable to the dissemination of movies. Almost anyone can put a CD in their computer and convert the files thereon to MP3s, whereas it takes a certain type of specialist knowledge to circumvent the copyright protection technology on DVDs, let alone then share them online. Such an emphasis on *sharing* also ignores that those who benefit from movie 'filesharing' networks may not necessarily contribute to the growth of the pool of available files – they may simply *leech*[5] from such networks and not actually go on to share the content that they have downloaded. Furthermore, the term 'filesharing' over-emphasises the role of the individual as both consumer and distributor of content and does not allow for the level of gatekeeping that this study has found to be present within peer-to-peer networks. Moreover, as the findings of this study bear witness, varying degrees of 'sharing' can be noted amongst different peer-to-peer communities. While the term 'filesharing' is used within this research, it is accompanied by the qualification that not everyone who engages in such practices is both a consumer and distributor in equal measure, nor are they necessarily overly concerned with the notion of 'sharing' while engaged in such activities.

From films to files

While the term 'filesharing' might be problematic, it does remind us that the artefacts we call 'films' increasingly circulate as 'files'. As filmmakers across the globe abandon celluloid (willingly or not), films are increasingly being made using anything but 'film'. While this digitisation of film has undoubtedly been coming for many years, there are significant repercussions not just for how films are made, but also for how they are able to circulate. Just as VHS led a revolution that freed film spectatorship from the shackles of the picture palace, so the process of digitisation allows films to be experienced not just at home but almost anywhere. At the time of writing, this fact does not come as a revelation. However, this has lead to a terminological and ontological crisis. In other words, what do we actually mean when we use the word 'film'?

'Film' and its compatriots 'cinema', 'moving images' and 'moving pictures' are historically contested terms. Furthermore, the ontology of film has received renewed attention as technological developments are increasingly threatening the supposed 'essence' of what we might loosely call 'film'. The above terms are often used interchangeably, and thus it might be prudent to be clear exactly how 'film' is being used in

this book and, more importantly, how the term might be challenged by the practices described herein. However, although I might designate my own understanding of the term, it is with the recognition that simply providing a definition here does not fix its meaning in the minds of academics, film critics and audiences. Terms such as 'film' will always eschew definition and continue to have a resonance and meaning beyond that set down through official channels. As Rosenbaum suggests:

> People nowadays don't always mean the same thing when they use terms like 'cinema,' 'film,' 'movie,' 'film criticism,' and even 'available' – terms whose timeframes, experiences, and practical applications are no longer necessarily compatible. Older viewers typically refer to what can be seen in 35mm in movie theatres and read about in publications on paper. Younger ones are more likely speaking about the DVDs watched in homes and the blogs on sites accessed on the Internet.
>
> (2010, p. xiii)

The question 'what is cinema?' has been preoccupying film theorists since the birth of the art form. Early discussions on the ontology of cinema and the specificity of film often tried to establish the difference between film and other art forms such as literature or theatre. Such discussions would often verge on essentialism, as if 'different media have "essential" and unique characteristics that form the basis of how they can and should be used' (Maras and Sutton, 2000, p. 98). The idea that film has certain innate properties that dictate its use has been substantially criticised, but the discussion of media specificity has recently been enjoying a resurgence of interest in relation to the development of various 'new' media and technological changes in the cinematic form (Maras and Sutton, 2000, p. 98). Indeed, there is much discussion concerning the future of 'cinema', quite often technological determined and broadly proclaiming either the death or revival of 'film' (McQuire, 2000, p. 41). Thus, as Janet Harbord states, 'in the wake of film's encounter with digital matter, the question of film's ontology is given a new urgency' (2007, p. 16).

According to Noël Carroll, medium-essentialism 'is the doctrine that each art form has its own distinctive medium, a medium that distinguishes it from other forms', it furthermore presupposes what the medium is *for* and what should (and should not) be done with it (2006, pp. 113–114). However, as Carroll suggests, if we understand

a medium to be 'the material stuff out of which artworks are made' (2006, pp. 114–115), then we cannot assume all art forms have a singular 'medium' when sculptures, for instance, can be variously made of stone, plastic, metal and a host of other materials. While for many people celluloid is still at the heart of the 'apparatus' of film (just as the camera, projector and screen might be), in reality it has been replaced by digital data. Thus, the term 'film' becomes a 'misnomer' as the 'film' itself is shot, mastered, distributed and displayed in digital form (Culkin and Randle, 2003, p. 81). However, one might argue that the term 'film' has been somewhat of a misnomer for a significant length of time, as might 'cinema', when we consider that films have been consumed on VHS and television for decades. Thus, for such reasons, the term 'moving image' might be more happily applied to avoid the technical inaccuracy of the word 'film' (Carroll, 2006, p. 113).

If we take such an approach, then we might understand 'cinema' or 'film' as simply members of the overall class of 'moving images' (Carroll, 2006, p. 113). However, having made such a decision, it would still be necessary to consider the ontology of this preferred term. One approach might be to consider moving images or pictures in their broadest sense, that is, as '*pictures* which move' (Danto, 2006, p. 108). However, such a definition might be so vague as to be practically useless. Furthermore, another issue with the term is its historical context and connotations. To reject the word 'film' and to replace it with another (more technically accurate) term conveniently ignores that 'film' has a meaning in the minds of people that cannot be recalibrated just because the terminology is not accurately applied. Words such as 'moving image' and 'moving pictures' are arguably anachronistic and outdated; while they might be preferable for their (rather vague) accuracy, they do not have the resonance with audiences that the term 'film' does. Indeed, Harbord has suggested that using the term 'film' no longer implies the material properties of celluloid, nor does it suggest that the film is 'projected' within the walls of a 'cinema' (2007, p. 1). Film has had its boundaries blurred and is now made up of 'multiple and proliferating objects' (2007, pp. 1–2). With this in mind, we might make more headway if we accept that films can be made without cameras, without film and may be shown in somewhere other than a cinema. What this book will go on to show is how the consumption and dissemination of film help to create and cement our social relationships. Indeed, 'film' and 'cinema' are not simply about celluloid or screen, but also about 'social and textual protocols or behaviours (spectatorship, "going to the movies")' (Maras and Sutton, 2000, p. 104).

In terms of how the word 'film' is discussed within this book, we might simply replace it with the designator 'file', as all of the 'films' discussed herein are, in one way or another, available in digital form. However, such a label would be unsatisfactory because on one level defining 'film' is not a tortuous academic task. For many people, film is not a vague, slippery or nebulous concept. It is easily understood as a series of moving images strung together to divert, inform and entertain us at home, in the cinema, on an iPad or even on a mobile phone. I would contest that the general populous are largely unconcerned about redefining their own understanding of 'film' or 'cinema' simply because on a technical level these words are misnomers. 'Film' as a concept exists in the minds of the spectators and so a final definition will remain elusive for the film ontologist. Regardless of the problems of definition, 'film', whether in celluloid form or not, does continue to exist. The theoretical wrangling concerning what is meant by film, or cinema, again fails to recognise that to a certain extent these concepts are created in the minds of audiences, not finally decreed in the tomes of theorists. Cinemas (as physical structures) continue to exist, and in some cases thrive. Films, whether on celluloid or in digital form, continue to be made. Indeed, while the filmic experience might be expanded to include DVD extras, merchandising, reviews, theme parks and so on, the audience is still able to identify the 'film' within this accompanying chaff. In other words, our experiences and understandings of film or cinema are not being replaced, but *expanded*.

Harbord puts forward the suggestion that 'out of the cinema, film comes wrapped in cellophane and contained in a plastic folder of a box' (2007, p. 127), but no sooner has film escaped the cinema and established itself as a piece of tangible property, it retreats from that form and reduces itself to a file, an encode, digital data in a proliferation of formats. What Harbord points out is that 'a search for film's ontology, the characteristics of its fundamental mode of being, is a futile exercise' (2007, p. 144). So, perhaps we should not be looking for the fundamental or the essential, but rather contributing to a wider project to examine the way in which film is expanding and proliferating into new spaces and modes. While an attempt to once and for all 'define' film may be futile, the pursuit of mapping its journeys and trajectories into new spheres may not. As Harbord suggests, 'in the present moment the method has to be one of addition, of an "also" and an "and", elaborating the paradigm of what it is that film does' (2007, p. 144). This is what this book in part seeks to do: to examine and consider what film 'does' and how it is used when it circulates amongst audiences.

Chapter outlines

The first chapter of this book provides a general theoretical introduction to film distribution by considering the existing work on formal film distribution that has predominantly examined Hollywood through the lens of political economy. The chapter provides an overview of the Hollywood model of film distribution and examines how this structure maintains the status of Hollywood films as dominant global products that enjoy global box office success far beyond the more prolific industries of India (Bollywood) and Nigeria (Nollywood).

Chapter 2 begins by briefly considering the problematic use of the word 'independent' in the film industry and how the term is increasingly applied within film marketing to indicate a certain *type* of film rather than referring to the context of a film's financing, production or distribution. Having acknowledged these issues, the chapter nonetheless uses the term 'independent' to refer to formal film distribution that exists alongside, but is separate from, the Hollywood studio system.

The chapter then goes on to consider how 'independent' film distributors function through a case study of two small professional distribution companies based in the UK. The chapter makes the claim that film distribution companies are made up of individuals who negotiate their position within their industry in quite complex ways, and that it would be naive to view such professionals as necessarily primarily motivated by the blind pursuit of profit. The chapter then makes the argument that the acquisition decisions of the distributors are informed by specialist knowledge accrued by the circulation of social and cultural capital within the film industry. In this context, developing an 'expert' industry knowledge is key, but the sources for such knowledge (within the industry or from film fans) distinguish the distributors in question from each other.

Chapter 3 examines the more recent changes to the traditional distribution model that have largely been facilitated by what Cunningham (2013) terms the 'disruptive innovators', companies such as Netflix, Amazon and Hulu that allow audiences to stream or download films via online subscription or pay-per-view services. The chapter questions to what extent these services are at the vanguard of developments in film distribution and whether they represent a cultural shift in the way that audiences experience film. These ideas are then discussed in more detail through a case study of the 2013 film *A Field in England* (Dir. Ben Wheatley), a film notable for having a simultaneous theatrical, online, DVD and TV release. Again, this strategy is considered in relation to whether it represents a shift in the way that films are made available to

global audiences or whether such a distribution strategy will most likely only be employed for films aimed at niche audiences.

Chapter 4 examines work on film piracy from a range of disciplines, and in particular will consider the sampling and substitution arguments, as well as the concept of network effects, before outlining research that has considered the social aspects of 'filesharing'. In looking at such research, it becomes clear that academic studies have hitherto often been polarised between those that ask how best to halt the relentless spread of piracy and those that question whether methods of informal distribution are as damaging to the industry as the anti-piracy lobbyists have suggested. Furthermore, it is proposed that acts of piracy that are perceived to be potentially 'promotional' (in that they stimulate legal purchasing of media content) or 'instrumental' (that is they lay the groundwork for new business opportunities) are often 'legitimised' within discussions of media piracy as the 'ends' produced by such forms of piracy are presented as ultimately justifying their 'means'. However, I am critical of such attempts at legitimisation because they prescribe a hierarchy of piratical acts that are ultimately judged on economic grounds.

Chapter 5 continues to provide a context for the wider discussion of film distribution by providing a brief history of informal online film distribution. While many of the practices described in this chapter will already be out of date upon publication, and many others will rapidly become so due to the rate of change in this area, this chapter will provide an invaluable contextual overview for readers who are perhaps unfamiliar with the development of informal online distribution and in particular its variable manifestations. The chapter also provides both an historical and a typological account of the illegal dissemination of film texts. In doing so, it will consider that, while some methods of informal online distribution can be quite straightforward, other forms take place in closed communities and require the person downloading to have a reasonably detailed knowledge of numerous programmes and methods of encoding and decoding data; as is the case with the forums that provide a focus for Chapter 6.

Chapter 6 engages in a detailed examination of a particular form of community-based filesharing by examining two online forums that specialise in sharing East Asian films. The opening section of the chapter considers how these forums function and how the space is constructed and policed by its members. In doing so, it will argue that the online distributors in question perceive themselves as part of an imagined knowledge community, where dissemination of films involves

emotional, aesthetic and symbolic (as well as economic) considerations. Within the chapter, Benedict Anderson's concept of the 'imagined community' is invoked to illustrate how online participatory activities are interpreted by registered forum members as indicative of belonging to a larger community of film fans.

Chapter 6 then goes on to discuss what motivates and shapes the decisions of the online distributors in question. The chapter examines how the online distributors are motivated by a wish to share films, not only because it raises their status within the forum community, but also because they consider their actions to be raising the profile of East Asian cinema and thus furthering the goal of the *wider* imagined community of East Asian cinema fans. Here it is presented that the activities of the distributors themselves are varied, as are their ethical and intellectual considerations of such practices. Despite the varied nature both within and across the forums, I argue that online distributors are not simply motivated by cost avoidance (as the anti-piracy rhetoric would maintain), but exist within a complex social community where individuals perceive their activities to be promoting the industry rather than competing with it.

Chapter 7 probes the interconnections and intersections between formal and informal film distribution networks. In doing so, it argues that the activities of the distributors within both formal and informal networks should not be viewed as necessarily antagonistic and oppositional but in many cases are based on similar motivations and goals. The chapter considers the case studies of small distribution companies and 'filesharing' forums used earlier in the book to draw parallels between the ways that distributors both online and offline engage with East Asian cinema and proposes the metaphor of 'symbiosis' to consider the relationship between these formal and informal distribution networks. However, it is important to note that, while the metaphor of symbiosis would suggest a relationship that is mutually beneficial, it is nonetheless not equal, as the majority of gatekeeping power still resides with the industry-based professionals. As such, the second half of the chapter proposes that the professionals seem barely concerned with the activities of 'filesharers', while the online distributors seem particularly interested in the professionals, who are not only held in high regard and respected for their quality releases but are also relied upon for a constant supply of DVDs. Furthermore, this symbiotic relationship is underpinned by the notion of socio-network externalities, where the activities of both the professionals and the online distributors are

perceived to increase the overall value of the wider network of East Asian film distribution.

Conclusion

Film distribution is a growing but currently disparate area of enquiry. This book seeks to make a contribution to this burgeoning field by linking some of the strands together so that the nature of the crossovers and interconnections within the film distribution ecology can be examined in more detail. While I would critique the previous tendency towards a political economy approach to the study of distribution, the intention of this volume is not to disregard such preceding research, but to build upon and expand it so that we can create a more complete and nuanced map of the complexities of film distribution in the digital age.

Designations like 'distribution', 'filesharing', 'piracy', 'film' and 'cinema' must be examined with a critical eye as the boundaries dictated by such terms become increasingly uncertain and permeable. In such a context, this book examines some of the various incarnations of the film distributor and in doing so foregrounds the social as well as the economic context of such activities. Furthermore, while it has been necessary on presentational grounds to split this book into chapters that compartmentalise certain distribution practices under particular banners (traditional, independent, disruptive innovators, piracy and so on), the overall contention is that these dissemination operations are not discrete and easily demarcated entities and thus must be considered as part of a much wider and infinitely more complex global film distribution ecology.

1
Formal Film Distribution

Introduction

Film distribution has recently migrated to the forefront of academic enquiry as the traditional modes and mechanisms of movie dissemination are allegedly being 'disrupted' by technological developments from the VCR to video on demand. The challenges and possibilities brought about by new forms of formal online distribution are considered in detail in Chapter 3, and the growth of new forms of informal online distribution are examined in depth in chapters 4 and 5. However, in order to understand these new developments and their possible implications, it is first necessary to explore the nature of the pre-existing models of distribution that these new modes and methods are said to be 'disrupting'. Therefore, this chapter will examine what this 'traditional' Hollywood structure of distribution is, how it functions and, significantly, how it has hitherto maintained Hollywood's dominance over the global film industry.

Use of the term 'distributor' when referring to the film industry has the potential to be quite misleading. Such intermediaries might better be understood as publishers, but even that term does not go far enough to encapsulate the dominant role that distributors play within the film industry or indeed the varied nature of their activities.

As Alisa Perren notes:

> Intellectual property attorneys, acquisitions executives, festival programmers, television schedulers, web technicians, and marketing assistants all could be identified as part of the distribution business. Importantly, distribution can be seen as taking place when 'fan subbers' (i.e., amateur translators of movies and television series

who operate outside sanctioned industrial channels) upload content to torrents, when truck drivers transport comic books from warehouses to retail stores, and when tablet devices are shipped from online retailers to individual residences. Determining the full range of intermediaries involved in distributive processes, and the types of influence they exercise over content individually or collectively, thus becomes a central research challenge.

(Perren, 2013, p. 170)

However, while acknowledging the wealth of people and activities that might come under this mantle, this particular chapter is concerned with the 'traditional' film distributor. That is, the company or 'arm' of a larger conglomerate that acquires the distribution rights to films (either before production or after production as a 'negative pick-up') and brings them to exhibitors. In doing so, such distributors do not just 'distribute' or 'publish' films: they also control the marketing of the film, they often have the power to dictate the final cut, and they normally retain the intellectual property rights to each film they distribute.

From their job title, one might be forgiven for believing that film distributors are essentially middlemen or wholesalers, but while 'most industries have wholesalers, ... their role is almost always more narrowly defined than in the film industry' (Wasko, 2003, p. 84). Film distributors are certainly in charge of the practicalities of organising exhibition arrangements with venues and of managing the logistics of getting films (as prints or in digital form) to film exhibitors. In basic terms, the theatrical distribution of a film involves such mundane tasks as 'licensing and booking in movie theatres, marketing through advertising and publicity, manufacturing release prints and delivering these prints to those theatres licensed to play the movie' (Blume, 2006, p. 336). However, the role of the distributor can also be much more extensive than this depending on the point during film production at which the distribution deal is arranged.

One thing that distributors certainly do control is the marketing of the films that they distribute, and thus, they have the power to shape how potential audiences perceive a film even before it is released. Furthermore, if the film is financed by one of the major Hollywood studios, then the way a film will be marketed is considered as soon as the project is given the 'green light' (Friedman, 2006, p. 284). At this point, executives in charge of marketing, distribution and consumer products all consider the script that is about to go into the pre-production stage to discover how the film might be positioned and what other revenue

streams related to merchandising might be possible (Fellman, 2006, p. 364). Thus, as marketing is a consideration from the outset, it is not just about working out how best to promote this particular film, but about the marketing strategy reflexively shaping the product *during* production. As such, distributors do not simply control the *ways* a film is marketed, but often they can dictate the final form of any given film whose rights have been acquired. As Janet Wasko suggests, the influence that film distributors can have on film production is extensive, as 'often they are totally in control of a film, but even for other projects, they can influence script and title changes, casting decisions, final edits, marketing strategies, and financing of the film' (Wasko, 2003, p. 84). In this respect, within the Hollywood system at least, the distributor might have much more creative control over a film than audiences may imagine.

Global film distribution

The distribution of film has long been an area of academic interest for those researching the film industry. However, work on distribution has often been hidden within larger studies of the film industry more generally. Furthermore, such industry studies have tended to focus almost exclusively on Hollywood and have been predominantly concerned within two particular aspects of film distribution: the distribution deal and film marketing.

For instance, Janet Wasko's *How Hollywood Works* (2003) provides a detailed discussion of the process of film distribution and the types of distribution deals that are arranged in Hollywood. In the process, Wasko illustrates how 'Hollywood is dominated by a handful of companies that draw much of their power from film distribution' (2003, p. 59). Here Wasko is primarily concerned with explaining the distribution process and illustrating how creative accounting ensures that some profit participants never get paid. In doing so, it is made clear that 'the distribution process is designed to benefit the distributors, but not necessarily production companies' (Wasko, 2003, p. 60). Wasko's work is invaluable for the latter part of this chapter in which Hollywood's dominance through distribution is illuminated. However, her work does not examine why distribution deals are made for some films and not for others. Similarly, Allen J. Scott (2004) provides an interesting investigation into the functioning of Hollywood's distribution arm. However, he does not go any further than mapping the structure of *theatrical* distribution, a limitation he himself acknowledges when he points out that theatrical

distribution is not where profits are to be made and that, as far back as 2000, domestic sales and rentals of VHS brought in three times the revenue of domestic box office returns (Scott, 2004, p. 143). Thus, any consideration of theatrical distribution alone inevitably provides only a partial understanding of how formal film distribution functions.

Other work that considers distribution in detail makes an understandable pairing between distribution and marketing. For instance, in *Global Hollywood 2* (2004), Miller et al. suggest that, before the 1948 Paramount Decree, the whole of the film business was vertically integrated and thus single organisations could own companies dealing with all aspects of production, distribution and exhibition. However, after this ruling, 'distribution became the locus of industry power, and film marketing began its inexorable move to the centre of industry activities' (Miller et al., 2001, p. 147). The authors go on to suggest that, while distribution personnel are largely invisible, their activities are nonetheless extremely significant. Similarly, Tino Balio's section on film distribution within his book *Hollywood in the New Millennium* (2013) also focuses primarily on film marketing and, like the aforementioned publications, his work highlights the importance of distribution within the Hollywood film industry, pointing out that it is distribution (and not production) that actually forms 'the principal business of the Hollywood majors' (Balio, 2013, p. 66). Significantly, Balio notes that, within the Hollywood system, marketing is a consideration *throughout* the production process and so, as has already been suggested, marketing is not something that is applied to the final film product but is ultimately something that shapes the film during the production process (Balio, 2013, p. 70).

Again, while Balio's work gives interesting insights into how distribution works and the central place it holds within the film industry, such work sheds little light on the process of acquisition itself. It does not enlighten us regarding why certain films manage to get distribution deals and others do not. There are some non-academic publications that make inroads to this effect, but these tend to be written by single individuals within the film industry; so, while being useful and informative, there is still a lack of extensive academic research into this issue. One such non-academic publication that contains particularly detailed information on film distribution is Jason E. Squire's edited collection *The Movie Business Book* (2006) that contains chapters on both theatrical distribution by Daniel R. Fellman, the President of Warner Bros. Pictures Domestic Distribution, and Bob Berney, the President of Newmarket Films, the distribution arm of Newmarket Capital Group. These chapters, in a similar manner to the aforementioned industry studies, tend

to explain the detail of the distribution process and never examine *why* certain films are selected for release while others are overlooked. As such, I would contest that the matter of *how* films are selected for distribution has not been put under the scrutiny that other gatekeeping activities have been.[1]

Furthermore, previous studies of film distribution have had a perhaps understandable, but nonetheless limited, tendency to focus on how Hollywood distributes its own products. Indeed, Dina Iordanova suggests:

> It is about time to acknowledge the new realities. A quarter of the world's most commercially successful films come from sources other than Hollywood; many are more profitable and bring higher per screen averages than the studio blockbusters. Not only are many more peripheral films being produced, many more of them are also seen and appreciated, due to the vitality of growing alternative channels of distribution.
>
> (Iordanova, 2010, p. 24)

Thus, we must cease looking at the channels of distribution as discrete entities if we want to get a complete picture of how film circulates transnationally. Iordanova suggests that 'in most cases the focus has been on a single distribution channel that, for the purpose of convenience, is taken out of its complex context' (Iordanova, 2010, p. 25). One notable exception to this tendency is Janet Harbord's *Film Cultures* (2002). Here Harbord provides a detailed examination of the sites of distribution, exhibition, official competition and marketing across which, she argues, the *value* of a film is created. However, although Harbord avoids the pitfalls that concern Iordanova, her work does not consider those methods of dissemination that exist outside the formal and sanctioned sites of the film industry (in other words, piracy) (2002, p. 2). Work that does attempt to bridge such a boundary is the 2002 book chapter by Janet Wasko that discusses traditional distribution, piracy and new forms of digital distribution. Here Wasko makes the point that, even though the technology is changing rapidly, it is still unclear what the future of digital exhibition and distribution will be (2002, p. 195). As Chapter 3 of this very volume will attest, it would seem that the situation is still somewhat uncertain well over a decade later.

The work of Ramon Lobato on 'subcinema' might be seen to be the most apt response to Iordanova's request thus far. According to Lobato:

Subcinema is a loose way of *conceptualizing* certain forms of film culture, which are incompatible with more familiar paradigms (Hollywood cinema, art cinema, national cinema, independent cinema, etc.). It is not a bullet-proof taxonomic category, but rather an attempt to think seriously about kinds of film production and consumption, which don't show up on other maps.

(2007, p. 117)

Lobato's discussion is intriguing but, as the author admits, it only breaks the surface of the area and anticipates further lines of enquiry into those channels of distribution that are critically ignored (2007, p. 119). As such, Lobato's more recent work *Shadow Economies of Cinema* (2012) pushes this project further by providing a more detailed study of film dissemination. Perhaps the most valuable contribution that this publication has made to the study of distribution is in terms of the lexicon of this particular area of interest. Lobato proposes the terms 'formal' and 'informal' when referring to a range of different dissemination practices, thus avoiding the celebratory or pejorative connotations of binary opposites like legal/illegal. Therefore, by providing new terminology and examining the range and scope of informal film distribution practices, in what Perren describes as a 'distribution-from-below' approach (Perren, 2013, p. 169), Lobato has moved this area of study away from examining discrete channels of (primarily formal) distribution and towards an exploration of the 'complete context' of distribution that Iordanova called for earlier.

Indeed, Lobato is not alone is expanding the remit of this growing area of interest. The work of Julia Knight and Peter Thomas (2012) and Erika Balsom (2014) has done much to counter the dominance of discussions of Hollywood within the academic study of film distribution by considering the distribution and exhibition of artists' cinema. However, their work, while immensely valuable and rich, primarily focuses on the distribution of relatively specialist filmmakers. As such, there is still space for further work that explores the kinds of independent distribution that take place in the space between Hollywood blockbusters and artists' films.

The development of new technologies of dissemination has precipitated a change in the way that film distribution has been examined so that 'much of the recent discussion has been on the likely impact of new technologies on the circulation of content' (Perren, 2013, p. 167). In this area it has been Stuart Cunningham, in his work with both Dina Iordanova (2012) and Jon Silver (2013), who has potentially made

the most significant contribution to the study of how distribution is being 'disrupted' by recent developments. This work will be covered in more detail in Chapter 3, but at this point it is worth noting that, while the traditional distribution landscape discussed within the current chapter has undoubtedly been influenced by recent technological changes, I would urge caution to those who might describe these developments as a 'revolution'. Indeed, while the media landscape is always shifting to a certain extent, there are many who wish to protect their interests by enabling the continuation of the status quo.

Furthermore, we must not get distracted by the spectacle of the 'new' and thus fall back into the trap of considering only discrete entities of media distribution. Focusing on the digital nature of distribution can be limited because it ignores the fact that there is invariably a physical manifestation of distribution. As Perren notes, 'notwithstanding industry rhetoric about the decline of physical media (e.g., DVDs, CDs), distribution practices have substantive material consequences' (2013, p. 170), as data must be transmitted via cables or stored within vast server farms.

While the study of distribution is far from underserved, there is nonetheless a lack of communication between studies in this growing area (Crisp and Gonring, 2015; Perren, 2013, p. 165). As the above discussion attests, film distribution is receiving more academic attention in recent years, but work in this area has hitherto focused on examining the structure of the industry rather than scrutinising how individuals negotiate and navigate their position within that structure. As such, the case studies of distribution practices that are presented throughout this book go some way to addressing this imbalance in the field.

However, while the focus on Hollywood within distribution studies has undoubtedly been pervasive, this is potentially an inescapable bias given the power that the major Hollywood studios wield. As such, this sector of the film industry cannot and should not be ignored. Indeed, my suggestion is that, while it has been hitherto afforded an undue emphasis, the practices of Hollywood should rightly still be part of more holistic investigations of how films circulate worldwide. This is in no small part because, arguably, the structure of Hollywood (where all aspects of film production, distribution and exhibition come under the control of a few major transnational corporations) allows them to secure and perpetuate their dominance of the global film industry (Miller et al., 2004, p. 116). The following section will discuss this structure in order to illuminate how it allows the Hollywood studios to maintain their pre-eminence over the film industry more generally.

Hourglasses and windows: How Hollywood dominates the film industry

Distributors are largely invisible to the general film-going public despite the fact that they exert a powerful influence on the films that audiences actually get to see. Harold Vogel observes that 'unlike in marketing for laundry soaps or sodas or cigarettes, a distributor's brand name doesn't matter much (with the possible exception of Disney); no one goes specifically to see a film distributed by Fox instead of, say, Paramount' (2006, p. 141). That is not to say that audiences have never heard of many of the major distributors like Sony Pictures Releasing and Buena Vista International (UK distributors for Disney) but, if the major Hollywood studios are renowned for anything, it is as *producers* of motion pictures rather than as their distributors. However, it is actually within the distribution sector of the film industry where money is to be made and where power can be leveraged.

As Vogel has suggested:

> Ownership of entertainment distribution capability is like ownership of a toll road or bridge. No matter how good or bad the software product (i.e. movie, record, book, magazine, TV show, or whatever) is, it must pass over or cross through a distribution pipeline in order to reach the consumer. And like at any toll road or bridge that cannot be circumvented, the distributor is a local monopolist who can extract a relatively high fee for the use of his facility.
>
> (Vogel cited in Balio, 2013, p. 11)

Thus, I would suggest that the metaphor of an 'hourglass effect' (Deuze, 2007, p. 211), which has been used in relation to employment within the cultural industries,[2] might also be transposed to the nature of the Hollywood model of film distribution. That is, while a great number of film production companies exist (albeit housed within or contracted by larger conglomerates), a small number of distributors reside at the centre of the hourglass controlling distribution to audience at the bottom of the structure. For instance, within the domestic market, usually considered to be the US and Canada, the 'major studios completely control the theatrical distribution arena, consistently earning more than 95% of market share. In international territories, films released by the major studios control anywhere from 45% to 90% of the box office on a country-by-country basis, with an overall average of about 65%' (Blume, 2006, p. 336).

So, while previous academic studies have established that distribution is key to financial return and dominance within the film industry (Balio, 2013; Miller et al., 2004; Wasko, 2003), we must examine in more detail exactly *why* this is the case. In other words, what specific aspects of formal film distribution enable Hollywood to maintain their dominance of distribution and thus the global film industry more generally? In answer to this question, it is proposed that the manner of the arrangement of film distribution deals, the structure of release windows, the control over marketing, and the protection from risk though membership of parent transnational conglomerate corporations all combine to enable the Hollywood studios to maintain and preserve their privileged position. However, despite their power, the major studios are all too aware of the fragility of this situation and the threats posed by the new kids on the block, for instance, Netflix and Hulu (see Chapter 3) and the exponential growth of online film piracy (see Chapter 4).

The distribution deal

The extent of the power that distributors have over the final film and the way it is marketed is largely dictated by the distribution contract that is made between the producers and the distributors.[3] Distribution deals vary and, while there are some standardised factors, the organisation of a deal will depend on the levels of power enjoyed by the various participants, but also on 'when and how a film commodity becomes associated with one of the major distributors' (Wasko, 2003, p. 86). If a deal is made at the script stage, then what is referred to as a PFD (production, financing and distribution) agreement is made (Kravit, 2006, p. 199); whereas a distribution deal agreed after production is typically called a 'negative pick-up'. Significantly, Kravit suggests that distribution is the 'heart of the PFD agreement' (2006, p. 204), as this contract defines the allocation of gross receipts, that is, how the film's gross profits are divided amongst the interested parties. This agreement states the distributor's fee for releasing the film in various territories: typically 30% in the domestic market (Picker, 2006, p. 169), rising to 40–45% in overseas markets, with some exceptions (for example, the UK, where the fee is 35%, largely because subtitling and dubbing are not needed) (Kravit, 2006, p. 204). This 'fee' is the cost for the distributor's services, but the distributor then also makes charges on top of this for other associated distribution costs, for instance, prints, advertising, interest, taxes and so on. It is important to note that the distributor's fee and their costs are always charged out of the gross receipts.

Of course, distributors are not the only players that have considerable clout within the negotiation of the distribution deal. Some above the line talent (typically well-known and influential producers, directors and sometimes actors) will be able to negotiate 'gross-receipts participation deals'. In this case, the gross participants are given a percentage of the film's gross, but significantly, this is typically only *after* all the distributor's fees and costs have been paid (Garey, 2006, pp. 124–125). Thus, such gross participation deals are invariably not from the 'true' gross, but from the gross minus the distributor's fees and costs (which can be considerable). There are then various other types of participation deal and money may be received from the 'first dollar'[4], after an agreed figure has been reached, or when 'a multiple of the negative cost is reached' (Picker, 2006, p. 170). As such, the term 'gross participation' can be misleading because, when the 'gross' is reached, it is not fixed but is subject to complex negotiations between distributors, exhibitors and profit participants.

However, the major Hollywood studios do not finance all of the films produced each year and so the distribution arms of the major studios often distribute films they did not finance too. If the distributors wish to acquire the distribution rights to a film, then they might be willing to pay the negative cost (or more) to secure such rights. If the producer does not need to cover the negative costs (because they have secured, for example, foreign pre-sales), then they can engage in the 'rent-a-system' approach; in other words, they can 'hire the studio as a pure distributor on a reduced distribution fee basis' (Garey, 2006, p. 125). As a filmmaker, it is ultimately better financially to raise your own production financing because, if you do not ask the studio to take on any risk, then you are able to negotiate a more favourable distribution deal (Garey, 2006, p. 125) – not to mention the fact that you will have retained creative control of the project. Ideally such deals would also include a 'guarantee' from the studio towards prints and advertising. Such a 'guarantee is very important because the commitment of exploitation money frequently indicates the seriousness of the distributor's intent. Even the best film is not going to be successful if it's advertised poorly or inadequately promoted' (Garey, 2006, p. 124). Of course, if a filmmaker raises their own finances, they may be able to negotiate a better financial deal, but there is no guarantee that they will be able to make any agreement. So, while this is potentially a lucrative strategy, the filmmaker in this instance is shouldering much more risk than the distributor.

Returning to PFD deals, it is through such arrangements – where, according to Miller et al. there are assurances that one third of

production costs will be returned no matter how well the film actually performs at the box office (2004, p. 296) – that the distributor's investment is always protected. This is achieved through the levying of a range of fees, fronting the costs of particular activities and then charging interest on those upfront costs. The distribution fee covers the fixed costs for the distribution (for example, staff, offices and so on) and 'the fee is charged for the distributor's efforts in soliciting play dates, booking the picture, and collecting rentals' (Wasko, 2003, p. 92). In effect this seems to be the fee for the distributor's services and these are 'paid before any distribution expenses, production costs, or other charges, and before most profit participants' (Wasko, 2003, p. 92). Thus, by assuring that their own charges and costs are recouped first, the distributor can make sure that they are always paid before any of the other parties involved.

Once the distributor's fees and costs have been paid, and all the gross participants have received their share, the remainder is often called the 'net producer's share'. However, with PFD deals, this amount has to be used to repay the loan that funded the film in the first place. Often provided by the distributor, such a loan will incur both a fee and interest. Once such loans and interest have been repaid (typically to the distributor), then the profits are split between the distributor and producer. The division of such funds can provide as much as a 50/50 split for the producer but it is more usual for an 80/20 division of these monies in the distributor's favour.

Furthermore, the distributor also receives a particularly high share of home video revenues because distribution contracts are drawn up to ensure that shares returned to the profit participants from this lucrative ancillary markets are artificially low. Thus, 'worldwide home video represents the largest difference between the studio's profit and the amount reported to the talent participants in the film' (Blume, 2006, p. 341). This arrangement is a hangover from the early days of home video when the major studios were only 'dipping their toe' in the water of this new venture and so wanted to mitigate the risks that they might face. Thus, 'the initial royalty rate set by distributors for titles priced for the rental market was 20% of the gross sales, leaving the distributor with 80% of gross sales to cover their costs and earn a profit' (Blume, 2006, p. 340). Such a system enabled the major distributors to move into home video while being sure they could cover the expensive costs associated with VHS production and distribution in the early days of this format. However, as costs decreased and thus profits increased, the share that went back to the profit participants did not rise to reflect this change (Blume, 2006, p. 340).

Furthermore, not only do distribution deals ensure that the distributor gets paid, recoups their costs (with interest) and pays as little as possible to profit participants, the agreement also ensures that it is the distribution company that owns the intellectual property rights to the film. Indeed, each distribution deal contains:

> relatively standard provisions covering the ownership of the picture, the right of the financing entity to copyright it, the right to distribute the picture in all media worldwide (including the Internet), the right to settle or file lawsuits and the right to settle with exhibitors and other licensees. This group of provisions is intended to state that the financing studio, not the filmmakers, is the owner of the picture, although the filmmakers are entitled to certain financial interests.
> (Kravit, 2006, pp. 205–206)

Despite the fact that the public tend to view people like directors, producers, musicians, writers and other 'creative' individuals as authors of their works, it is invariably the publisher or distributor who actually owns the intellectual property and thus has the capacity to decide how and when (and indeed whether) media content is released. While audiences might associate movie stars or directors with particular films, those individuals invariably have few (if any) intellectual property rights pertaining to that film. Indeed, it is not uncommon for the rights to entire film catalogues to be purchased wholesale and completely detached from the original filmmakers. As Picker identifies, 'the library of United Artists pictures from the late fifties to the early seventies ... is not longer related to anyone who had any involvement in making those movies; it's in the hands of money people who paid for the rights to that library' (2006, p. 173). Indeed, while in everyday discussions of copyright we might perceive ownership and authorship to be synonymous, in reality, intellectual property rights are about the ability to exploit something for profit and not about designating the legal 'author' of a work. Thus, by making sure that it is the distributors (and not the filmmakers) who maintain those rights, the distributors perpetuate the situation whereby control over distribution is at the heart of profit-making within the film industry.

Marketing, release strategies and windows

As has been established, the distribution deal and intellectual property agreements give the 'distributor the right to decide how, where and when [a] film is distributed, how it is advertised, promoted etc.' (Wasko,

2003, p. 86). So, the PFD agreement will commonly stipulate that the distributor also has the right to market the film in any way they see fit and that they get to decide on the manner of the film's release strategy. There is often an obligation in the agreement to consult with the producer and director (and sometimes the stars) on these matters, but it is the distribution company that has ultimate control over the marketing, advertising and release strategy of any film they acquire for distribution.

Until quite recently, motion pictures were released sequentially on different platforms and adhered to a rather rigid release schedule. Typically a film was released theatrically first before becoming available sequentially on cable PPV, VHS/DVD/Blu-ray, premium television and terrestrial television. Again, it is the distribution deal that stipulates the length of release windows in different media though 'holdbacks', that is, contractual agreements that 'prevent release in subsequent media' until a certain amount of time has passed (Blume, 2006, p. 334). Thus, while different mediums have their own position within the windowed system, the length of time that a film will spend within each window can vary considerably. The release window system was created by the film industry to ensure that the maximum amount of profit can be made on each platform 'with a minimum of cannibalisation from one market to the next' (Blume, 2006, p. 334). While the time scales of these windows have reduced over recent years, the theatrical release of a film (however brief) has traditionally been the first opportunity for audiences to see a film.[5]

A number of release tactics are employed for different films in different territories to enable particular films to achieve maximum financial returns but there are broadly three strategies for the theatrical release of feature films. The most common strategy is a 'wide' release pattern where a film opens simultaneously at 700–3,000+ theatres. According to Fellman, the President of Warner Bros. Pictures Domestic Distribution, such a strategy is 'necessary because the high costs of producing and marketing a film almost always require a wide release to maximise the return' (2006, p. 366). Obviously, such a strategy is not suitable for all films and certainly is not employed by distributors that do not have the marketing budgets of a company like Warner Bros. In such instances, a 'limited' release (in 50–700 theatres) might be more appropriate. This type of release allows films to be targeted at specific niche audiences. If there is some concern about whether a film might find an audience, or if a theatrical release is necessary to enable other promotional activities to kick in (for example, reviews in newspapers and magazines), then an 'exclusive' or 'platform' release might be an alternative release strategy.

In this case, a film is released in maybe just one or two theatres in major cities and then booked into more cinemas (or not) based on the initial performance in its exclusive run. In recent years films have also enjoyed releases simultaneously on multiple platforms and this is also something that seems (at present) to be confined to films that are released according to a 'limited' or 'exclusive' strategy.

It must be acknowledged that, while theatrical is the *first* of the release windows, it is 'not necessarily the most lucrative' (Squire, 2006, p. 3). Indeed, the point when the theatrical market ceased being the major breadwinner was, according to Squire, marked in '2000 when universal's hit *The Mummy* grossed more in its first week of US home-video release than in its first week in theatrical' (2006, p. 8). Assuming a film's release adheres to the typical sequential windowed release strategy outlined above, the next state after theatrical release in cinemas is retail/rental home video. While the term 'home video' might seem anachronistic in some senses, it is also a useful term to encapsulate the release of films into the home market on a variety of constantly changing formats, from VHS to DVD to Blu-ray. While Hollywood's initial resistance to home video has become almost legendary, it has long been acknowledged that, far from killing the film industry, the home video market ushered in a new era of prosperity for Hollywood and now home video can represent 'the largest single source of worldwide revenue' (Blume, 2006, p. 334).

As films make more money in the 'home video' window than they do at the box office, one might enquire why it is necessary to release films in cinemas at all. However, the answer to this question (at least for the time being) is that the theatrical release serves the important function of setting 'the value for the markets that follow' (Wasko, 2003, p. 88). According to Blume, at present, the theatrical release remains 'the key to the profitability of a feature film' more generally as 'a successful the-atrical box office performance will help define and increase the value of later revenue streams such as home video and pay and free television, as well as consumer-product opportunities generated from merchandising and licensing of the characters and their likenesses' (2006, p. 335). Thus, even if theatrical is not the most directly lucrative of markets, releasing a film in this manner first attaches a certain prestige to a film and serves to raise its profile so that it can keep generating profit within all of the subsequent windows. Without a theatrical release, and the marketing potential and promotional hype that accompanies this, the assumption is that a film would not go on to make as much profit within the sub-sequent release windows because the film's reputation would not have first been established in the legitimised theatrical realm.

For instance, according to Blume, 'pay television revenue for a film is directly related to its box office performance' (2006, p. 342). Back in 2006, the pay-TV window might begin up to eight months after a film's theatrical release (Blume, 2006, p. 341); however, this window has again significantly reduced in recent years. For instance, the time it takes for a film to come out on DVD in the UK has reduced from an average of 27 weeks in 1999 to an average of 17 weeks in 2012 (The Cinema Exhibitor's Association, 2012). It is further important to note that films are 'licensed to television and cable channels, not sold' (Fellman, 2006, p. 368) and so the distributors retain the rights to films throughout all of the release windows. For these revenues, the distributor would license a third party to negotiate with the cable operator. In this instance too, the distributor would see most of the profits – a typical split being 10% to the third party, 45% to the cable operator and 45% to the distributor. Thus, alongside the PFD agreement, subsequent contracts that allow the distributor to exploit their intellectual property rights in different markets are drawn up so as to provide maximum returns for the distributor.

Marketing and conglomeration

Along with the nature of contractual distribution agreements, the fact that film distributors are in charge of the marketing of films enables them to perpetuate their significant position of influence. Control over marketing allows the Hollywood studios to maintain their dominance for two central reasons: firstly, the significant amount of capital that they can invest into marketing means that Hollywood's films are promoted widely; and secondly, as the costs of production rise, generally only films with extensive marketing budgets are able to generate enough 'buzz' to receive significant box office returns. Because of the nature of the typical distribution deal, 'the average film has to generate a vast amount [of money] just to break even' (Dekom, 2006, p. 101). So, because so many people have to be paid before a film can be said to be in profit, films have to reach as wide an audience as possible in order to maximise the film's profit potential. Consequently, there has been a rise in blockbusters and a veritable arms race in terms of film budgets to secure those sought-after box office revenues. As such, the majors have created a system whereby they are the only filmmakers who have the financial liquidity to 'finance and market motion pictures worldwide on their own and on a consistent basis' (Balio, 2013, p. 87). Thus, increasing amounts of capital are required to achieve returns in a famously risky business.

One way that the majors protect themselves from the financial risks inherent in the film business is by being part of larger multimedia conglomerates. The ownership of such companies is subject to change but, just as an illustration of the levels of convergence that has taken place in this sector in recent years: as of 2011, Paramount was a subsidiary of Viacom Incorporated, Columbia of Sony Pictures Entertainment, 20th Century Fox of News Corporation, Universal of Vivendi, and Warner Bros. of the Time Warner AOL company. The major Hollywood studios oversee their films through pre-production, production, distribution and exhibition before finally generating profits in a multitude of ancillary markets (Doyle, 2013, p. 108). This, the media economist Gillian Doyle suggests, is one of the major reasons why independent filmmakers have trouble getting their films exhibited at all (2013, p. 113). The status of the majors as one of many interests of multinational corporations, and their control over the product from conception to consumption, allows them to absorb some of the high levels of risk that are said to accompany film production and distribution. Hollywood has the ability to bankroll large productions regardless of whether they will be a success, safe in the knowledge that one blockbuster will make up for the losses of multiple films (Doyle, 2013, p. 108).

Thus, there are a number of reasons that the Hollywood distributors are able to maintain their dominance. As powerful, financially secure members of large multinational conglomerates, these companies are able to agree distribution deals that favour themselves above all other parties. These deals ensure that the distributor's costs and fees (often with interest) are returned regardless of box office success. Furthermore, these arrangements stipulate that it is the distributors who own the intellectual property rights for all of the films that they distribute. They are also granted rights to market films in whichever way they see fit and release films using whatever strategy they choose. As production budgets continue to rise, marketing budgets race to keep up and films are released on as many screens as possible simultaneously. As such release strategies become commonplace, only companies with significant levels of financial capital and the security of parent companies with diversified interests can compete as global film distributors.

Conclusion

This chapter has outlined the traditional model of Hollywood film distribution in order to illustrate how this structure has enabled Hollywood to ensure that studio-distributed films are the most widely seen and the

most profitable, both in the domestic market and globally. Financial risk is managed through arranging PFD deals which ensure that the distributor gets paid before the other profit-participants and, furthermore, this contract ensures that it is the distributor who retains intellectual property over the film and associated merchandising rights; this is a strategy that further ensures that the distributor is the main financial beneficiary of all profits. As the Hollywood studios are also part of larger transnational conglomerates, they have the financial clout to release and market films widely and expensively, relying on an economy of scale to mitigate against the increased risks this can bring. By retaining control over marketing and copyright, and by making contractual arrangements that guarantee that the distributor's costs are returned regardless of whether a film turns a profit or not, the Hollywood distribution structure ensures that the film distributor is remarkably influential and also protected from the vicissitudes of the market.

2
'Independent' Distributors

Introduction

While the word 'independent' is often employed when discussing various aspects of the film industry, from individual films to production companies to small cinemas, the meaning of this term is not as fixed as its ubiquitous use would suggest. This chapter will examine the 'independent' *distribution* of feature films, but, in doing so, it is necessary to acknowledge that what counts as 'independence' and what distributors can be said to be independent *from*, are both complex questions. As such, this chapter will begin by examining the many ways in which 'independence' can be defined and understood within the film industry. Such an enquiry is necessary in order to enable the examination of two specialist UK-based feature-film distributors that forms the focus of this chapter. These case studies demonstrate that film distribution companies are made up of individuals who negotiate their position within the industry in quite complex ways. Furthermore, the acquisition decisions of such distributors are informed by specialist knowledge accrued through the circulation of social and cultural capital within the film industry. In this context, the development of expert knowledge of film is key, but it is the sources for such knowledge (within the industry or from film fans) that distinguish the distributors in question from each other.

Independent film: From economics to aesthetics

Film distribution on a global scale can be very complex and a number of companies might distribute the same film in different territories at varying times; however, despite this complexity, the Hollywood studios

continue to dominate this aspect of the international film business. One of the ways their dominance has extended more recently is into the 'independent' film sector. Such a move might seem a contradiction in terms, as an 'everyday' understanding of independence in the film industry would suggest independence *from* the Hollywood studios. With this issue in mind, it is imperative to make a distinction between independent film distribution and the distribution of independent film. While independent distributors might primarily distribute independent films, independent films themselves may not necessarily be distributed by independent distribution companies. That is, of course, if we define independence in industrial terms as pertaining to films produced outside of the Hollywood studios and without their financial support. However, as Holmlund and Wyatt suggest, independent film distribution is being augmented by the increasing prominence of the majors in funding their own 'independent' distribution companies (2004, p. 5). These 'independent' arms of the major Hollywood studios then produce big-budget 'independent' films like *Gangs of New York* (Martin Scorsese, 2002) or *Chicago* (Rob Marshall, 2002) (Holmlund and Wyatt, 2004, p. 5).

The date of inception of this move into independent distribution is a matter of some debate. According to the filmmaker and independent distributor Bob Berney, the first major studio indie label was United Artists Classics, set up in 1980 to 'platform-release review-driven art films, marketed slowly and carefully to control costs, [thus] creating a model that other studios followed and that still exists today' (2006, p. 377). However, the independent film writer/director Henry Jaglom notes that as far back as the 1970s 'it was slowly dawning on the major distributors that there was money to be made releasing smaller, artistic pictures' (2006, p. 51). Some view the entry of the majors into this sector as posing a threat to smaller companies and ultimately 'eroding truly independent distribution' (Boyle, 2006, p. 176). Nonetheless, in addition to the effect that such a move might have on the film industry, Hollywood majors producing and distributing 'independent' films also throws into sharp relief the difficulties involved in trying to define what is meant by independent film and, indeed, independent film distribution.

For instance, when designating the independence or otherwise of a film, do we need to take into account the source of the film's funding, the level of creative control that the filmmakers have over the final film, the formal properties of the film itself or all of these things at once? Must all aspects of a film's production and distribution be 'independent'

from the Hollywood studios for a film's independence to be assured or can a film retain such a status after it has been picked up for distribution by a major Hollywood studio? This is all a matter of some debate.

According to Julian Petley, 'the word "independent" has usually been taken to denote that the distributor in question is not tied to the products of any particular Hollywood studio' (1992, p. 78). Furthermore, the concept of 'independent' film is commonly understood as describing a film that has been financed and created outside the Hollywood studio system; thus one might imagine that for a film's 'independence' to be maintained beyond this, distribution of that film must also take place outside of the Hollywood system. However, the industrial context of a film's production and distribution are not the only factors to consider when judgements of 'independence' are made.

The President of Newmarket Films Bob Berney suggests that independent distribution is not just about separation from the studios but is also about 'lower-budget films that are financed and distributed on a small, guerrilla-style basis' (2006, p. 376). Indeed, Berney's reference to such activities having a 'guerrilla-style' highlights the fact that 'independence' is a very weighted term: one steeped in moral, ethical and aesthetic associations. For instance, according to Stafford, independent also suggests a 'romantic positioning "against" a central power, of being rebellious, "individual" etc.' (2007, p. 71). However, Stafford counsels that such a romantic notion is, just that, romantic. Indeed, no commercially made and released film can ever be completely divorced from the industrial and commercial context of the wider film industry, regardless of the specific conditions of its own production or distribution. So, while according to Stafford, 'independent' really means 'not the majors' (2007, p. 71), such a definition is nowhere near as straightforward as it sounds, for each 'independent' film will still need to engage with the wider structure of film distribution deals, film markets and festivals and commercial competition for audiences. Therefore, while the film might start off its existence somewhat separate from the majors, its potential to subsequently survive and circulate independent of commercial considerations, influence and imperatives would be limited. As Thomas Guback writes:

> The motion picture is not only a means of communication and an art form. In a capitalist-orientated economy, filmmaking is a business – well organized, heavily capitalized, and powerful. A film is often conceived, produced, and marketed in much the same way as many other commodities. One could point to factors which seemingly

separate film from other products, but on closer examination many differences would prove illusory.

(1969, p. 7)

Although written over 40 years ago, the significance and resonance of this statement has not diminished. The suggestion that film is a product not dissimilar to any other in consumer society is not a particularly radical one. The nature of the film industry as a business and the control that large corporations have over film as 'product' has been extensively researched, especially in relation to Hollywood and its dominance of the global film marketplace (Balio, 2013; Miller et al., 2004; Wasko, 2003).

So, it would seem that a definition of 'independence' that solely concerns being disconnected from the Hollywood studios might be both overly romanticised and unrealistic. However, due to the attractive connotations surrounding the term 'independent', the distribution and financing of independent films has clearly become of interest to the majors. In the context of mini-majors and 'classics' labels, Holmlund and Wyatt have questioned whether ' "indie" [has] become merely a brand, a label to market biggish-budget productions' (2004, p. 5).

Furthermore, there are studio-financed films that are released overseas using partner distributors that are not owned by the major Hollywood studios, and so are technically independent but are certainly not branded as such. For example, Stafford points out that:

Films from New Line (owned by Time Warner) are usually released in the UK through the major UK independent, Entertainment Film Distributors. Thus, technically, the *Lord of the Rings* films were independent releases by an independent distributor – even though they made millions in the multiplexes across the country.

(2007, p. 71)

The idea that the *Lord of the Ring* trilogy might be designated as 'independent' (at least in the UK) due to the status of their UK distributors would also seem at odds with the *type* of film the imagination conjures up when 'independence' is suggested. In that respect, one might seek to explore a definition of 'independent film' that is based on questions of style, content, focus and country of origin, rather than commercial affiliation. In that vein, Julian Petley has suggested that an 'independent' film company might be defined not only by its separation from

Hollywood but also by the kind of product it chooses to distribute (1992, p. 78). As such, according to Petley, in order to be worthy of the label, an 'independent' film company should not only maintain its autonomy from the US majors but it should furthermore have a commitment to British, European, Third World and 'left-field' US cinema (Petley, 1992, p. 78). Aside from the fact that Petley lamentably overlooks some other important non-US film industries in this suggestion, his expansion of the term 'independent' allows it to transform into an assertion of a kind of genre rather than simply an indication of independence from the multinational media giants.

Indeed, Petley is not alone in his assertion that independent film is far more than an industrial category. The Independent Spirit Awards, set up in 1984 to specifically recognise independent films and filmmakers, suggest that in order to be nominated for one of their awards, a film must speak to their own definition of the 'independent filmmaking sensibility', that is: 'uniqueness of vision; original, provocative subject matter; economy of means (with particular attention paid to total production cost and individual compensation); and [a] percentage of financing from independent sources' (Boyle, 2006, p. 178). Such a definition is by no means universally accepted as the final word on what criteria a film or film company must meet in order to be designated as independent. However, the fact that such a prestigious award stipulates that 'independence' is much more than a financial or industrial category, points to the fact that the definition of this term is far from stable.

Furthermore, the term 'independence' is also often used interchangeably with 'arthouse', as though these types of cinemas share aesthetic features. However, Janet Harbord suggests that, as with independent film, there are no solid rules for defining arthouse films either. Despite this, she contests that there are nonetheless certain ideas that are evoked by the term, both political and aesthetic (Harbord, 2002, p. 43). Harbord makes the point that, 'at its best, arthouse cinema attempts a heterogeneous programme of films made outside of the studio system, embracing at least three forms of filmic classification: the formally innovative film, the socially realist text and foreign films' (2002, p. 43). While Harbord's definition of arthouse confirms the understanding that, normally, such films originate outside the Hollywood studio system, such a description also highlights the way that such designators are also often synonymous with certain assumptions about the *type* of cinematic experience that will be on offer. Thus, we might understand the definition of an 'independent' distributor as intimately concerned with both the *types* of films

that they choose to distribute as well as the financial backing for each organisation.

Such wrangling about what the term 'independent' does and does not mean has led some to make distinctions between the 'true independents', who are not backed financially by the major studios, and the 'indie-film divisions' of the majors (for example, Miramax and New Line Cinema) when classifying the independent distribution sector (Marich, 2005, p. 228). As such, in understanding the nature of independents, we must also consider their status within larger media structures and how this may differ from the organisation of the major Hollywood studios if we are to make the case, as this chapter does, that the independents discussed here are less driven by profit than one might expect, given the distinctly risky nature of the business. In fact, despite romantic notions to the contrary, one might conclude that the 'true' independents, who do not have the ability to spread risk across multiple productions or multiple business interests, might have more day-to-day financial concerns that the more economically stable Hollywood studios.

Leaving this issue aside for a moment, it has become clear during the preceding discussion that 'independence' within the film industry means different things in different contexts. It may refer to a straightforward financial separation from the Hollywood studios during either production or distribution, it may pertain to an aesthetic sentiment present in the film itself, or it may indicate a film that is designated as independent in order to be branded and marketed as such. However, in this chapter, 'independence' is understood to indicate a company that does not have financial backing or reciprocal agreements with any of the major Hollywood studios. That said, while the distributors themselves might be seen as 'independent' due to this fact, it does not necessarily follow that the films each company distributes would necessarily fit into the more aesthetic genre-based understanding of independence outlined above. Indeed, much of the output of both of the distributors in question here would struggle to fit into the criteria provided by the Independent Spirit Awards. While some films might certainly be seen to have 'provocative subject matter' and 'uniqueness of vision', other films were much more 'mainstream' offerings in their domestic settings and it was only by virtue of being distributed abroad that the films were marketed as more 'arthouse' fare. Indeed, their independence may have been secured by the lack of connections with Hollywood, but that alone did not divorce such films from the developed film industries of Japan, Mainland China and Hong Kong.

Fans or aficionados: Tartan and Third Window Films

What follows is a case study of two independent, specialist, UK-based feature film distributors, Tartan Films and Third Window Films. Tartan became associated with the distribution of films from the cinemas of East Asia due to the prominence of their 'Asia Extreme' label, although the company originally distributed quite a large range of films from across the globe. Third Window Films, on the other hand, is a much more specialist distributor and only releases Japanese films in the UK. The companies will be introduced before examining in detail how films are selected and acquired for release within both organisations. This examination will be based on interviews with a selection of ex-employees from Tartan Films and Adam Torel, the founder of Third Window Films.

Tartan Films

Film producer Don Boyd, Scottish distributor Alan Kean and entrepreneur Hamish McAlpine founded Tartan Films in 1984 (Macnab, 2008). Tartan formed a brief alliance with Metro Pictures in 1992 to form Metro Tartan but reverted to Tartan Films in 2003. Tartan Films was an independent distributor boasting a catalogue of over 300 films in 2005 (About Tartan, n.d.). The Tartan brand expanded overseas in 2004 with the birth of Tartan Films USA, but this venture was short-lived and Tartan Films USA went into administration in May 2008 followed closely by Tartan Films UK in June of the same year. Tartan's film releases, theatrically, on VHS, and latterly on DVD and Blu-ray, were renowned for their diversity. Their impact on the face of UK film distribution cannot be underestimated and Tartan has been described as one of the 'most adventurous independent companies in the UK for more than 20 years – and one of the few with a recognizable brand name' (Macnab, 2008).

Although, arguably, Tartan became synonymous with Asian film through their 'Asia Extreme' label, their output was remarkably varied. *Time Out* marked their passing with an article about a few films from their 'impressive canon' (Huddleston and Jenkins, 2008): films as diverse as *Wild Strawberries* (Ingmar Bergman, 1957), *Society* (Brian Yuzna, 1989), *El Topo* (Alejandro Jodorowsky, 1970) and *Mysterious Skin* (Gregg Araki, 2004). Tartan's founder Hamish McAlpine was, according to ex-Operations Co-ordinator at Tartan Ben Stoddart, 'an important influence on both the company and the industry in general' (2008). A controversial figure at times, McAlpine once got into a physical fight with film director Larry Clark over the 9/11 bombings, an incident that

led Tartan to withdraw distribution of Clark's film *Ken Park* (Larry Clark and Edward Lachman, 2002). However, he was also described by Tartan co-founder Boyd as a 'brilliant, creative distributor with passion for what he does' (Macnab, 2008).

In November 2007, Tartan Films announced they would be making no new acquisitions and this lasted until they went into administration in June 2008 (*Screen Daily*, 2008). Tartan Video USA went first, with Palisades Media Group acquiring Tartan's US back catalogue of 101 films in May 2008 (Frater, 2008). The UK catalogue of over 400 films was also taken over by Palisades some two months later (About Palisades Tartan, 2009). The company is now run out of the US and under the new name Palisades Tartan. The Palisades Tartan website suggests that the company will continue to be a theatrical and DVD distributor, and Chairman/CEO Vin Roberti suggested shortly after the creation of Palisades Tartan that they 'will be aggressively ramping up future acquisitions' with the aim of achieving a back catalogue of over 2,000 films by 2010 (Swart, 2008). When Tartan finally closed its doors, it was reported that 22 employees were made redundant (*The Scotsman*, 2008). According to the Head of Acquisitions at Tartan from 2004 to 2008 Jane Giles, the company had been downsizing and restructuring for some time (2008).

Third Window Films

The website for Third Window Films boasts that the company was 'born in 2005 when its film-loving founders grew bored of the stream of worn-out shock horror vehicles from the Far East' (About, 2010). Despite the suggestion in this quote, Third Window Films was actually founded by just one man, Adam Torel, also an ex-employee of Tartan Films. As Third Window Films has only one full-time member of staff, jobs that require more personnel are contracted out to public relations, sales or marketing agencies. Third Window Films deals exclusively in Japanese films and Torel regards himself as a film 'geek', and openly describes himself as a 'fan' of East Asian cinema (Torel, 2009). Torel suggests that his concern has always been to seek out new Asian cinema and circulate it to as many people as possible (2009). A sentiment supported on the Third Window Films website, which suggests:

> Third Window Films works hard to bring you the wonderful world beyond long-haired ghost films and mindless Hollywood action copies, sourcing the finest works in new Far Eastern cinema. We strive to represent a rich variety of film genres, be they dramas, comedies, political satires, action or anything else in between. Expect

everything from the unknown and cult to the off-beat and even the occasional mainstream masterpiece . . . or expect nothing but quality Asian cinema!

(About, 2010)

Although Third Window is a one-man company and was only founded in 2005, by April 2009 the company had released 19 films and had a steady stream of titles showing at specialist cinemas around the UK, most notably at the ICA in London. By 2015, Third Window Films' catalogue had risen to over 50 titles. Third Window relies on the success of each film to finance the next, so arguably the company exists in a permanently precarious situation. But, as will be discussed later, Torel suggests he is primarily concerned with bringing the films he sees as new and innovative to UK audiences and downplays the importance of securing the financial future of the company (2009).

The acquisition process

In order to investigate the nature of the acquisitions process within both Tartan and Third Window, three central questions will be posed: Firstly, who is ultimately responsible for acquisition decisions within these independent distribution companies? Secondly, how do the films come to the attention of the distributors in the first place? And finally, what aesthetic, commercial and financial criteria contribute to judgements of quality and suitability of particular films? Such questions allow us to consider in more detail the motivations of distributors and also the significance of *types* of knowledge and expertise in shaping the acquisitions process.

At Tartan Films the responsibility for deciding what films the distributor released, on DVD[1] and theatrically, was primarily in the hands of the Head of Acquisitions. The Head of Acquisitions would also consult with what ex-Tartan employee Ben Stoddart (2008) referred to as a 'triangle' of executives made up of the Head of Theatrical, the Head of DVD and the owner Hamish McAlpine. Although the work of actually seeking out films and keeping in touch with sales agents was carried out by the Head of Acquisitions, the final decision was not laid entirely at her door.

As has already been suggested, the company owner Hamish McAlpine had a prominent role within the company and, according to Adam Torel (2009), during an interview where he reflected upon his time at Tartan, this also translated into a significant amount of control over the films that were finally selected for release. According to McAlpine, the Tartan 'Asia Extreme' label was born when the company owner watched

both *The Ring* (Hideo Nakata, 1998) and *Audition* (Takishi Miike, 1999), and identified films of this ilk as 'the next big thing' (2004, p. iv). Thus McAlpine was particularly influential in steering Tartan Films towards their latter focus on East Asian cinema, having previously been distributors of a much wider range of titles. In any event, regardless of the extent to which the owner could influence the Head of Acquisitions, control over which films got selected (and which did not) appeared to be focused in the hands of the most senior members of the company. An approach that was met with concern by Torel, who suggested: 'you can't just make all the decisions yourself. Effectively you'll get pigeonholed ideas' (Torel, 2009). Regardless of the validity or not of such a claim, it would seem that a few key individuals held power over acquisitions decisions at Tartan Films.

However, while decision-making power resided primarily within this 'triangle' of senior management (implying that only those within this privileged group were possessed of the necessary expertise to make such decisions) the day-to-day work of considering unsolicited screeners was farmed out to the most junior members of staff. Indeed, screeners were regularly sent to Tartan, and it was part of the role of junior members of staff to watch these and advise their senior colleagues as to the quality of such releases. Such activities might suggest that, despite the locus of power at the top of the company, there was the possibility of influence from below due to this practice. However, in reality, it was rare that such a process would result in a film being acquired by the company (Torel, 2009). As such, while less senior colleagues were asked to judge the quality of films in this case, their power was limited because, in seeking films for acquisition, Tartan did not really consider with any seriousness the unsolicited films that arrived on their doorstep.

However, it must be recognised that, firstly, even in a relatively small organisation such as Tartan, decision-making by committee might not exactly be practicable, and secondly, despite the concentration of decision-making power amongst key individuals, acquisition decisions were not just left to the whim of subjective personal opinion but were informed by a variety of sources. This was best described by Jane Giles, who suggested, when commenting on her role as Head of Content at the BFI, 'it is my final responsibility, but it is not just what I like or I think... it is kind of like a consensus opinion once we have worked out the sort of things that we want to do' (Giles, 2008). In the case of the BFI, when I spoke to Giles in 2008, this consensus was developed with Margaret Deriaz, the Head of Film Distribution, Sam Dunn, the Head of DVD, and Jeff Andrew, the Head Programmer at the BFI Southbank.

Furthermore, according to Giles (2008), these individuals would also listen to other voices outside of the organisation, like Jason Wood of City Screen Circuit, an influential cinema programmer. So, to suggest that decisions at Tartan were completely centred on key members of the management might be a little misleading, because their opinions were in turn likely to be formed by external influences.

However, such external influences were also often confined to key individuals within the film industry, for example, other distributors, agents, producers and so on, and thus did not generally extend to considerations of the opinions of the audience. The strategy is markedly different at Third Window Films, where Torel has sole responsibility for deciding what films are released. Despite the seeming monopoly Torel has over deciding what to release, his decisions are nonetheless informed by a detailed knowledge of fans of East Asian cinema. Fan discourses surrounding this area of interest are of high importance to Torel, and he uses these to gauge what films would appeal to his audience and what sectors of East Asian cinema might have been overlooked by other distributors. Such an attitude demonstrates a marked difference from all of the ex-Tartan employees interviewed, who all took a somewhat less favourable attitude to fandom.

All of the professionals I interviewed had studied film (or a cognate discipline) at university, and so their knowledge of film was, at least partially, informed by the canon of that discipline. The tastes of the respondents varied in terms of the types of films that they would actively seek out and enjoy. Looking to the work of Bourdieu (1984), capital exists in more than economic terms and, as such, it could be argued that the professionals had amassed a certain amount of cultural capital while at university and their position within the film industry only served to increase that capital.

Arguably, knowledge is another form of capital and has become increasingly prominent within the current 'knowledge economy' (Pillay, 2008, p. 81). However, despite the claims that we are living in a 'knowledge economy' or a 'knowledge society', the exact definition of 'knowledge' has not been adequately theorised within such discussions (Hearn et al., 2008, p. 1). Furthermore, work in this area has tended to focus on 'knowledge' in terms of disciplines such as science and engineering, and has failed to recognise the economic prominence of culture and the creative industries within the so-called knowledge economy (Hearn et al., 2008, p. 3). Not only is culture at the forefront of such an economy, but it is also the individuals who hold such knowledge that become increasingly valued and respected.

Traditionally accepted economic thinking says that increasing economic returns for investors involves the pursuit of self-interest through the exploitation of resources (human, natural and other resources) to supply the demands of the market. However, with the emergence of the knowledge society and the 'knowledge worker', human resources are no longer perceived as merely a passive asset that just performs routine tasks in the cycle of production and supply.

<div align="right">(Pillay, 2008, p. 83)</div>

As such, those who possess knowledge are able to use it, trade on it, exploit it and transfer it into other forms of capital: whether social, cultural or economic. However, as knowledge is such a valuable commodity, it is unsurprising that it therefore becomes guarded, gated and protected, as ubiquity is so often inversely proportional to value. Knowledge is protected, not just through the official instigation of intellectual property controls such as copyright, but also through the valorisation of particular types of knowledge and the denigration of others. As such, not all knowledge is created equal and at Tartan certain forms of film knowledge, those gained through traditional channels for legitimate culture, tended to be valued more highly than others. It became evident that, amongst the majority of the participants, the sort of knowledge about film generated at university or in professional circles was considered superior to the kind of knowledge amassed within other arenas, in particular those associated with fandom.

For instance, while the respondents would all identify themselves as keen film enthusiasts, on the whole they would not particularly identify themselves as film 'fans'. In Giles' case, this was specifically in relation to Asian cinema: 'I was never particularly a fan of Asian film, I just found myself working for companies, first the ICA, which had a legacy of working with Asian arthouse cinema' (2008). Only Torel, the owner of Third Window, is a self-identified fan, and he actively encourages fandom around the products he distributes. One example of this is the Third Window online forum that provides information on Third Window's films, but also creates a space for fans to have general discussions on Asian cinema (Third Window Films Discussion Board, n.d.).

In addition, Third Window has a Facebook page (n.d.) and before that it had a MySpace page (n.d.), thus demonstrating a long history of fan/audience engagement through social media on the part of the distributor. However, such a strategy is not so unusual, because, as social networking has established itself as a part of everyday life, a large

number of companies and organisations now have a presence on a variety of social networking platforms. Tartan, for one, previously had both a MySpace and a Facebook page. However, the distinction between the pages that Tartan and Third Window both have/had on social networking sites relates to whether those pages are constructed as primarily promotional or explicitly social.

For instance, the tagline used on the original MySpace page for Third Window Films was 'for the fans' (n.d.). Tartan, on the other hand, used the tagline space to promote their next film on release, the last one before they folded being 'P2 in cinemas nationwide May 2' (n.d.). Furthermore, Tartan's social networking pages did not list any directors or any interests, in complete contrast to Third Window's, which provide an extensive list of East Asian directors. Although it would be incorrect to say that Third Window's social networking pages are exclusively social (there is undoubtedly a promotional element), a significant difference is that Torel runs the pages himself, responding directly to questions posted. In the case of Tartan, and many other organisations for that matter, responsibility for monitoring the social networking pages falls to the most junior members of staff. What this indicates is a differing relationship to fans, fandom and audiences. For Torel, it would seem that the fans are central, and creating a dialogue with them is paramount. For Tartan, social networking is not used to open up a dialogue, but is a space that can be capitalised upon for promotional purposes.

In fact, the general attitude towards fandom amongst employees of Tartan was one of distancing. It is interesting to note that, although the respondents all identified themselves as keen film *enthusiasts* (as indeed they all seemed to be), when interviewed they did not go so far as to refer to themselves as *fans*. Furthermore, as well as appearing to wish to distance themselves from fans, the respondents often also referred to the rest of the industry in a less than favourable manner. Although they saw *themselves* as enthusiasts, the respondents overall described the industry in general to be bereft of such connoisseurs. In fact, Torel (2009) even claimed that having a passion for film was a curse rather than a blessing when working in distribution.

> They're all business people, they could be selling anything ... but the problem with knowing about film is it is not good when you [work in the] film industry ... You just become really cynical of the whole industry, it could be selling paper towels. If you love a film you could get blind to the fact that it could make any money.

Despite this suggestion that expertise was a hindrance, it seems that – in contrast to other respondents – Torel's knowledge of film is attached to notions of passion and enthusiasm, rather than a preference for knowledge developed through formal education and professional practice. This is not to suggest that Torel in any way lacks knowledge in these areas, but rather to assert that, in contrast to his counterparts at Tartan, he discusses fan-based knowledge in a much more favourable manner.

Despite Torel's claims that knowledge of film can be a drawback if working within the film industry, I would suggest that it is not so much knowledge in general, rather than specific (and perceived) types of knowledge that may be a blessing or a curse. For instance, Ben Stoddart, a former Tartan employee and now Operations Coordinator at the BFI, got his job at Tartan after a chance encounter with Hamish McAlpine at his previous place of work. He was subsequently employed on the basis that he had an impressive knowledge of film which he had predominately accumulated while at university. At the time, he had no specific experience of working in the industry, but his enthusiasm and understanding of film was deemed to be a valuable asset (Stoddart, 2008).

While not wishing to be aligned with fan knowledge, some of the respondents were also keen not to be regarded as film 'snobs' or as having a particular interest in 'inaccessible' cinema. Phillip Hoile, an ex-Tartan employee and now working as Head of Marketing at small distributor Bulldog, suggested that he likes to watch 'fairly serious foreign language cinema' (Hoile, 2009), but was also keen to point out that he nonetheless regularly goes to watch the same big blockbuster films as everyone else. In fact, one respondent was quite derisive about people who were 'all about' world cinema.

> Once I started studying [film] . . . I got into more different types. However I'm not purely into world cinema and I'm not purely into mainstream stuff either. I met a lot of people at university who were hard-core film nuts, when it came to the classics. They were all about Bergman, Almodovar, and Tarkovsky. They were all about the names that pop into your head when you think of world cinema. I tend to be like, yes, there are some great foreign language films out there, however there are also some quite frankly cack ones (just as there is with all types of cinema). Obviously you have to watch a lot of them to know that though! I will never deny that I like going to stuff where I can switch my brain off, sit back, and relax. I'm perfectly happy with that because I don't want to be pigeonholed.
>
> (Stoddart, 2008)

So, on the one hand, knowledge about film was prized by the distributors and, on the other, *too much* knowledge or interest in film (or particular types of film) was deemed to be distinctly negative. This was despite the fact that Tartan was cited as a good place to work *precisely because* everyone working there had a keen interest in film. As Stoddart (2008) stated, 'it was a good company and everyone who was there really liked the product and was really behind it'. Stoddart further suggested that working at Tartan Films 'expanded his horizons' because he watched films that he would not have ordinarily come across. In particular, he cited the release of *The Death of Mr Lazarescu* (Cristi Puiu, 2005) as an example of an 'inaccessible' film, suggesting it was 'one of those things that I just didn't think I'd be vaguely interested in but kind of gave it a go and actually really liked it. That is what Tartan is great for, it is a great company to work for like that' (Stoddart, 2008).

To summarise at this point, at Tartan, while the acquisition process might also be influenced by prominent external industry figures, within the organisation itself, such decisions resided solely with the Head of Theatrical, the Head of DVD, the Head of Acquisitions and the owner, Hamish McAlpine. According to Jane Giles (2008), during her time as Head of Acquisitions at Tartan, much of her job involved keeping up to date with developments in East Asian cinema by visiting festivals and markets, reading reviews, maintaining relationships with sales agents, and developing other informal networks. It is significant to note that information about releases was gained *before* festivals and markets so that pragmatic decisions about what to view and who to speak to were made in advance, and a game plan was developed before the events themselves.

According to Giles (2008), there were various channels through which films would come to her attention and in her role as the Head of Acquisitions she was required to keep a close eye on films in production while also maintaining close ties with associated sales agents (whose job it is to secure distribution for the films they manage). Maintaining such industry contacts was mutually beneficial because through such relationships the agent improved their chances of selling their product and the distributor kept up to date with the films that were available.

Unlike the Hollywood studio model of 'pre-buying' discussed in Chapter one, within independent distribution, 'negative pick-ups' (acquiring distribution rights to films that have already been made) are more common and Tartan Films was no exception in this respect. According to Giles (2008), Tartan Films did not often pre-buy the films they distributed, especially not their Asian releases. The reason given

by Giles was that Asian films are not star-driven in the UK and thus represent a substantial risk for distributors. The suggestion was that East Asian films have no immediate draw for UK audiences because arguably most Asian stars are not easily recognisable in the UK. However, pre-buying, although generally rare, might be a consideration if the director of the film already had a substantial reputation as an auteur, and thus the film could be marketed on that basis.

Despite the fact that films would rarely be pre-bought, the job of the Head of Acquisitions at Tartan involved keeping up to date with the films that were currently in production. Although rights deals would typically not be made before the film was finished, the company would already have an idea of the product they might wish to acquire when it came to attending film markets and film festivals. Furthermore, because many of the films under consideration had already been released in their country of origin, it was possible to gain information about both the box office and critical acclaim of the films domestically before entering into talks over rights to UK or US distribution of the films. Box office and critical acclaim in one country (especially the country of origin) would not guarantee similar success across the globe but this information was still influential in allowing Tartan to consider which films they might potentially release. Reviews from *Screen International* were one such source of information, although Giles (2008) commented that it took the publication some time to start reviewing East Asian films after they started to become popular in both the UK and the US. Nonetheless the opinion of critics was highly influential, and whether it was considered likely that critics in the UK would receive a film favourably was also an important factor when deciding on the suitability of a film for release. Thus, interestingly, the opinion of critics (rather than audiences) was considered a key factor that influenced distribution decisions: another indicator that certain forms of 'legitimate' cultural knowledge were privileged over others during the acquisitions process.

Torel (2009) suggested that informal networks of information were also utilised (at both Tartan and Third Window) to ascertain the domestic success of possible releases in their countries of origin. These might be friends, relatives or informal industry contacts in various East Asian countries. Through these informal networks, the Head of Acquisitions or other senior members of staff at Tartan would discover which films were generating significant levels of interest, both critically and commercially, in their country of origin. Here, the social capital of the person responsible for acquisitions became key. It was important that the distributor had a sense of the market: a sense that was only

made possible through creating and maintaining informal personal and industry networks.

Despite the necessity of having many contacts in East Asia, it was not a specific strategy at Tartan to visit East Asian countries to gather intelligence about what films were performing well or to attend festivals just to identify films that might be of interest. It might be possible to attribute the lack of these tactics to the fact that they would not only be expensive but would most likely produce highly unpredictable results. So, while the promotional line at Tartan was that they were 'searching' for the new and innovative, it is important to highlight that such 'searching' involved liaising with others in the industry and charting industry opinion on particular releases rather than having their own employees scouring East Asia for the next big thing.

Significantly, what can be seen here is that even though films were not pre-bought by Tartan, decisions were made about what films might be of interest for acquisition before those films were viewed by anyone in the company. As such, acquisitions decisions were not made by recourse to an individual's aesthetic judgement, but rather through a reliance on the opinion of critics, informal networks and other members of the industry. Therefore, particular critical and industry judgements of quality would be reproduced during the acquisition process.

One particular site of the reproduction and validation of legitimate industry sources of knowledge were film festivals and markets. At Tartan, the process of acquisition did not involve trawling through films at film festivals and markets looking for surprise hits; rather it was a matter of adhering to a predefined festival agenda. Such a pragmatic approach is hardly surprising given the fact that the major international film festivals are awash with choice. For instance, in 2014, there were 1,047 feature films shown at Cannes alone (*Festival de Cannes*). In such a context, the struggle for recognition is fierce and practical decisions need to be made about which films to actively pursue out of the myriad being screened.

Furthermore, the person in charge of acquisitions at any distribution company could not possibly hope to attend all of the festivals across the globe. Therefore, as Torel suggests, 'film companies go to the big film festivals and big markets' (2009). Furthermore, when they are there, decisions need to be made about what films to see and which to avoid. Consequently, Torel suggests that the bigger distributors 'just go and meet the big companies and say, "what's your big film?" and then watch that' (2009).

In this respect, festivals and markets are about far more than watching films; they concern the validation of those who are 'in the know' versus those who are not. They are places where distributors gain knowledge, not only about particular films, but also about the industry itself. The knowledge about what films to watch has to be gained in advance so one can be there for the 'right' films. Furthermore, attending the event allows individuals to meet the contacts that increase their social capital and aid them in planning future festival agendas.

Torel's attitude to the festivals and markets when acquiring films for Third Window Films, on the other hand, implies a rejection of the commercial side of the industry while using such events to identify 'films that all people like me know about but that no-one else knew about' (Torel, 2009). Thus, Torel expressed interest in acquiring and releasing what he termed 'fan films' (2009), and deliberately wanted to acquire the films that fans were interested in but that he thought other distributors were unlikely to pay much attention to. So while Torel also values insider knowledge and social capital, his contacts and concerns are primarily located within fan communities rather than the film industry.

If, as has been suggested, distributors like Tartan Films attend festivals and markets with a pre-established idea of the types of films being sought for acquisition, then it is important to consider what ideas and priorities serve to construct this acquisition plan in the first place. As one might imagine, there were a number of factors influencing decisions. The opinions of other senior members of the organisation and considerations of the Tartan brand in general and the specific criteria for Tartan's labels, such as Tartan 'Asia Extreme' and genres linked with that label, were all important. In addition, running through all of these considerations were issues of the potential profitability of titles.

Despite the company's latter focus on their 'Asia Extreme' label, Tartan's general remit was far broader. During the 1990s, 'it was all about the breakout, it was all about films that were unavailable...that people wanted to be able to see and couldn't, let alone buy it on VHS or DVD' (Stoddart, 2008). The remit in the early days was all about the controversial; 'picking up films that Tartan felt people *needed* to see' (Stoddart, 2008). *Hard Boiled* (John Woo, 1992), *Battle Royale* (Kinji Fukasaku, 2000) and *Old Boy* (Park Chan-wook, 2003) were some of those films. However, Stoddart (2008) was keen to emphasise that it is often forgotten that Tartan's output was far more varied at first, before they became synonymous with 'Asia Extreme'. As he pointed out, Tartan released some of Pedro Almodovar's early films on VHS, but their ownership of the rights

lapsed: 'a lot of the stuff the BFI have done on DVD, are titles that Tartan had back in the day on VHS' (2008).

The Third Window Films website would suggest a similar mission to bring new and undiscovered films to UK audiences when it states that the company 'works hard to bring you the wonderful world beyond long-haired ghost films and mindless Hollywood action copies, sourcing the finest works in new Far Eastern cinema' (About, 2010). That being said, in an interview, Torel (2009) represented the motivation behind the company as one of bringing these films to audiences rather than particularly receiving recognition for 'discovering' the next big thing. Having said that, the films released by Third Window are not restricted to the incredibly obscure, as is demonstrated by the fact that Johnny To's *PTU* (2003) was one of their first releases. A fact acknowledged on the website by the statement: 'expect everything from the unknown and cult to the off-beat and even the occasional mainstream masterpiece' (About, 2010).

However, it is important to be critical about what is meant by 'a discovery' in this context. For whose sake are companies trawling the globe for the next big thing? Is it in the name of art, audiences, distributors, or all three and some others besides? In the case of 'Asia Extreme', the label was very much the brainchild of Tartan owner Hamish McAlpine. As Giles (2008) suggests, McAlpine 'hit on the fact that there was something particularly interesting going on in Asian cinema around the time of *The Ring*'. Consequently, Tartan experimented with releasing films from East Asia, found they sold well, and then set about establishing the label. Tartan marketed the label at a young and predominantly male audience, their publicity materials emphasising 'the subversive and explicit aspect of the titles' (Shin, 2008). However, as Jinhee Choi and Mitsuyo Wada-Marciano suggest, 'the strategic designation "Asia Extreme" has undoubtedly created a regional affiliation among these [Park Chan-wook, Miike, Kim Ki-duk and Fukasaku] directors' films, but the category itself is purposefully flexible in order to include a range of Asian cinema that seems exportable' (2009, p. 5).

At the turn of the new millennium, East Asian film was receiving increasing attention in the West, not least due to the efforts of Tartan and the development of their label Tartan 'Asia Extreme' in 2002 (Pilkington, 2004, p. v). Indeed, Tartan was not alone in seeing 'a distinct growth in terms of audiences for Asian films' at that time (Chin and Qualls, 2002, p. 50). At the height of its popularity, Tartan 'Asia Extreme' was synonymous with a particular type of film rather than a specific distribution company, which led films like *Ichi the Killer* (Takishi

Miike, 2001) to be considered part of 'Asia Extreme', even though it was actually distributed by another company. [2] Tartan's focus on Asian cinema led to a spate of other distributors trying to capitalise on the trend. As such, Jinhee Choi and Mitsuyo Wada-Marciano make the important point that ' "Asia Extreme" is a distribution/marketing term rather than a production category such as melodrama or western, which are largely based on narrative structure and components' (2009, p. 5). However, despite its status as a marketing term, in many respects, 'it also carries a set of cultural assumptions and implications that guides – and sometimes misguides – the viewer in assessing the political and ideological significance of the films' (Choi and Wada-Marciano, 2009, p. 6).

The focus of the label on the 'bizarre' and the 'shocking' has provoked comment about the image of the Far East that this presents to the West. As Shin suggests, 'the output of the label, and indeed the name of the label itself, invoke and in part rely on the western audiences' perception of the East as weird and wonderful, sublime and grotesque' (Shin, 2008). Although 'Asia Extreme' titles came to be associated with Asian films in general, Shin argues they are not really representative of what fares well domestically or even the types of genres that succeed in East Asian territories: these being on the whole melodramas, comedies and romances (Shin, 2008). Indeed, when speaking about Hong Kong comedy in the 1980s, Jenny Kwok Wah Lau makes a similar point, when she claims that Hong Kong remains famous for its Kung Fu and arthouse films despite the prevalence of comedies being made there and their popularity with domestic audiences (1998, p. 23). Lau attributes this to the fact that comedy does not travel well, and while this may be true, the focus on certain types of genres from East Asia and the popularity of the 'Asia Extreme' label would seem to reveal 'more about the Western perceptions and obsessions about the East Asian countries rather than what people or societies are like there' (Shin, 2008).

Aside from the question of how the label presented an image of the Far East to UK audiences, it is now important to consider how the development of 'Asia Extreme' influenced the type of films that Tartan earmarked for distribution. When Tartan 'broke out' Asian cinema in the UK with *Battle Royale* (Kinji Fukasaku, 2000), their focus became securing more East Asian films because these films were making money. Stoddart suggested that some of this money was used to acquire 'key' European releases, 'but a lot of it was ploughed into buying more Asian cinema' (Stoddart, 2008). This resulted in Tartan amassing a huge back catalogue of Asian films (of varying quality). The focus was on Asia for a number of reasons: firstly, to ensure continued success; secondly, to

make the films available to UK audiences; and finally, to 'stop other labels releasing them' (Stoddart, 2008).

Tartan described 'Asia Extreme' as a genre, amalgamating thrillers, horrors and a whole host of other filmic types under one classification (Shin, 2008). In describing 'Asia Extreme' as a genre, Tartan was able to reinforce the promotional line that they were as distributors 'in the know', as this process of 'genrification ... [can] be understood as an integral part of providing illusions of discovery; a way of knowing and classifying East Asian cinema' (Shin, 2008). Shin's comments become particularly interesting if we examine owner Hamish McAlpine's statement that 'unfortunately, I can't take any credit for having discovered "Asia Extreme", because I didn't. It found me. I merely gave it a name' (2004, p. iv). Despite this disingenuous proclamation, Tartan also suggested in the very same publication that they had brought the 'genre' of 'Asia Extreme' to Western audiences by scouring the globe to find the new and interesting (Pilkington, 2004, p. v).

Furthermore, the directors whose work was released under the 'Asia Extreme' label were positioned as auteurs, as masters of their trade; in the way that Tartan described them, these were not simply directors, they were craftsmen. As their promotional material suggests: 'Determined to seek out new areas of cinematic experience, Tartan uncovered a new breed of directors, crafting wilder, scarier and darker stories that ever before' (Pilkington, 2004, p. v). While positioning directors as auteurs was necessary in order to generate star appeal, some might argue that heralding some particular directors as 'auteurs' ran very short of the mark. Takashi Miike, for instance, is generally part of the straight to video market in Japan and thus he does not enjoy auteur status in his domestic market (Shin, 2008). Nonetheless, the emphasis on star directors mirrors the findings from William Bielby and Denise Bielby's study that genre and stars are pivotal for cultural intermediaries when considering how to reproduce previous commercial success (1994, p. 1292).

In all respects Tartan's films were positioned in opposition to the 'mainstream' and, in particular, Hollywood. As the Spring 2005 release catalogue suggests, 'see the originals now before the inevitable Hollywood remakes' (Tartan Video Catalogue: Issue One, 2005). The inference being that Hollywood lacks originality and backbone. Consequently, I would suggest that, in terms of securing the cultural capital of the organisation, Tartan were defining 'Asia Extreme' against what it was not; it was not boring, not 'run of the mill', not suburban. It was edgy and exciting, and by extension so were Tartan and anyone who

watched their films. By concentrating on the label, Tartan was develop-
ing the image of their own expertise, fostering the notion of themselves
as searching 'the globe to bring back the most exciting and provocative
films' they could find (Pilkington, 2004, p. v).

Conclusion

This chapter has examined what factors shaped the acquisition decision-
making processes at two specialist, UK-based, independent distributors.
In doing so, it became apparent that specialist knowledge and cultural
capital were key for both companies. Responsibility for acquisition deci-
sions was placed in the hands of relatively few key individuals who
were perceived to have the requisite specialist film knowledge. How-
ever, for Tartan, industry knowledge and expertise were paramount and
were acquired and circulated at the larger film festivals and markets.
These places form important arenas for the circulation and demonstra-
tion of such industry knowledge. For Third Window, knowledge was
also an important commodity, but fan knowledge and spaces where this
was circulated (including smaller festivals, social networking sites, and
online forums) were preferred over the perceived commercial focus of
industry knowledge. Thus, when making acquisition decisions, special-
ist knowledge is called upon. Consequently, how knowledge is perceived
and where it is to be obtained ultimately influenced the decisions of
both companies over what to release.

In examining these two case studies this chapter has also sought to
examine how we might consider the role of independent film distrib-
utors rather than focus on the distribution of independent films. The
opening discussion of the complications that surround defining what
'independent' means in terms of both production and distribution has
served to highlight that, while the term is used liberally, the meaning
of 'independence' in relation to film and the film industry is far from
fixed. As such, any discussion of independent film and/or independent
distributors must take into account that the categorisation is somewhat
fluid and subject to flux.

Ultimately this chapter has shown how the paths of film dissemi-
nation are shaped by more than just the economic wiles of the film
industry. Indeed, even those within the industry must be acknowledged
as autonomous and independent human beings who are neither solely
nor ultimately shaped by their profession or its associated commercial
concerns. While it may seem reasonable to talk in abstract terms of a
profit-oriented industry, such a generalisation ignores that fact that any

institutional structure is comprised of, and influenced by, networks of individuals who cannot be reduced to economic incentives. As such, to produce a more rounded account of distribution, further work is needed that considers distribution on both a macro and micro level, and that does not seek to create distinctions between the professional/amateur, commercial/aesthetic, product/art and production/consumption, but views these features as inextricably intertwined.

3
Disruptive Innovators

Introduction

At this point in time, any examination of the classic Hollywood model of film distribution seems to be sorrowfully out of date. Ostensibly it might appear unquestionable that the distribution sector of the global film industry has been revolutionised in recent years. This surface image would seem to suggest that this transformation has ushered in an era of plenty, where a whole host of films and TV shows (not to mention books, computer games, web series and so on) are available within the blink of an eye. Furthermore, if we count the developing informal (and often illegal) channels of online distribution facilitated by the growth of the Internet, then the last 10–15 years has witnessed an explosion in the availability of films and TV programmes for audiences. At least, this is how it seems, and arguably there is some truth in this assessment of the current media distribution environment. However, I would argue that this veritable smörgåsbord of content is not universally available, nor is it presented in an unmediated form where audiences are free to pick and choose the content that interests them. As Finola Kerrigan has suggested, 'on demand distribution is not the free for all panacea that some claim, as the structural impediments of the global film industry still prevail to a certain extent' (2013).

It is important to acknowledge that our film-viewing decisions are funnelled, curated and directed by these new mechanisms of online distribution. As much as our film choice was once limited by the titles available in the high street video rental store or through our cable TV provider, online on-demand options are still shaped by the contracts and marketing arrangements discussed within Chapter 1 of this book. Furthermore, new distribution platforms are unevenly distributed

across the globe and, where they are available, they are subject to the vagaries of access to high-speed Internet connections, not to mention reliable access to electricity. Such a context is convincingly summed up by Knight and Thomas when they suggest that, 'despite the perceived benefits of the "digital revolution" for moving image distribution – and there certainly are very clear benefits – many of the issues governing the diversity of the film culture that we as audiences experience remain the same' (2012, p. 274).

To take one obvious example, many of the key players within on-demand distribution only operate in a few key territories.[1] Furthermore, Internet access itself is unevenly distributed across the globe. To illustrate this point, according to data available from the World Bank (2015), the East African country of Eritrea has the lowest level of Internet access, with only 0.9 people per 100 of the population able to access the worldwide web in 2013. This figure rises across the African continent with access in South Africa reaching 48.9 people per 100 of the population. However, such a figure is still rather low and, looking at the so-called BRIC countries (Brazil, Russia, India and China), nations specifically identified as undergoing advanced economic development at present, we can see that Internet access here is also uneven. Russia leads the pack with a figure of 61.4 per 100, while India exists at the other end of the spectrum with only 15.1 people out of 100 having access to the Internet. China and Brazil reside in the middle of the table with 45.8 and 51.6 respectively. At the top of the scale, the Scandinavian countries all boast access for around 95% of their population and Iceland has the highest figure with 96.5 people per 100 able to access the Internet. However, in the UK the number is only 89.8 and the US is even lower with 84.2. So, even if online on-demand companies offer their products in a certain territory, the variations in Internet access within that country may mean that such services are still only accessible to a proportion of the population. In addition, the costs required for an Internet connection and the premiums levied to access on-demand services may also prevent potential audience members from experiencing such content. As such, the idea that we are experiencing a *universal* era of plenty in terms of film and TV distribution is undoubtedly a fiction.

While never forgetting this global context, it is still true that in many parts of the world things have indisputably changed. I am fortunate enough to have had access to the Internet and DVDs from my late teens but, even in such times, cinephilia was still a troublesome pursuit. I spent large portions of my time perusing the shelves of the local Blockbuster video rental store frustrated by the fact that I seemed to

have viewed most of the films on offer multiple times. To counteract this lack of availability, I stayed up late into the night to record films programmed in the graveyard shift on the four terrestrial channels that were available in the UK through the 1990s. I amassed an extensive collection of poor-quality long-play VHS tapes that hosted two or three films each. This collection then required a complicated cataloguing system so I could identify (with relative ease) which VHS housed which film. This collection has long since been retired, as DVDs, and now Blu-rays, have replaced the format of my youth. Furthermore, these copies were played on so many occasions that they became almost unwatchable towards the end of their lives. Nonetheless, I remember them fondly and one or two still exist for sentimental reasons and/or to allow me access to films that I have not yet been able to locate through other means.

So, with this context still fresh in the minds of many, it might seem short-sighted to suggest that the introduction of Hulu, iTunes, Netflix, Amazon Instant and the like have not revolutionised film viewing in countries where such services (and reliable Internet connections) are readily available. Indeed, things have undoubtedly changed dramatically over the last 15–20 years (if they had not, there would be very little point in writing this book). However, I would suggest that this change does not amount to a revolution: a term that would imply that an alternative system has *replaced* the incumbent one. While Iordanova claims that 'cinema is in the process of moving on-line' (2012, p. 1), such phrasing, although acknowledging that such a process is still underway, also implies an inevitability that I would dispute.

This book does not pretend to claim that the experience of film spectatorship has not changed dramatically in recent years but, if we look back across the history of cinema, then it is clear that the methods and modes of consuming films have been forever changing and developing. To take one example, the architecture of cinemas has changed dramatically over the years, so much so that the majority of cinemas we attend now bear little resemblance to the picture palaces that were popular in the early part of the 20th century. Furthermore, the conventions of cinema viewing in the UK require that one sits in the dark in silent reverence while the film is screened, but this practice is very far removed from the way films were watched in Nickelodeons and is certainly not representative of the many ways that films are now experienced in public settings the world over. So, when concerns over the 'death of cinema' are raised, they seldom take into account the fact that cinemas and practices of film consumption have always been in a

perpetual process of change and adaptation. We must remind ourselves that to watch films collectively on a large screen is a convention and not a necessity of the medium. Furthermore, just because alternative film-viewing practices present themselves, it does not mean that audiences will all simultaneously reject decades of tradition surrounding film consumption.

As such, this book rejects the suggestion that the theatrical presentation of films will ultimately be *replaced* by online film consumption. While it must be acknowledged that significant changes to film viewing are being felt in certain countries, in other territories cinema attendance is in very good health. In this respect, one would be ill advised to claim that a wholesale global decline in theatrical film attendance is in evidence.

When examined from a global perspective, the health of the film industry is much more complex than might be inferred from the frequent news coverage suggesting an industry in crisis (*Daily Mail*, 2011). For instance, in 2013, global box office revenue rose to $35.9 billion, an increase of 4% from 2012 (Motion Picture Association of America (MPAA), 2014, p. 2). Domestic (that is, US and Canadian) box office receipts also grew in 2012, but only by 1% (MPAA, 2014, p. 9). Nonetheless, it must be acknowledged that this slight enlargement was due to a rise in ticket prices and not an increase in admissions. According to the MPAA, 1.34 billion cinema tickets were sold in 2013, down 1% from the 1.36 billion figure of 2012 (2014, p. 9). However, to put this decline in context, the MPAA also point out that 'movie theatres continue to draw more people than theme parks and major U.S. sports combined' (2014, p. 10); with a mere 371 million tickets for theme parks and only 125 million tickets for sports events sold in 2013. When these figures are compared with the 1.34 billion tickets sold for cinema admission in the same year, the social pastime of cinema-going might be considered in much more than reasonable health.

We might also be forgiven for thinking that the European theatrical market is also performing poorly, with the European Audiovisual Observatory (EAO) publishing a press release in February 2014 reporting a 4.1% decline in European cinema attendance in 2013 (2014, p. 1). However, what this headline news does not mention is the fact that not all EU territories have experienced this reduction. Indeed, Bulgaria, Hungary, Italy, Lithuania, Latvia, the Netherlands and Romania have all witnessed an increase in cinema attendance over the same period. Furthermore, if non-EU European countries are included (as they are in the EAO's release), then it is notable that the Russian Federation and

Turkey have enjoyed attendance increases of 10.5% and 14.8% respectively. That being said, I would no more wish to suggest that such growth in these territories is indicative of a wider upsurge in attendance than I would praise the use of the 4.1% statistic as symptomatic of an overall downturn.

The problem is that there seems to be a tendency to focus on the negative within such industry reporting rather than highlight the areas of growth and prosperity within the film industry. Indeed, I would suggest that the headline used within the EAO's press release could have just as easily focused on the fact that Turkish films represented 58% of cinema admissions in Turkey in 2013, a figure 'unparalleled in any other European market in the past few decades' (2014, p. 2). Considering the aforementioned 14.8% growth in Turkish cinema admission, this would seem to point to a Turkish film industry in incredibly good health. Again, that is not to say that we should take this case as evidence for the widespread health of cinema, but we should look at the issue for what it is, a complex picture of varying territories with differing and fluctuating practices of film spectatorship.

With this intricate understanding of theatrical distribution in mind, this chapter will examine the growth of new methods of online film distribution spearheaded by companies like Netflix, Amazon Instant and Hulu; those Stuart Cunningham has termed the 'disruptive innovators' (2013, p. 69). In doing so, I shall question the extent to which these organisations have already changed, and indeed may continue to augment, the reigning models of formal film distribution. However, this chapter is sceptical overall about the potential of these 'disruptive innovators' to reorganise existing power dynamics within formal film distribution and proposes that the 'revolution' they have facilitated has largely been overplayed. While it is certainly easier for some of us to access *popular* content using platforms like Netflix and Hulu, the films and TV shows offered from these providers is tantamount to the titles offered in the Blockbuster that I frequented in my youth. While these new platforms mean that one does not need to go to a physical video store in order to rent popular titles, I would argue that the *variety* of titles on offer in many respects remains the same. Extensive empirical work still needs to be carried out in this area but this chapter seeks to continue the discussion begun by a number of theorists (Kerrigan, 2013; Knight and Thomas, 2012; Perren, 2013) who suggest we should be cautious when claiming that cinema on-demand might give us access to more a more diverse film library.

While to claim a 'revolution' might be premature, there have undoubtedly been some substantial shifts in the media landscape of

late and the situation is changing very rapidly. In 2007, 'VoD services and Internet distribution attract[ed] so little consumer traffic as to be virtually worthless' (McDonald, 2007, p. 176); however, in the US, '[b]y 2011, VOD accounted for about a quarter of the $8 billion consumers spent on video rentals' (Balio, 2013, p. 110) and the video-on-demand (VoD) market in the UK grew by 416% from 2002 to 2013 (BFI, 2014). Such statistics suggests that this sector of the market has grown dramatically in recent years and, if such a trend continues, then VoD could indeed represent a substantial source of revenue for film distributors.

One other significant change that has accompanied the growth of these new platforms is the increased convergence of our consumption of TV and film. However, as I have earlier identified, a significant method of accessing niche or hard to find films was, as least in the UK, often through the TV itself. Thus, the convergence of these two mediums is not as new as it might at first appear. In fact, UK television now broadcasts slightly *fewer* films than it did before. For instance, in the UK in 2013, 1,990 films were broadcast on terrestrial television (*BFI Statistical Yearbook*, 2013, p. 139) compared to 2,103 in 2002 (UKFC Statistical Yearbook, 2002). However, this is not a particularly dramatic drop and may seem even less significant if we consider the range of films available on non-terrestrial channels. While many of these might be subscription only (for example, Sky Movies), there are also freeview film channels (for example, Film4) and non-specialist freeview channels, like ITV2, ITV3 and so on, that broadcast a range of films during their scheduled programming. Indeed, the TV film audience in 2013 was just below 3.4 billion people, a figure over 20 times greater than UK cinema attendance in the same year (BFI, 2011, p. 138). Thus, scheduled broadcast television and associated catch-up services (for example, BBC iPlayer and itvPlayer), still represent a significant portal to films for UK audiences.

So, while we can see that film and TV viewing have long been intertwined, what is significant is that arguably the *manner* of convergence is changing. One can watch both films and TV on a television set through an application (app) available on a games console or smart TV. Furthermore, one is able to access such content at a time and place of one's own choosing. However, it is worth highlighting that what is available to watch is still curated for us, even if we are now free to view it at any time of our choosing.

In considering how these innovations have influenced film distribution in particular, the following section will establish what is meant by the term 'disruptive innovators': specifically, who are these new players and how do they operate? The chapter will then move on to a case study of the simultaneous theatrical, online and DVD release of the

film *A Field in England* (2013, Dir. Ben Wheatley). This case study will allow the examination of whether such simultaneous release practices are likely to become commonplace in the future or whether they will ultimately remain the preserve of films that would only otherwise enjoy a limited theatrical run.

VoD and SVoD online: Netflix and co.

In their 2012 contribution to the edited collection *Digital Disruption: Cinema Moves On-line* (Iordanova and Cunningham, 2012), Stuart Cunningham and Jon Silver suggested that a new breed of content distributors/exhibitors has entered the film distribution market. These companies are said to be 'disrupting' the traditional patterns of film distribution by offering films and television programmes to audiences outside of the time-honoured window schedule outlined in Chapter 1. While business models vary across companies, what connects these 'innovators' is that they have 'disrupted' the distribution market by offering films and TV through a video-on-demand (VoD) model, to be watched at any time and on a variety of devices. These services vary between pay-per-view, subscription or combination purchase models. While it has long been possible to watch films at home through premium cable/satellite subscriptions and/or PPV services, what is different about these 'disruptive innovators' is that they have not simply been absorbed into the current windowed distribution system and allocated a place in the hierarchy of the release schedule. As content is available through these services 'on demand', that is whenever and wherever the consumer wishes to view it, then the almost sacred theatrical window appears increasingly anachronistic. While they are undoubtedly 'disruptive' in that sense, it remains to be seen whether these 'innovators' offer increased access to a more diverse film library.

What is video on demand?

When we speak of VoD, there are a number of practices and platforms that come under this categorisation. According to the BFI Statistical Yearbook (2014), online VoD services in the UK can be subdivided into four overall business models (see below). While the BFI understandably provides a specific UK analysis, their subdivisions do encapsulate the rough organisation of the online VoD models that exist the world over (Table 3.1).

As has already been mentioned, in many respects VoD is not a particularly new phenomenon, as the lineage of television-based VoD can

Table 3.1 UK VoD business models

Television-based VoD	Online VoD
Cable PPV	Rental VoD – one-off rental, also known as download-to-rent (DTR), e.g. from Google Play or BlinkBox.
	Retail or download-to-own (DTO), also known as electronic-sell-through (EST), e.g. iTunes or Xbox Video.
	Subscription VoD (SVoD) – unlimited access to content for a fixed monthly sum, e.g. Amazon Prime Instant Video or Netflix.
	Free/advert-supported VoD from catch up services, e.g. BBC iPlayer or 4oD.

Source: Adapted from *BFI Statistical Yearbook* (2014, p. 133).

be traced back to previous cable PPV models. This form of VoD allows consumers essentially to 'rent' a film title for a specific length of time or for a certain number of viewings. An example of such a service is Sky Box Office, which originally offered viewings at predetermined times but now conforms more accurately to the designator 'on-demand' by offering a number of titles that the consumer can download to their Sky box to watch within a given period of time (usually 48 hours). This practice has enjoyed a privileged position in the film-release window schedule for some time, with films historically being available on PPV within two months of cinematic release and up to four months before the film becomes available to buy on DVD/VHS.

While the cable PPV system had been established for some time, the introduction of online rental VoD has introduced new players into the game and made it clear that PPV VoD is no longer the sole purview of the cable providers. In 2012, the UK online VoD market overtook television-based VoD revenues for the first time, with television-based VoD bringing in only £111.9 million in revenue in comparison with the £124 million achieved by online VoD (BFI Statistical Yearbook, 2013, p. 132). In many respects, PPV VoD available through platforms such as smart TVs and computer game systems (for example, Microsoft's Xbox One or Sony's PS4) closely resembles more traditional cable PPV offerings. Typically a single film is purchased for a limited period of time using an interface accessed through one's television. The fact that the technology that facilitates this process is somewhat different is largely invisible to the user. When accessing PPV VoD through a console or directly via a smart TV, audiences do not typically need to have a specific

subscription, but there are other requirements to access; for example, one has to have the appropriate hardware, the necessary subscription to an internet service provider (ISP) and an appropriate app on one's system. Example interfaces include Xbox Live and PlayStation Store that are tied to games console subscriptions and stand alone apps like BlinkBox (owned by the supermarket chain Tesco) that enable one-off purchasing. A further distinction from previous forms of cable PPV is that the apps that can be accessed through one's TV are also available through smartphones, tablets and computers. Thus, while the model mimics cable PPV in some aspects, it has developed far beyond this.

The online VoD market is also not particularly new and there have been a number of players who have attempted to develop businesses in this area.[2] For instance, Movielink was a non-subscription VoD service created as a joint venture by Sony, MGM, Paramount, Universal and Warner Bros. that launched as far back as November 2002 (McDonald, 2007, pp. 172–173). In August 2007, Movielink was acquired by the high-street rental chain, Blockbuster, allowing them to enter the movie download service market that had been populated by Netflix, Apple, Amazon and Wal-Mart in the previous 12 months (Bloomberg, 2007). While Blockbuster announced in November 2013 that they would be closing their rental stores and stopping their mail DVD operations (Stelter, 2013), the VoD service that Movielink had become, www .blockbusternow.com, still operates in the US offering PPV rental to audiences on TV, tablet, PC or phone for $2.99 per title. Indeed, there have been, and continue to be, a range of PPV VoD options available to film audiences in some parts of the world. These vary in terms of price, catalogue and territory, and it is not the intention or purpose of this chapter to provide an overview of all of them. Indeed, detailed information on the rise and development of such services can be found in the work of Balio (2013), Cunningham and Silver (2012), McDonald (2007) and Pardo (2015). However, the fact that this early example of a venture into the online VoD market was largely unsuccessful, despite being backed by five major Hollywood studios, is a matter of some note and ultimately left space for companies like Amazon and Netflix to enter the arena.

Like rental VoD services, download-to-own options have also been available (in the US at least) for nearly ten years. The major Hollywood studios started to make their films available as 'download-to-own' from April 2006, priced in the same region as a physical DVD (McDonald, 2007, p. 173). However, there were restrictions on how these downloads could be used by audiences. For instance, on the platform CinemaNow, the downloaded film was restricted in such a manner that it could only

ever be replayed on the device that was originally used to download it. Movielink was a bit more generous, allowing purchasers to play the film on a further two computers and to make a back-up DVD. However, the backup disc could only be played on a computer and not through a DVD player (McDonald, 2007, p. 174). This effectively meant that for the casual viewer there were technological barriers that made it difficult to watch the purchased films on anything but a computer, which, according to McDonald, made such permanent download options unpopular with audiences (2007, p. 174).

However, since McDonald examined this issue in 2007, the download to own market has developed considerably. For example, iTunes, Amazon Prime and BlinkBox are all strong contenders in this market in the UK. Indeed, while not yet as established as rental VoD, by 2013 online retail sales had grown to 28% of the online VoD market in the UK. This amounts to revenue of £55.5 million, but it is important to note that these figures combine data for film and TV, and the disaggregated data is confidential (BFI Statistical Yearbook, 2014, p. 133).

While the Movielink experiment was ultimately unsuccessful, the studios returned with a more promising (and more extensive) collaboration in the form of Ultraviolet, a joint venture between 20th Century Fox, Universal, Sony Pictures and Warner Bros., and other Digital Entertainment Content Ecosystem (DECE) members such as Adobe, Cisco, Intel and AMD. The Ultraviolet website describes the service as a 'cloud-based digital rights library' (Ultraviolet, n.d.). When one purchases an Ultraviolet DVD/Blu-ray, then it is accompanied by a code that allows the customer to add the purchased film to their online Ultraviolet library. Customers within Ultraviolet's territories[3] can also buy films from participating online retailers (for example, BlinkBox) and as long as the user's accounts with both the online retailer and Ultraviolet are linked, then the purchased film automatically appears in their online Ultraviolet library. Theoretically, rights to view the film last in perpetuity but, if one has bought a DVD/Blu-ray with a digital copy included, there is a time limit for redemption – though this is usually a few years.

While the success or otherwise of Ultraviolet in the PPV VoD market remains to be seen, the growth of Netflix and subscription-based VoD (SVoD) seems undeniable. Indeed, the move towards subscription models for VoD perhaps represents an even greater schism between early VoD practices and their current manifestations. Such services allow customers to pay a monthly fee in return for varying levels and modes of access to a film catalogue. This form of distribution grew out of the postal DVD rental services that developed in the early 2000s. Companies such as Redbox and Netflix in the US, and LoveFilm in the UK, allowed

users access to a certain number of DVD rentals per month in return for a subscription fee. Users would then have titles posted to them and would either post them back (as with Netflix and LoveFilm) or drop them off in specific locations (as with Redbox). Netflix have long been the leader in this field, as since 2006 they have 'offered in excess of 60,000 titles, boast[ed] over 4.9m subscribers and ship[ed] from thirty-one regional distribution centres' (McDonald, 2007, p. 162).

When these companies were first developing, their film and TV catalogues were restricted to older titles that had already been available to buy for some time and were way past their theatrical window. Such early restrictions may be attributed to the reticence of the Hollywood studios to get on board with such services fearing that they would not only eat into DVD profits but would also provide ready-made digital copies for 'pirates'. As Finney suggests, 'any damage to the DVD window creates fear and hostility in the risk-averse Studio ecology' (Finney, 2010, p. 124). This is despite the fact that research from Warner Bros. and Comcast, the largest cable operator in the US, has suggested that the simultaneous release of a title on VoD and DVD does not reduce DVD profits (Balio, 2013, p. 110). Such research concluded that, in general terms, DVD purchasers were not interested in VoD and VoD subscribers were not particularly concerned with buying DVDs. Thus, potentially the concern is not with subscription models per se (or even online VoD in general) but rather with allowing new players like Netflix to threaten existing monopolies.

Before concluding this section it is important to mention that, while they are not typically thought of as VoD platforms in the way that BlinkBox and Netflix are, services like YouTube and Vimeo also allow users to search for content and access it 'on-demand'. While YouTube has not yet been a platform for the large-scale release of films, it is regularly used to promote films. That said, the difference between YouTube and other VoD services may largely be one of perception because, in 2012 and 2013, it was actually YouTube that 'was the most popular VoD provider among UK online film viewers aged 12 or over' (BFI, 2014, p. 134). It is certainly notable that, of the top six VoD platforms in the UK in 2012 and 2013 (YouTube, LoveFilm, Netflix, iTunes, Amazon and SkyGo), the most popular of these was also the only one funded through advertising and not subscription or PPV. Thus, it was also the only platform on the list where films could be watched for free and this fact might contribute to its popularity. So, although YouTube does not represent the kind of VoD that is the focus of this chapter, its place in the new ecosystem of film consumption cannot be ignored.

Overall, while the VoD market has expanded exponentially in a number of territories, one might argue that the biggest growth in this area is attributable to the 'disruptive innovators' like Netflix and Amazon and not the major Hollywood studios. As concerns over perceived increases in 'piracy' abound and traditional distribution mechanisms designed to boost the profit of the studio-based distributors are threatened, 'the only growth area is the net'; yet, as Finney goes on to suggest, 'the Studios are not servicing it proficiently to date' (2010, p. 124). This point was made in 2010 but these words still ring true in 2015. So, while it was commonplace by 2008 to simultaneously release all titles on VoD and DVD, this was typically though the PPV model and not the SVoD model offered by Netflix.

It is fair to say that VoD and SVoD are still in their infancy. Furthermore, while the big players have successfully become household names in the territories where they operate, it remains to be seen whether Amazon Instant Video, Netflix, Hulu and the rest will go the way of Netscape, Ask Jeeves and Alta Vista. Nonetheless, via PPV or SVoD, streaming or download, accessing content 'on-demand' seems to be the future of film and TV distribution.[4] However, exactly *when* titles become available on demand, in particular, whether on-demand releases are available 'day and date' with the theatrical release is a hotly contested issue. As such, the following section of this chapter will consider a case study of one attempt at a multiplatform simultaneous release in order to examine whether such strategies might promise to be the future of film distribution.

In (online) cinemas now: *A Field in England* (2013)

> The future is here. This morning, we downloaded a copy of A Field in England hours before cinemas even opened.
>
> (Radford, 2014)

As the above quote highlights, the 2013 release of Ben Wheatley's film *A Field in England* was widely heralded as a 'UK distribution first' on account of its release on DVD, TV, VoD and in cinemas concurrently on Friday 5 July 2013 (Wigley, 2014). At the time, the UK newspaper *The Guardian* asked if this strategy amounted to 'a bold new model, or a reckless experiment'? (O'Neill, 2014). This chapter contends that the strategy is neither a vision of the future of film distribution nor is it a one-off phenomenon. While such release strategies may become increasingly commonplace, as their popularity grows, their

impact may also wane because (at this point in history at least) one of the primary benefits of such a strategy is precisely the fact that it is *novel*. As will be seen, by being able to claim loudly and publicly that this approach is just the beginning of a revolution in film spectatorship, then films like *A Field in England* are able to gain large amounts of publicity simply because of the manner in which they are distributed. However, if such multiplatform simultaneous releasing did become the norm, then arguably such strategies would also loose their promotional edge.

Produced by Rook Films, *A Field in England*'s release strategy was made possible thanks to the specific remit of the BFI Distribution Fund's 'New Models' strand to finance such innovative approaches to distribution. According to the BFI's website, 'The film's multi-platform release is the result of a partnership between Film4, Picturehouse Entertainment, 4DVD and Film4 channel, enabling viewers to decide how, where and when to view the film' (Wigley, 2014). The BFI professed that such a strategy aimed to court viewers who live outside of major cities or who simply prefer to watch films in the comfort of their own homes (Wigley, 2014).

While the film's UK release was actively promoted as being a dramatic departure from the norm, it was actually only slightly bolder than previous attempts at simultaneous multiplatform releases and thus potentially part of a gradual disintegration of the traditional release window schedule rather than representative of a sea change in this area. Indeed, simultaneous VoD and theatrical releases were not uncommon by 2013, but *A Field in England* was reported as the first to have a simultaneous release on *free to air* TV as well as on DVD and online (Weedon, 2014). Indeed, it has been possible to purchase a VoD version of a film on the same day as the DVD release ever since copies of *Brokeback Mountain* (Ang Lee, 2005, US) went on sale on 4 April 2006 (McDonald, 2007, p. 174). Furthermore, a full seven years before *A Field in England* was even made, Michael Winterbottom's film *The Road to Guantanamo* (2006) used a similar release strategy. *The Road to Guantanamo* premiered at the Berlin Film Festival in February 2006 and it was then shown on Channel 4 on the 9 March of the same year before being released in cinemas, on DVD and online the following day (BBC, 2006).

However, while the novelty factor of the way *A Field in England* was released may have been somewhat exaggerated for promotional effect, we might still see this approach as indicative of the wider shift towards on-demand film spectatorship. For instance, Katie Ellen from

the BFI Distribution Fund promoted this strategy as an 'exciting distribution model' that offered audiences the opportunity to see Wheatley's new film 'no matter how they like to watch films' (Ellen quoted in Wigley, 2014). Such a description implies that it is the audience (rather than industry or technology) that is somehow driving the changes within film distribution, suggesting that it is audiences who wish to have more options to watch new films outside of theatrical space and at a time of their own choosing. This sentiment is echoed by Sue Bruce Smith, Head of Commercial and Brand Strategy at Film4. When speaking of the release of *A Field in England*, she claimed that 'we've wanted to do something like this for quite some time, to give the audience what they say they want: to be able to watch a new film when and where they want to' (cited in O'Neill, 2014).

However, the BFI's press release announcing the film's distribution strategy also alluded to the industrial context for this approach. The situation for small distributors was presented in this release as rather bleak due to the fact that large exhibitors demand that films shown in their cinemas are not released on any other platforms for 17 weeks (Wigley, 2014). This four-month window, the press release claims, is a challenge for independent distributors who want their films to have a cinematic release because the gap between releases on different platforms means that promotional activities must be paid for twice. Indeed, Katie Ellen, Senior Distribution Manager at the BFI, suggests that:

> Today's film distribution landscape is as cluttered as a Bosch triptych and almost as treacherous, with up to a dozen new releases every week. Studio-made leviathans scoop up most of the attention and box office takings, while numerous smaller fish are left fighting over the scraps. Even independent films with a buzz about them can struggle to be noticed and many are left without a distribution deal.
>
> (cited in Abraham, 2013)

Thus, it becomes clear why it might be beneficial in promotional terms to have a multiplatform release for films like *A Field in England* that would not normally have particularly generous advertising budgets. Because, as Anna Higgs, Executive Producer for *A Field in England* suggests, 'by having all platforms working together, we generated a real buzz and put the film on the map' (cited in Rosser, 2013). Indeed, much of the press coverage of the film's release discussed it as an 'event' and, furthermore, pointed to the marketing potential of such a strategy. This can be seen in coverage from online magazines like *Little White Lies*,

which proclaims that the *A Field in England*'s 'multiplatform release strategy . . . has afforded the film an unparalleled marketing opportunity (Weedon, 2014).

Nonetheless, the distribution strategy of this picture is not only representative of shifts in distribution but also points to concomitant developments in theatrical exhibition of films, be that in traditional cinemas or on big screens in non-traditional settings. In both marketing terms and for the audiences, the film's release was structured as an event. Furthermore, while multiplatform releases of this type remain novel, the release strategy itself becomes instrumental in framing the film's release as about so much more than traditional cinema-going. Such a sentiment was ably summed up by one journalist from the VoD specialist review site VODZilla that hailed the release of *A Field in England* as 'the kind of event that normally only comes with oodles of marketing money and gigantic CGI robots punching aliens in the face' (Radford, 2014).

The 'event' status of the film's release was generated in a number of ways across the varying platforms. Those who watched the film in the cinema on the day of release were able to experience a Q&A session with the director at the Ritzy Picturehouse in Brixton, and this activity was also streamed to other cinemas showing the film on the day of release. The DVD release, of course, was accompanied by extra features: an interview with the director, audio commentary for the film, a camera test reel, a trailer, and what was described as a 'Digital Masterclass', that is, 'over 40 minutes of in depth interviews and explanation of the entire film making process' (How to See the Film, 2014). The Blu-ray contained the same extras but with a further 35 minutes of material included within the 'Digital Masterclass'. An introductory programme, including an interview with the director, preceded the showing of the film broadcast on Film4. Only the VoD release, it seemed, was truly the 'vanilla' version of the film, as this did not include any of the aforementioned 'extras'. From this one might presume that the very fact that audiences could choose when and where to watch the film was the 'added extra' provided by that particular option. The film itself was also screened over the summer of 2013 in various 'fields' in England. Furthermore, the construction of the film's release as an extraordinary event experience did not stop with the film itself but was extended on the film's website where audiences could view some of the aforementioned 'Digital Masterclass' videos alongside additional behind-the-scenes production information. Indeed, according to Phelim O'Neill from the UK's *Guardian* newspaper, 'there's even a limited edition VHS release being planned, so no one feels left out of the fun' (2014).

Although not part of the initial simultaneous multiplatform UK release, Drafthouse Films, the film's US distributor, are themselves renowned for employing some rather innovative practices when releasing their films. In the past, Drafthouse have partnered with BitTorrent to offer 'bundles' with extra content attached to films like Michel Gondry's *Mood Indigo* and Joshua Oppenheimer's *The Act of Killing*. For their release of *A Field in England*, the film was offered on Blu-ray or DVD with 'over 2 hours of bonus material' plus a Digital Rights Management (DRM) free digital download of the film for $17.99 or a 'watch now' version that gives the customer the DRM-free download plus instant streaming of the film and 'permanent access to the film to download and stream' for $9.99. With the DVD/Blu-ray package you can pay $21.99 and get a theatrical one-sheet as part of the bundle, but this can also be bought separately for $7.99 (*A Field in England*, n.d.)

So, one might suggest that the release strategy employed for *A Field in England* was about both marketing and audience demand; as the journalist O'Neill says, 'this is an experiment in distribution designed not only to turn the release into an event, but also to finally acknowledge that our viewing habits – how we consumers consume movies – have changed drastically over the past decade' (2014). While O'Neill is undoubtedly correct that the viewing habits of audiences have changed, he does also still refer to such a strategy as 'an experiment'. Indeed, Sue Bruce Smith, Film4's Head of Commercial and Brand Strategy, also referred to this strategy as an experiment when she commented in a 2014 interview that 'we're lucky to have found in Picturehouse Entertainment, 4DVD, the Film4 channel and BFI partners who share our vision to disrupt the status quo and experiment with new distribution patterns, to create this exciting event style release' (cited in Kemp, 2014). Their reference to the experimental nature of such a strategy reminds us that this kind of approach is still an oddity and not the norm. So, the question remains whether such strategies will grow in popularity and start to displace more traditional approaches, or instead are likely to be an addition to the status quo and not the all-out 'disruption' that Sue Bruce Smith proposes.

For some, this form of multiplatform release is undoubtedly the future and sounds a death knell for the current windowed releasing strategies that have dominated the film industry for so long. For instance, according to Andy Starke, one of the producers of *A Field in England*, 'in five years time when every single piece of entertainment is on a server somewhere that's being downloaded to your phone or to the cinema, it's just going to seem ludicrous that people gatekeep stuff' (cited in Weedon,

2014). So, it is clear that, for Starke at least, this future is not merely probably but inevitable.

Indeed, when defending the proposal that such a release strategy is the inevitable way of the future, one might point to *A Field in England*'s financial success. For instance, the film generated £21,399 on 17 screens over the opening weekend, giving a screen average of £1,259 (Rosser, 2013). A modest amount by some standards, but the opening night showings at Brixton's Ritzy, Curzon Soho, Hackney Picturehouse, Edinburgh's Cameo and Brighton's Komedia were all reputedly sold out (Rosser, 2013). On Film4 and Film4+1 there was an audience of 288,000 on the day of release with the recorded viewing figures for Saturday and Sunday increasing that number up to an estimated 357,000 viewers (Rosser, 2013). A total of 1,462 copies of the DVD were sold on Amazon and at HMV over the opening weekend. Opening weekend purchases on 4oD and iTunes amounted to more than 1,000, and the film 'was also the most-mentioned film in social media terms for Film4 all week and was the number one trending topic on Twitter in the UK on Friday evening' (Rosser, 2013). While moderate in some respects, such figures point to a very good performance for an otherwise niche film release.

However, Gabriel Swartland, Head of Communications at Picturehouse, is less convinced that simultaneous releases that include free-to-air broadcasts are likely to catch on and suggests that they would be a 'massive hurdle for any distributor to cross for a more commercial title' (Weedon, 2014). Indeed, some who have suggested that multiplatform releases will be the wave of the future also suggest this will only be the case for those more 'esoteric' titles (O'Neill, 2014). Swartland further observes that for *A Field in England* there was a TV channel involved as part of the film's production. As such, he suggests that:

> I don't think the same approach is going to be something that we see in the near future. We believe people will come to the cinema to experience film the way the filmmakers intended. If anything, we hope this experiment will confirm some of those assumptions.
>
> (cited in Weedon, 2014)

So, it would seem that even those involved in this 'experiment' do not necessarily believe that such releases will be commonplace but, interestingly, also do not suggest that such strategies would necessarily undermine theatrical cinema attendance. Such sentiments echo Balio's comment that for films with 'only limited theatrical potential...the day-and-date release was just a way to increase awareness in ancillary

markets' (Balio, 2013, p. 111). In such respects it might seem that, for films that would be unlikely to reach a large theatrical audience anyway, a simultaneous release on all platforms has enormous potential.

Despite the confidence of some that such a strategy is ultimately promotional for the film as a whole, some have questioned whether the approach will subsequently limit the ability of the film to travel to foreign markets. This perspective is exemplified by a review in *Variety* which suggests that 'Drafthouse Films will have a far trickier time when it releases "Field" in the U.S. next year, since the most receptive potential viewers will have already sampled it via illegal means' (Debruge, 2013). Such a comment is based on a presumption that US audiences will have *already* watched the film (illegally) online rather than waiting for an official release. However, were this to be true, might this fact then support a further move towards *global* simultaneous multiplatform releasing so as to counteract audiences finding films through informal online networks before they are officially released in their own territory? This is a perspective that even some Hollywood executives are starting to espouse with the CEO of Time Warner, Jeff Bewkes, controversially suggesting in 2012 that it made sense for the industry to release films on all platforms early in their run because to not do so 'would create a gap for piracy' (cited in Child, 2012). Such a perspective would seem to suggest that multiplatform simultaneous release strategies will not be reserved for 'arthouse' films but might also enable more commercial films to combat 'piracy'. However, in such a scenario, the smaller independent films may then become lost in the mass of VoD content available online, as such simultaneous releasing strategies also loose their novelty and thus their promotional potential.

Indeed, before heralding cinema on demand as the future, we also have to consider the consequences for past films as well as for future ones. If film spectatorship were to move entirely online (a scenario I would argue is rather unlikely), then the film catalogue available to us would ultimately be shaped by which films have been digitised and which have not. As Knight and Thomas identify, 'despite widespread perceptions to the contrary, not all films *are* available online or even on DVD. Sometimes this is because of rights clearance issues, but even if they are online, there is no guarantee they will remain so' (2012, p. 17). Thus, online VoD, rather than representing increased access to content may actually create what Claudy op den Kamp (2015) refers to as a 'digital skew', whereby only the work that is digitised is remembered and viewed, and work that is not available online is ultimately marginalised and forgotten.

However, such a scenario is only really likely if we accept the thesis that theatrical exhibition is inevitably going to die out: a scenario I would suggest is very unlikely. As with the release of *A Field in England*, the VoD release *accompanied* the theatrical show of the film; it did not replace it. Indeed, despite the oft-mentioned early concerns, home video formats like VHS and DVD did not replace theatrical consumption of film even when they became more profitable than box office receipts. This is because 'real world exposure is still vital' and theatrical distribution attracts media and editorial coverage that effectively promotes the film in other markets (Knight and Thomas, 2012, p. 273).

Even Ben Wheatley, the director of *A Field in England*, does not present the film's release strategy as a move away from theatrical distribution when he claims:

> A cinema is still the best place to see film. I don't think that what we're doing is an assault on the theatrical experience, I think it's saying that the theatrical experience is the pinnacle of this thing, and if you know your eggs and you like film, go and see it in the cinema. But if you don't care so much, then you can see it in all these other ways. You don't have to spread [the release] all over the year, because that doesn't really help. Also, if we give it away for free on the telly, it means that we've got access to a general audience which we'd never get. And once they see it, half of them might hate it, but then you've got a chance that half of them like it.
>
> (cited in Clift, 2014)

Conclusion

So, we go back to the 'also' and the 'and' proposition from Harbord (2007, p. 144) that was mentioned in the introduction to this book. What we are witnessing with VoD is the continuing proliferation of viewing options for films rather than the replacement of one window with another. That said, the difference with the current manifestation of online VoD is the manner in which it has disrupted the traditional windowed release schedule and moved us towards simultaneous releasing (although one could argue that such a strategy is as much about curtailing 'piracy' than anything else).

Furthermore, while VoD is certainly an attractive option for many, part of the problem with it at the moment is precisely the sheer amount of choice that is on offer; not of films themselves but of platforms through which to view them. At present, if I buy a DVD at

Tesco, I also get an electronic version through my BlinkBox account, and Amazon offer me the same service but through their own system. If a buy an Ultraviolet Blu-ray elsewhere, then I can link this with my BlinkBox library but not with my iTunes, Amazon, Sainsbury's Entertainment or Netflix catalogues. I may be able to find all of the films I 'own' or the catalogues I subscribe to through my smart TV or games console, but ultimately the films I have at my disposal at any given moment are dispersed across a number of platforms. Thus, just as Finney identified in 2010, when talking about legal VoD services, 'one overriding problem[s] ... is that the choice of what is legally available remains less impressive and slick' (Finney, 2010, p. 124) than what is available through informal channels. Therefore, the following chapters will consider in detail some of these informal distribution methods and how they too are potentially disrupting current models of media dissemination.

4
Informal Distribution: Discs and Downloads

> It is [...] salutary to remember that piracy, far from being something new and unique to the internet age, is a historical feature of most media markets. Early print culture was rife with unauthorised copying. Entire nations became literate on the back of intellectual property 'theft' (the United States did not respect foreign copyrights until 1891). History tells us that legal and pirate trade are coconstitutive and entangled rather than ontologically separate.
>
> (Lobato, 2012, p. 88)

The above quote reminds us that piracy is not a modern phenomenon and, furthermore, that its networks of distribution have always coexisted and often been interconnected with the official circulation of goods. However, as recent technological changes have increased the ease of media copying, they have also expanded the opportunities for media piracy. As the avenues for informal distribution have developed exponentially, scholarship in this area has seen a concomitant rise. Nevertheless, as this chapter will make clear, much of the academic work in this area that developed around the growth of the Internet has been polarised between two camps: those that ask how best to halt the relentless spread of piracy, and those that question whether the actions of pirates are as damaging to the industry as the anti-piracy rhetoric would suggest. While there are understandably issues with the construction of film piracy as necessarily threatening to the health of industry, the opposing representation that suggests such practices have the potential to challenge Hollywood's dominance of the film industry (Strangelove, 2005; Wang, 2003) still falls into the trap of considering pirates as *either* outright thieves or black market activists (Andersson,

2010; Klinger, 2010). Therefore, this chapter will move away from such debates to examine the social and cultural contexts of piracy rather than its potential economic consequences.

Before investigating the academic literature on piracy, it is first prudent to briefly mention that, despite its ubiquitous use, reaching a consensus on the definition of this term is not as easy as one might imagine. Examinations of how piracy has been defined and how this might serve wider political ends have been considered in a number of publications (Crisp, 2014; Denegri-Knott, 2004; Lobato, 2012; Yar, 2005). Indeed, what these examinations tell us is that 'piracy' is not a fixed concept. As Ramon Lobato rightly suggests:

> Piracy, as the space outside legal distribution, is [...] best viewed as a product of the regulatory systems operative at particular historical moments. As the legal boundaries around media distribution expand and contract so do pirate markets. Over time activities move in and out of the legal zone.
>
> (2012, p. 88)

Thus, it must be recognised that what is defined as an act of piracy has always been subject to the ebbs and flows of national and international laws, regulations and agreements on intellectual property. If we look beyond media piracy and to the historical context of maritime piracy, it is clear that the distinction between the pirate and the privateer has long been ambivalent. As Gary Hall (forthcoming) points out, who is defined as a 'pirate' and who a 'privateer' has always depended upon the whims of those in power. In this respect it is important to highlight that any definition of piracy is necessarily as fluid as the regulatory systems that define its boundaries. Such observations echo those of Majid Yar (2005) who, in suggesting that piracy is a social construction, has sought to argue that it is the regular movement of regulatory and legal goalposts that plays a major part in defining the scope of acts of piracy before further dictating how figures relating to its reach and damage to the creative industries are calculated.

Discs: Markets and streetsellers

The continuing development of the academic literature on piracy serves to highlight that the whole world has not been revolutionised by online distribution in a consistent manner. In recognising that any distinction between digital and physical piracy is a false binary, this

chapter nonetheless acknowledges that the demarcation between the two sections that follow (*discs* and *downloads*) might suggest a wish to reproduce such a falsity. However, this separation was not created to suggest that online and offline practices are entirely distinct or to imply that there is any sort of straightforward boundary between the digital and the physical. Indeed, to take an obvious example, what are DVDs if not a physical conduit for digital data? I must emphasise that, by organising this chapter into two sections on *discs* and *downloads*, respectively, I do not wish to suggest that these practices are disconnected from one another; indeed, there are intersections and interrelations between all film distribution practices. That being said, by first considering the existing literature on film piracy in geographical terms, this chapter seeks to foreground the fact that informal distribution of films on physical formats like VHS and DVD is still alive and well; further, it is a varied practice worthy of continued study both as a distinct practice and as one that is inextricably linked to a wider context of both formal and informal distribution activities online and offline.

This opening section does not seek to provide a comprehensive literature review on piracy but rather makes some key arguments with regards to how the geographical context of pirate activities on both a micro and macro level must be considered when examining pirate practices. In taking such an approach, the specifics of the geographical locale must be considered alongside the position of that context within the wider global political, regulatory, legal and social systems within which we all operate. As such, in order to elucidate these arguments and for the purposes of clarity and structure, this chapter will first take a loosely regional approach when considering the literature on film piracy. By employing this mode of organisation I do not wish to imply that piracy activities are ultimately bound by national and regional boundaries. Indeed, without exception, the practices considered below challenge and transcend such frontiers. However, it cannot be denied that geographical divides and legal jurisdictions exist and continue to wield considerable power. Thus, when examining networks of piracy, one must consider both the specific political, economic and cultural context of the locations within which that piracy is enacted as well as how that context itself interacts with the wider global ecosystem(s) of formal and informal distribution.

As an opening example, an important lesson to be learnt from academic studies of media piracy in India is that the informal and formal circuits of media distribution are not easily demarcated and separated. As Athique posits:

it has not always been easy to distinguish between illegal and legal production regimes in the context of India's informal economy. The intimate relations that exist between the disorganized industry and the black money underworld in India work to undermine the typical 'creative privilege versus organized criminality' rhetoric on media piracy.

(2008, p. 701)

Indeed, as will be examined in greater detail in Chapter 7, many consumer markets for film have either grown out of underground pirate networks (as in the case of anime distribution in the US) or continue to use the same distribution networks to circulate films both officially and unofficially (for example, Nollywood). However, that does not mean that these formal and informal mechanisms of distribution have always existed harmoniously, and it is plain to see that, as new distribution technologies have developed, they have invariably been accompanied by concerns about the effects they may have on the incumbent distribution and publishing monopolies.

To continue with the Indian example, as far back as the 1980s, the growth of piracy enabled by VCR technology prompted concerns over the death of Indian cinema. This was largely because, on a global scale, Indian films have been commonplace within informal distribution networks but largely invisible within formal ones. However, Athique claims that 'without the pirates it would have been difficult to have adequately developed these export markets in the first place' (2008, p. 705). Indeed, Athique is rather celebratory about the capacity of such informal distribution mechanisms to morph into legal markets, claiming that 'one thing that has been demonstrated very effectively by the global networks supplying Indian films is the capacity of piracy to build new markets and to foster increased levels of habitual film consumption' (2008, p. 706). However, we must be careful not to then extrapolate these findings to suggest that the Indian situation might be representative of a wider trend. We should instead remain critical about whether such possibilities are viable or even desirable in other contexts.

Without making similar claims regarding the capacity for informal markets to develop into formal business opportunities, in his work on the Nigerian film industry (Nollywood), Brian Larkin (2004) notes the similarly interlaced nature of formal and informal networks of distribution in the Nigerian context. Here, Larkin suggests that previous research on piracy has tended to focus on the illegality of the issue. He argues that this focus fails to account for the complex infrastructures of piracy

and how these mediate and shape film consumption and aesthetics. Therefore, in his own research, Larkin proposes that Nollywood:

> has pioneered new film genres and generated an entirely novel mode of reproduction and distribution that uses the capital, equipment, personnel, and distribution networks of pirate media. These Nigerian videos are a legitimate media form that could not exist without the infrastructure created by its illegitimate double, pirate media.
>
> (Larkin, 2004, p. 290)

So, in the Nigerian context, we see an extreme blurring of boundaries between the formal and informal channels of distribution and, as these industries have developed in tandem, it is debatable whether they could ever be disaggregated. Furthermore, while it is indisputable that Nollywood has grown exponentially, its development has been accompanied by a crisis concerning how such expansion might even be measurable. As such, Larkin points to the fact that it has been claimed that '70 percent of current Nigerian GDP is derived from the shadow economy' (2004, p. 297). At the same time in reference to this he has urged caution, suggesting one should question such claims because 'like many statistics about Nigeria, [they are] often simulacra, being not so much a numerical reference to the actual state of affairs in Nigeria but rather a mimicking of rationalist representations of economies that are measurable' (2004, p. 298). What is indisputable is that Nollywood provides an interesting example for examination for anyone interested in how formal and informal production/distribution networks both coexist and interact.

Furthermore, as I suggested previously about Indian piracy, the specifics of the Nigerian context must also be considered, as the particularities of the Nollywood industry are unlikely to be duplicable elsewhere (even if such a thing were called for) owing to the contextual factors that have shaped the development of this particular industry. For instance, it cannot be ignored that in 1981 the MPAA stopped the distribution of Hollywood films to Nigeria after some of the MPAA's assets were commandeered by the Nigerian government. As with prohibition of alcohol in the US and countless other examples of products being restricted or banned in certain regions, the restriction of such items is invariably accompanied by the birth of a concomitant black market in said goods. These restrictions came quickly after the spread of VCR technology in Nigeria had been expedited thanks to the wealth generated in the 1970s from oil. The combination of these factors meant that 'far

from disappearing, Hollywood films have become available at a speed and volume as never before' (Larkin, 2004, pp. 294–295) as a result of pirate networks.

According to Larkin, a further factor that contributed to this growth in informal distribution was the fact that Kano, a city in Northern Nigeria, was already an established trade hub with 'northern Nigeria and the wider Hausaphone area (which covers parts of Chad, Cameroon, Benin, Ghana, and the Sudan)' (Larkin, 2004, p. 295). However, while recognising these specifics, it was precisely the fact that Kano *connected* Nigeria to the rest of Africa that meant the national network was able to develop, as it was ultimately supported by the wider regional one. Furthermore, as Hollywood films were restricted, they had to be sourced from other countries and in the 1980s these films primarily came to Nigeria from the Middle East. Thus, it is important to consider the local, national and global context of such informal distribution systems. Furthermore, it is not possible to consider these globalised flows in isolation because the VHS tapes themselves demonstrate the 'visible inscription of the routes of media piracy' as they contain overlaid subtitles in a number of languages as well as anti-piracy watermarks embedded within the source copies of the films (Larkin, 2004, p. 296).

Indeed, what is particularly interesting about Larkin's work is the fact that he focuses on the way that:

> Pirate videos are marked by blurred images and distorted sound, creating a material screen that filters audiences' engagement with media technologies and their senses of time, speed, space, and contemporaneity. In this way, piracy creates an aesthetic, a set of formal qualities that generates a particular sensorial experience of media marked by poor transmission, interference, and noise.
>
> (Larkin, 2004, p. 291)

While Larkin is interested in the aesthetic points of this, I would like to focus on how these observations point to the need to consider both the national and international contexts of the informal distribution of films. For example, the 'pirated aesthetic' of Nollywood films, if we can identify it as such, is inextricably linked with the experience of media (and life more generally) in the Nigerian context. As Larkin points out, all technologies in all circumstances are subject to decay and interruption. But, within Nigeria, where these factors are commonplace, 'they take on a far greater material and political presence' (2004, p. 291). Larkin's work reminds us that research that deals with the effects of

technology on our experience of space and time tends towards the celebratory and focuses on how these experiences are getting smoother, slicker and faster, while the reality is often far from this. The whole on-demand revolution rhetoric would suggest that all our lives have been irrevocably changed, but Larkin's work is informative precisely because it highlights that in many contexts this is by no means the case. However, in looking at the specifics of the situation in Nigeria, we also have to consider that those living and working in that context are all too aware of the fact that their experience of media is not the same as others in different parts of the world. Indeed, it is the very media that is marked by interruption and 'noise' that transmits images of a world where the experience of media technology is profoundly different. Thus, I would argue that what we should take from Larkin's work is that it is imperative to consider both the local and global contexts of media distribution.

However, it is important to note that, when taking this broadly geographical approach to examining work on physical media piracy, we run the risk of reproducing the bias within piracy studies towards a focus on Africa or East Asian piracy identified by Donoghue (2014, p. 352). I would argue that such a preoccupation with instances of piracy in non-Western and developing contexts has served to suggest a culturally embedded pathological association between certain countries and copyright infringement rather than considering the full economic and political context of such activities.

The most notable recipient of this rather xenophobic presumption is China. Indeed, according to Wu, 'as the country with the highest piracy rate, China stands at the heart of the international piracy "epidemic"' (2012, p. 503). To be more specific, 'according to a 2006 report by LEK Consulting, Chinese film piracy cost the worldwide film industry \$2.7 billion in 2005' (Ting, 2007, p. 429). In this context, China's perceived reticence to adopt a Western system of copyright protection is often represented as necessarily lodged in a specifically Chinese understanding of intellectual property and ownership. While it is true to say China is one of the few countries that only prosecute 'for profit' piracy (Ting, 2007, p. 410), such a different understanding of intellectual property does not in and of itself represent the vastly differing cultural understanding of ownership and property that is often suggested. Indeed, Ting has claimed that piracy in China is due to economic and political circumstances rather than cultural mores (2007, p. 415). In particular, Ting suggests that Beijing has little power over local governments and, as piracy provides vast numbers of people with regular employment, local governments have little incentive to curtail it. So,

again, I would contend that the economic, political and cultural circumstances of any acts of piracy ultimately shape how they play out in the lived experience of the people who produce, distribute and consume pirated media.

That said, piracy in China has received specific attention in both popular and academic publications because China's situation is most notably distinct due to the quota system that only allows 20 foreign films to be imported into China each year; a factor that acts as 'a tremendous "boon" to film pirates, who essentially have a market monopoly on the restricted foreign films until the legitimate DVD release' (Ting, 2007, p. 413). Thus, in such a context it might seem less surprising that '93 out of every 100 film products sold in the country were pirated' (International Intellectual Property Alliance (IIPA), 2010 cited in Wu, 2012, p. 503). However, as always, we should be sceptical about the reliability of statistics that seek to quantify illegal activities that are not as easily measured and accounted for as formal distribution practices. Furthermore, if such statistics are then employed to suggest that the citizens of certain countries are somehow predisposed to copyright infringement, an act constructed as a form of moral deviance in the West, then the ideologically and xenophobically reductive principles that underpin their production need to be challenged.

Thus, in considering the political, cultural, social and economic contexts of piratical practices, we must be careful not to reproduce such arguments that position 'deviant' acts as somehow an ingrained characteristic of some imagined Other. Furthermore, we must resist the urge to assume that practices that might be perceived as radical or transformative in one context can be used to support a wider argument that piracy is ipso facto beneficial in either social or economic terms. For instance, Andersson Schwarz reminds us that his 'observations in Sweden differ rather radically from the Greek experience in that Sweden has not suffered the austerity measures that southern European countries went through in the aftermath of the economic crisis that began in 2007' (2013, p. 60). So, in conducting research in this area, we should not make generalisations based on regions or even economic areas because of the variations that exist within.

Concurrently, it is imperative to acknowledge the global flows of informal distribution, not least as a means to acknowledge that national responses to the 'piracy epidemic' (should such a problem be perceived to exist) are largely ineffective because, as with MPPA restrictions to Nigeria or the quota system in China, informal networks are quick to respond to such 'problems' with their own 'solutions'. So, as Athique

observes, 'a clampdown in India alone, or even in concert with deterrent operations in the West, will not be enough to unravel piracy networks given the extensive involvement of third countries' (2008, p. 709). Thus, we must ensure that all piracy practices are not conflated and used to support general and universal claims about activities that are anything but, and in doing so we must also ask how these varying behaviours interact, intersect and overlap. So, despite segregating my own discussion into separate camps of 'discs' and 'downloads', such an holistic approach is necessary when considering the complex ecosystem of film distribution whether that be physical or virtual, local or global, informal or formal.

Downloads: Sampling, substitution and network effects

Before segueing into the following discussion, it is worth elucidating that it can be somewhat troublesome to settle upon terminology for informal media dissemination practices that take place online. This is because the various descriptors that are commonly used (filesharing, digital piracy and the like) all have their respective limitations. For instance, the term 'digital piracy' has been (rather vaguely) adopted as a handle to describe all forms of media 'piracy' that take place 'online'. However, the use of the designator 'digital' makes little sense in this context because, even when piracy involves physical formats like VCDs or DVDs, they still contain films stored as digital data. As such, this phraseology seems concomitant with the popular predilection to describe anything to do with the Internet as somehow 'digital'.

Because of such terminological wrangling, Andersson Schwarz has suggested 'it is more etymologically correct to speak of *file sharing* instead of downloading as, by default, most such downloading makes the user simultaneously upload while being in the process of acquiring the file' (2013, p. 35). However, while this may be true of Andersson Schwarz's own specific area of study, I would warn against the ubiquitous use of such a term because, when examined, piracy 'reveals a heterogeneous range of practices' as Andersson Schwarz himself attests (2013, p. 88). Making generalisations in this area is therefore highly problematic. That is not to say that links and commonalities cannot be drawn between webs of pirate practice, but we must be careful not to assume that piracy represents a uniform set of behaviours and outcomes. Indeed, Andersson Schwarz's own respondents can be seen to be more concerned with acquisition than distribution and thus file*sharing* is perhaps less apt when we consider that, despite the demands made

upon them, these filesharers are more focused on the act of download-
ing than the subsequent dissemination of the downloaded files (2013,
p. 36).

As such, within the following discussion, the term 'filesharing' will
only be used when particularly appropriate or when quoting others.
In general, the term 'informal online distribution' will be preferred.
However, as this phrasing is somewhat cumbersome, the term 'piracy'
will also be employed but with the caveat that its use does not imply
the usual pejorative connotations.

Significantly, the informal circulation of *film* files online has received
less specific academic attention than the informal online distribution of
music and software files (Higgins et al., 2007, p. 339). While demon-
strating a frequent presence within the news and public discourse,
academic discussions of film piracy have often been subsumed within
wider studies concerning informal online distribution more generally.
This is possibly because the informal dissemination of films online took
longer to develop due to the relatively large file sizes associated with
films in comparison to music. As such, while this book is particularly
concerned with the dissemination of films, research will be examined
that also concerns the online informal distribution of software and
music because such studies can offer important insights into how piracy
functions and how it is perceived across varying disciplines.

As intimated earlier in the chapter, many discussions of informal
online distribution have been predominantly concerned with resolving
the central question of whether (and to what extent) the cultural indus-
tries are being negatively affected by copyright-infringing activities.
Work that demonstrates this preoccupation can be broadly categorised
as defining informal online distribution as a form of substitution for
legal purchases or as a form of sampling. According to the 'sampling
effect', users look at the files they download as a sample copy and, if
they like it, they buy it, hence theoretically increasing revenue for the
rights holder. However, according to the opposing theory, the 'substitu-
tion effect', the user downloads for free when they would otherwise have
bought a legitimate copy (Quiring et al., 2008, p. 435). As Condry has
summarised, the competition argument is usually based upon a number
of assumptions, namely 'if music is free, no one will pay for it. If no one
pays, artists and producers will stop creating music. How can anyone
argue with that?' (2004, p. 437).

The substitution (or competition) effect argument is usually put for-
ward by representatives of the creative industries and is often based
on the broad assumption that each illegal download represents a lost

legitimate sale. However, Oliver Quiring, et al. criticise the substitution effect argument on the grounds that there is little evidence to show that people would want the files if they had to pay (2008, p. 444). They propose 'that under real conditions, not all files which are down-loaded illegally from the Internet would be saleable. Therefore, on no account can the number of illegally-acquired files be treated as commensurate with music industry losses' (Quiring et al., 2008, p. 444). Quiring et al. are not alone in their assessment of the common industry argument (Cenite et al., 2009; Lessig, 2004; Marshall, 2004; Rodman and Vanderdonckt, 2006). However, it must be acknowledged that the act of assessing the effects of informal online distribution on the cultural industries is notoriously difficult and, under such circumstances, it is easier to calculate projected losses rather than potential deferred gains (Chiang and Assane, 2010, p. 146).

A significant issue with some of the scholarship that examines informal online distribution is the fact that it is based on the underlying assumption that all forms of media piracy are necessarily damaging to the industries they affect (see Higgins et al., 2007; Malin and Fowers, 2009; Taylor et al., 2009). As Gilbert Rodman and Cheyanne Vanderdonckt suggest, within this discourse, 'filesharing is unequivocally immoral and illegal – this is no longer a point for discussion – and filesharing "evildoers" must be met with devastating force' (2006, p. 246). This perspective can be found across literature concerning a range of sectors within the cultural industries, including software, music and movies. For instance, a significant amount of work on software piracy, or 'softlifting', is concerned with the age-old issue of how to eliminate it (see Kini et al., 2003; Pykäläinen et al., 2009). The rhetoric is often quite rousing, with some suggesting that 'software piracy is becoming economically devastating to companies that develop and market software worldwide' (Kini et al., 2003, p. 63). As with software piracy, the default question for the recording industry is often, 'How can industry deal with this terrifying scourge?' (Holt and Morris, 2009). Again, much work in this field reinforces the rhetoric that losses to the industry are staggering, and that the main problem lies with youth, mainly college students, viewing piracy as commonplace and acceptable amongst their peers (Holt and Morris, 2009, p. 381).

Research that specifically concerns the informal online distribution of film is similarly dominated by the assumption that all forms of piracy are necessarily reducing profits and acting in competition with legal revenue streams (see Higgins et al., 2007; Malin and Fowers, 2009; Walls, 2008). Despite the continued growth of users downloading and sharing

movies over the Internet and the loud claims of industry bodies such as the MPAA about the damage to the industry, the majority of the academic work that considers online piracy tends to focus on music rather than movies. This is possibly due in part to the fact that the digital piracy of music grew to prominence before that of movies. Music files are smaller than movie files and, when informal online distribution was in its infancy, people were constrained by slower bandwidth and smaller hard drives.[1] Furthermore, the MP3 compression format meant that music file size could be reduced even more. Consequently, it was possible to download and share music files quickly and relatively easily long before the same was achievable with movies.

One interesting consequence of this largely polarised debate has been the work of theorists like Janice Denegri-Knott who suggest that the rhetoric around piracy is not an innocuous, innocent description of the moral 'realities' of behaviour, but is rather the deliberate naming of an activity as 'deviant' in a bid to dictate and control the activity of others. Denegri-Knott argues that the Recording Industry Association of America (RIAA) has sought to label informal online distribution of music files as unquestionably deviant behaviour. She suggests that the ability to construct something as either normal or abnormal through discourse is 'an act of power, and in keeping with contemporary approaches to deviance, reveals the idiosyncrasies of elites promoting their own interests' (Denegri-Knott, 2004, p. 4). Denegri-Knott further draws on Foucault's notion of how power moves through discourse and, as such, is not owned by a central person or group; there are elites whose interests are served and who can work to consciously or unconsciously mould discourse and public opinion (and received wisdom/common sense) but they are not a locus of power. As such, one might argue that the MPAA, the Federation Against Copyright Theft (FACT) and the Film Distributors' Association (FDA) (amongst others) seek to shape and promote their own interests and ideological standpoint within this discourse by consciously interpolating 'pirates' as 'thieves'. Furthermore, Martin Kretschmer, George Klimis and Roger Wallis illustrate that such 'naming' supports a deliberate ideological agenda when they propose that:

> Labelling unauthorized copying as 'piracy' suggests an undue rhetorical certainty about the property conceptions underlying copyright. It is a fundamental premise of any modern, open and diverse society that the dissemination and use of information goods ought to be encouraged. Thus, the onus must be on the proponents of

transferable, exclusive copyrights to show that without stronger protection desirable goods would be neither produced nor distributed, or that grave moral inequities towards creators would result.

(Kretschmer et al., 2001, p. 434)

Ramon Lobato further argues that 'piracy is not only a form of deviant behaviour but may offer routes to knowledge, development, and citizenship' in instances where markets or film culture more generally is underdeveloped (2008, p. 16). Thus, the 'substitution effect' argument is not the simple statement of fact as presented; rather, it points to a particular and subjective position within a contested discourse. Furthermore, this perspective belies a specific neoliberal ideological viewpoint that privileges the proprietary rights of the individual copyright holder over the cultural prosperity of society at large.

In addition to the questions that have been raised about the overall capitalist agenda that is perpetuated through the anti-piracy rhetoric, Mattelart (2009) and others (Lessig, 2004; Yar, 2005) have sought to question the academic rigour of the research upon which the anti-piracy rhetoric is based. One criticism proposed is that it is difficult to take seriously the statistics provided by the audio-visual industry when they are considering such an underground activity.

It is somewhat surprising that so many and such precise figures are published in the various studies of the pirating of cultural products, since this is a phenomenon operating by its very nature in the shadows, away from the prying eyes of national and international accountants.

(Mattelart, 2009, p. 309)

Tristan Mattelart makes the further argument that there is an issue with the priorities of both the report makers and the report commissioners when he suggests that many of the reports carried out which provide 'evidence' of the threat of piracy are concerned with changing laws and influencing public opinion rather than with 'establishing a body of reliable knowledge' (2009, p. 310).

Lee Marshall appears sympathetic with this perspective and also questions the logic of the recording industry when counting the losses to their industry (2004, p. 68). In his research, Marshall uses the example of when the music 'filesharing' came to prominence and the RIAA was bemoaning the devastating effect that this was having on the recording industry. The RIAA claimed that while CD-r sales and downloading increased, the global sale of CDs fell. Marshall contests that while this

may be true, it does not automatically demonstrate a simple causal relationship between the two occurrences. As Marshall points out, there were other factors that could just as easily have contributed to the global downturn in CD sales. He suggests the end of the rush to replace vinyl collections on CD, the general economic downturn and increasing competition with growth industries, such as, mobile phones, DVDs and computer games, may all have played their part (along with the escalation of downloading and CD-r sales) in affecting revenue (Marshall et al., 2004, p. 191). Indeed, Rodman and Vanderdonckt suggest that, in the same period the music industry reported a downturn in sales, they reduced the number of bands on their books, upped the price of albums and released fewer of them (2006, p. 255). As such, they claim that 'while the industry's aggregate sales declined, their per-album profit margin appears to have risen, and all those self-imposed shifts in industry practices arguably affected the overall profitability of pre-recorded music as much as (if not more than) filesharing did' (Rodman and Vanderdonckt, 2006, p. 255).

Questions have also been levelled at the film industry about the validity of their claims regarding the amount of damage they have experienced due to illegal digital downloads. Indeed, despite the public cries that piracy is destroying the movie industry, profits actually increased in Hollywood over the first couple of years of the 21st century. As Jon Lewis points out, 'Internet piracy is up, but so are revenues. Profits in 2001 reached an all time high of $7.7 billion. The year 2002 was even better than 2001. And in 2003 profits reached the $9.5 billion mark' (2007, p. 145). Indeed, the MPAA suggests that worldwide revenues from cinema tickets, videos and DVD sales actually *rose* 9% between 2003 and 2004 (Staff and Agencies, 2005). Lobato further contests that global theatrical revenues for Hollywood again increased by 20% in 2006 (2008, p. 16). Presumably the MPAA would claim that revenue would have risen even more if piracy were not so prevalent, but it would seem that the arguments concerning the damage that piracy is wreaking on the industry are very much dependent on which statistics one decides to use and what agenda one is trying to defend.

Furthermore, it must be acknowledged that the bulk of the profits that the music industry enjoys do not come from the album sales, but rather from the secondary rights sold, so the music might be used on adverts, TV shows and video games; a similar phenomenon can be observed when considering the film industry (Rodman and Vanderdonckt, 2006, p. 257). Indeed, Hollywood, despite its initial disgust at the birth of VHS, has gone on to reap generous rewards from such new technological developments. As is often mentioned in discussions of this sort, and

is nicely summed up by Rodman and Vanderdonckt, 'the film industry thrives today largely because of the technology that they swore would wipe them out, as video rentals have been a far more profitable revenue source than box office sales since the 1980s' (2006, p. 257).

Majid Yar goes even further than questioning statistics and makes the interesting suggestion that, far from a damaging trend, piracy is actually a social construction. 'Rather than taking industry or government claims about film "piracy" (its scope, scale, location, perpetrators, costs or impact) at face value, we would do well to subject them to a critical scrutiny that asks in whose interests such claims ultimately work' (Yar, 2005, p. 691). Yar discusses how the 'epidemic' of piracy is not related to the growth of the Internet and lax copyright enforcement in developing countries as is so often claimed, but instead is attributable to 'shifting legal regimes, lobbying activities, rhetorical manoeuvres, criminal justice agendas, and "interested" or "partial" processes of statistical inference' (2005, p. 691).

In making such claims about shifting legal boundaries, Yar makes the interesting observation that copyright infringement is gradually moving from a 'regulatory offence' into a criminal act of theft (2005, p. 685). Therefore, whether the practice of something deemed to be a 'crime' is seen to rise or fall is not necessarily straightforward because it is also determined by the categorisation of said criminal acts. So, Yar claims that one of the reasons for the rise of piracy is the increase of practices that come under its definition due to fluctuations in intellectual property law. He argues that, because adhering to the Trade Related Aspects of Intellectual Property Rights (TRIPS) agreement is compulsory for all World Trade Organization (WTO) members, pressure is exerted upon individual member nations to adopt a US-style attitude to rights which privileges the rights holder. Yar argues that, as this pressure continues, rates of piracy will inevitably increase as WTO members scrabble to fall into line with international agreements.

Many countries which previously had no or minimal restrictions on the reproduction and distribution of US copyrighted material have acquired rigorous IP [intellectual property] laws which, at a sweep, have brought the behaviour of numerous of their own citizens under the aegis of property theft. This instance shows how the supposed global growth of 'piracy' can be attributed in part to a shifting of the legal 'goal posts', rather than simply to any dramatic increase in practices of copying.

(Yar, 2005, p. 686)

It can be seen from Yar's sentiments that the perceived 'piracy epidemic' could be partially attributed to a global process of redefining the limits of ownership, property and theft. Thus it is necessary to avoid taking any claims about the impact of piracy on the cultural industries at face value, and to consider the priorities and perspectives that might be underpinning the claims of the industry bodies and the research that they rely upon. The copyright industries have become one of the fastest growing sectors of the US economy and 'copyright legitimises certain forms of media consumption and prohibits others' (Miller et al., 2001, p. 116). The importance and influence of this industry must be taken into account when examining what actions have been constructed as piracy and what have not.

As well as the numerous attacks on competition theory, there is also notable support for sampling theory. Mark Cenite et al. suggest that:

> While downloading as a substitute for purchasing can harm the content industries, downloading to sample could lead to eventual purchase, and accessing otherwise unavailable content is unlikely to harm artists, since the works would not otherwise have been purchased.
>
> (2009, p. 208)

In a similar manner, Martin Peitz and Patrick Waelbroeck support the idea that piracy causes *some* people not to buy music through legitimate channels but they also suggest that the positive effects produced by sampling counterbalance this loss (2006, p. 908).

One of the underpinnings of the sampling argument is that the copy is somehow inferior to the original and that pirates actually demonstrate a desire for the original (paid for) product (Peitz and Waelbroeck, 2006, p. 908). Such a claim at first appears counterintuitive because, due to the fidelity of digital copying, in many respects the pirated copy may be no different to the bought copy. Furthermore, the 'bought' copy, despite having an aura of legitimacy placed upon it, is in fact a copy itself. The significance of this finding is that piracy might be considered beneficial to the industry if the product that they offer can differ significantly from the one available from the pirates. Under such conditions, Peitz and Waelbroeck argue that 'file-sharing can lead to lower prices, higher unit sales and higher profits' (2006, p. 908). The authors suggest that sampling allows consumers to be in control of their purchasing decisions because of the extra information that sampling allows. Thus, they suggest that in their 'model, profits increase for a certain set

of parameters because consumers can make more informed purchasing decisions because of sampling and are willing to spend for the original although they could consume the download for free' (Peitz and Waelbroeck, 2006, p. 912).

Although their study refers to music downloading, Peitz and Waelbroeck suggest that their sampling model could be applied to games and software as well. Even though they do not specifically mention movies in their analysis, it is worth examining if the sampling effect theory could also be applied to instances of online film piracy. The study by Michael Smith and Rahul Telang (2008) on the impact of television broadcasting on both DVD sales and piracy sheds some interesting light on this issue. The authors suggest that competing with free content delivery methods may intuitively seem like an especially serious problem for the film industry because, unlike music, which we might listen to again and again (and therefore desire a permanent copy of), movies are more likely to be a once-only experience (Smith and Telang, 2008, p. 323). However, what they found in their study was that 'movie broadcasts on over-the-air networks result in a significant increase in both DVD sales at Amazon.com and illegal downloads for those movies that are available on BitTorrent at the time of broadcast' (Smith and Telang, 2008, p. 321). Such a result might seem unsurprising, as the user might be motivated to locate their own copy of a film which they either watched on TV and enjoyed, or saw it was scheduled but missed it.

However, more interestingly, the study also found that 'the availability of pirated content at the time of broadcast has no effect on post-broadcast DVD sales gains' (Smith and Telang, 2008, p. 321). As such, not only do the authors suggest that a TV broadcast stimulates DVD sales but that, if a pirate copy of a film is also available, there is no resulting cannibalisation of sales. Importantly, they attribute this to the fact that a 'television broadcast of a movie is sufficiently differentiated from the DVD version (in terms of convenience, usability, and content)' (Smith and Telang, 2008, p. 322). Basically, under conditions where the legal and illegal copies differ substantially, then distribution for free may even stimulate people to pay for DVD copies. At the very least, 'the presence of free copies need not harm paid sales' (Smith and Telang, 2008, p. 321).

On the other hand, Thomas Holt and Robert Morris suggest that, while there can be instances when unauthorised copying is advantageous to the copyright holder, this is not the case with *all* sampling opportunities (Holt and Morris, 2009, p. 382). They argue that new copying and distribution technologies can open up new revenue opportunities, as was the case with VHS and the movie industry, but

that the same beneficial effect has not been felt since the birth of online piracy. The authors draw on various economic studies to support their suggestion that people are downloading rather than paying for music through legitimate channels.

That being said, while their own paper was published in 2009, each of the studies that Holt and Morris consulted, although interesting, all concern research that took place in 2006 or earlier. As such, these papers span a period when viable legal alternatives were not commonplace, as iTunes only launched in the UK, Germany and France in June 2004, and in the rest of Europe in October 2004, having launched in the US in April 2003 (Waters, 2004). Furthermore, it was not until 2008 that iTunes actually became a market leader (NME, n.d.). With this in mind, these findings must be read in light of the fact that, at the time the studies were carried out, paying for digital downloads was not an established industry.

Another theory that is raised in support of the sampling argument is that of network effects or network externalities. This is the phenomenon in which 'the utility that a user derives from consumption of a good increases with the number of other agents consuming the good' (Katz, 2005, p. 35). This theory is particularly common during discussions of software piracy. The idea that underpins network effects theory is that, although much software can be useful in isolation, its value increases as more people use it, because they can share files, collaborate and so forth. Thus, a positive feedback loop is created and the more popular network is in turn likely to be more attractive to new users.

However, it has been suggested that the principle of network externalities cannot be applied outside the realm of software (Gayer and Shy, 2003; Higgins et al., 2007). The argument is made that those products most affected by online piracy (music, films and software) have distinct properties and thus illegal copying online affects their respective industries differently. Amit Gayer and Oz Shy sum up the argument by suggesting that:

> the assumed user externalities are less applicable for entertainment titles such as the distribution of music and video titles, than for the software industry. The reason is that the 'popularity' of these titles is not always enhanced directly from the build-up of large networks of users.
>
> (2003, p. 202)

Thus, one could argue that a software company would benefit from their products being pirated as it increases the overall value of the software,

but a film distributor would not benefit at all if copies of films are made available for free online illegally because this would make potential audiences less likely to pay for a cinema ticket or buy a DVD.

However, Molteni and Ordanini counter this suggestion by putting forward the concept of socio-network effects (2003, p. 391). This idea is explained in more depth in Chapter 7. Simply put, it suggests that there is a sort of social contagion side to consumption; in other words, people tend to like what other people like. Tastes also tend to cluster, so if someone likes a single film with a particular star or director, then they are likely to seek out other similar work. Thus, the principle of network effects can be extended into a model of socio-network effects when applied to films because it recognises that, while an individual film might be consumed for free through piracy, this might act as a gateway for the consumer to develop a taste for (and possibly purchase) connected films. Such an argument runs close to the sampling defence, but also recognises the important social dimension to taste formation and patterns of consumption.

Some work has sought to go beyond the sampling/substitution debate and broaden the discussion to consider that all piracy may not be equal and so acknowledge that different forms might also have different effects. Thus, we should not evaluate *all* online piracy equally as exclusively promoting content or cannibalising profits, but rather acknowledge that there are different practices within online piracy that might produce both effects concurrently. For instance, David Bounie, Marc Bourreau and Patrick Waelbroeck make the distinction in their work between two distinct *types* of downloading behaviour, which they then argue lead to two different effects: sampling and substitution. They categorise these two types of downloaders as either explorers or pirates (2007, p. 168). In this situation we can understand some informal online distribution as contributing to the competition effect (pirates) and some to the sampling effect (explorers). The 'explorers' use downloading as a method of sampling material before purchase, whereas the 'pirates' use the same facility to bypass the need to part with cash to obtain the items they desire.

> Thus new file-sharing technologies have amplified consumption patterns in the sense that music fans have used MP3 to discover new music and increase their consumption of pre-recorded music while people with low willingness to pay for music have used MP3 files as direct substitutes to legal purchases.
>
> (Bounie et al., 2007, p. 186)

Such research makes the important observation that the motivations of those who share material online are not necessarily consistent with one another. However, such a discussion does still focus the debate on what effect online piracy might have on the industry, and does not consider the possible social context of such activities.

'Filesharing' and the community: The social side of piracy?

The discussions presented so far have focused on considerations of the economic impact and influence of online piracy on the cultural industries. Aside from socio-network effects, the social side of piracy has often been absent from such discussions. However, within certain forms of informal online distribution, community and social interaction can form an important part of the dissemination process. In particular, the social and community aspects of online piracy have come into focus in contexts where there are technological and/or community requirements to 'share' as well as to download when engaging in informal distribution practices. This is not to suggest that all forms of online piracy are distinctly social (or involve or are particularly motivated by *sharing* per se), but rather to acknowledge that not all forms of informal online dissemination are alike and that in some instances there may be a distinctly social element to such activities that must be examined in greater detail.

For instance, Chun-Yao Huang suggests 'one may see file sharing as a kind of autotelic consumption for which socializing is an important motive' (2003, p. 43). In this context, informal online distribution is an activity that is about more than just acquiring goods; it is also a social activity that takes place within communities with rules, rituals and codes (Huang, 2003, p. 42). This is not to say that socialising within such communities is a prerequisite for membership. In many contexts, it is by no means necessary in order to download files. Accordingly, if we take a lead from consumption theory, where purchasing goods is not an end in itself but is a complex social interaction, then we can understand 'file sharing as a mode of... consumption [that] may be attacked from another angle: the social one' (Huang, 2003, p. 42).

Particular studies that have considered informal online distribution from this 'social' angle focus have often considered the reciprocal nature of the activity and how it might be considered in terms of anthropological notions of gift economies. Here, gift exchange is not simply about the exchange of physical goods *instead* of money, but is a completely different form of exchange with a distinctly social element (Levi-Strauss, 1969, p. 42).

Yet, the use of the term 'gift' should not be misunderstood as implying some benevolence on the part of the gift giver. Indeed, it is the very fact that gift giving *seems* voluntary, but is in reality made compulsory by the existence of strict codes and conventions, that was of particular interest to Mauss. He thus suggests that 'in theory...gifts are voluntary but in fact they are given and repaid under obligation' (Mauss, 1954, p. 1). The act of giving gifts may seem optional within a particular social group, but opting out of the socially proscribed gifting rituals would amount to a serious social transgression. Indeed, 'to refuse to give, or to fail to invite, is – like refusing to accept – the equivalent of a declaration of war; it is a refusal of friendship and intercourse' (Mauss, 1954, p. 11). In order for such gifting obligations to be upheld, they must be accompanied by complex rules and conventions. Gifting relationships are rarely about a selfless wish to give to others without concern for reciprocation. Indeed, the concepts of reciprocity and equivalence are integral to gift economies. The gift must be reciprocated, and the 'counter-gift' (Malinowski, 1922, p. 81) must be equal in value to the 'original gift' (Malinowski, 1922, p. 96). Therefore, it is central to the functioning of gift economies that, for each gift given, one will be returned and thus the cycle of gift giving is potentially endless.

However important the notion of reciprocity is for gift economies, it is not the case that gifts are *only* given in the anticipation that one might be received in return; gift exchange is not reducible to economic value or reward. According to Mauss, gift 'exchange is not exclusively goods and wealth, real and personal property, and things of economic value' (1954, p. 3). Indeed, he suggests that 'the circulation of wealth [is] but one part of a wide and enduring contract' (1954, p. 3). Drawing on these ideas, Levi-Strauss suggests that the value attached to objects goes beyond their status as economic commodities. Indeed, they also act as 'vehicles and instruments for realities of another order, such as power, influence, sympathy, status and emotion' (1969, p. 54). In this respect, the process of their exchange cannot be reduced to the economic, but must be understood as a 'skillful game of exchange', which 'consists in a complex totality of conscious or unconscious maneuvers in order to gain security and to guard oneself against risks brought about by alliances and by rivalries' (Levi-Strauss, 1969, p. 54). In this sense, gift exchange is about forming and securing social relationships and hierarchies through the giving and receiving of objects. To take the example of 'potlatch',[2] Mauss suggests that 'it is above all a struggle among nobles to determine their position in the hierarchy to the ultimate benefit, if they are successful, of their own clans' (1954, pp. 4–5). Levi-Strauss specifically draws

parallels between potlatch and gift-giving rituals surrounding Christmas in 'modern' society. He suggests the giving and receiving of Christmas cards is a particular method of marking out one's social status inasmuch as 'the quantity sent or received, are the proof, ritually exhibited on the recipient's mantelpiece during the week of celebration, of the wealth of his social relationships or the degree of his prestige' (Levi-Strauss, 1969, p. 56). This example demonstrates that gifting relationships, regardless of context, serve to indicate social status through the manner in which gifts are ritually given, received and displayed.

As such, understandably, ideas about gift economies have been readily applied to studies of 'filesharing' communities, that is, structured social situations where reciprocity is often tacitly encouraged and sometimes actively enforced. For example, Cenite et al.'s (2009) study emphasises how important community can be in terms of the behaviour of 'filesharers'. They note that 'respondents reported a norm of reciprocity and sense of community that motivated them to upload and an obligation to purchase content they liked' (2009, p. 206). As such, these listeners felt compelled to seek out legal copies of the music they appreciated and musicians they admired. Ian Condry backs up this sentiment by suggesting 'the common ground for fans and artists, it seems to me, is the sense of participation in a shared community supporting music that people care about' (2004, p. 358). What Condry is arguing is that another community exists outside of the 'filesharing' network and that is the music community at large. As such, Condry's findings mimic those of Cenite et al.'s, as they suggest that 'filesharers' will pay for music if it is seen to protect an artist, band, record label or community in which they have an emotional investment.

Further work in this area by Giesler and Pohlmann divides digital pirates into categories where either autotelic (an end in itself) or instrumental (a means to an end) gifting behaviour is prominent (2003, p. 276). Giesler and Pohlmann split users into those that have agonistic or altruistic motives, and use four metaphors to illustrate what motivates gift exchange on Napster:[3] realisation, purification, participation and renovation (2003, p. 273). In this case, realisation and participation are seen to have an autotelic purpose, whereas purification and renovation are seen to have an instrumental one (2003, p. 276). They also suggest that realisation and purification are more agonistic, whereas participation and renovation are more altruistic (2003, p. 276).

For those motivated by realisation, the use of Napster is more of an individual experience of music consumption that is primarily motivated by the act of giving and receiving music. The purification motivation is

also personal rather than communal but is linked to a wish to escape from the controls of mainstream music consumption, 'thus gifting as a means of boycotting at Napster can here be understood as an agonistic act of ethical purification for oneself' (2003, p. 276). Where participation is the motivation, the focus is on the community rather than the activity (2003, p. 276). Here, being a part of the community and adding value to it is considered to be paramount. Although defined as altruistic, this is not to be understood as pure 'selflessness' but instead indicates a wish to impress and aid the wider community. Renovation, on the other hand, demonstrates a more political motivation and a wish to break free from the shackles of the corporately controlled (music) industry. The authors suggest that 'it is a widespread practice to attach socialistic, anarchist and revolutionary metaphor [sic] to the gifting economy of Napster' (2003, p. 276). Thus, not only is there a social motivation at play, but also a political one. For certain members of the Napster community, 'gifting becomes a tool for the collapse of the old capitalist system and the end of capitalist market hegemony while serving as an alternative consumption activity at the electronic frontier' (2003, p. 277). Thus, Giesler and Pohlmann's work demonstrates that even among users of one piece of informal distribution software there are a number of motivations for sharing files, both autotelic and instrumental, social and selfish.

However, there has also been some critique of such an approach because, as Andersson Schwarz points out, the 'community' setting for filesharing is by no means universal. As such 'the proposition that filesharing is automatically related to gifting in this strategic sense is problematic, because it too needs to be contextualized: It is valid for some file-sharing protocols/applications but not necessarily to BitTorrent or cyberlockers' (Andersson Schwarz, 2013, p. 59). Such observations again foreground the perspective that practices of piracy are varied and must be examined by taking into account the economic, social, cultural and political contexts within which they operate.

Conclusion

This chapter has outlined the wealth of research into piracy that focuses upon the sampling/substitution argument but, ultimately, I have sought to go far beyond such discussions. However, in rejecting a model that only considers piracy in economic terms, I have also tried to avoid overly celebrating the radical potential of piracy or suggesting that we should ignore economic consequences completely and focus solely on the social

sides of piracy. As such, I would contend that we certainly must investigate piracy as a social and cultural activity as well as an economic one, but that we must ultimately consider how these contexts interact and not fall into the trap of assuming that one dominates another.

Furthermore, we must remind ourselves that piracy is far from being new and 'in many parts of the world, media piracy is not a pathology of the circulation of media forms but its prerequisite. In many places, piracy is the only means by which certain media – usually foreign – are available' (Johns cited in Larkin, 2004, p. 309). Yet, in making these observations we must also be careful not to assume that those 'pirates' in these othered 'many places' (where informal networks are dominant over or indistinguishable from formal ones) have something innate within their culture or genes that predetermines collusion or participation in such 'deviant' practices. Rather we should consider the economic, social and political landscapes that frame the ability of any of us to access films through formal and informal means: whether that be the stereotypical 'college kid' downloading in their bedroom or the market bootleg VHS seller in Kano.

5
A Brief History of Film 'Filesharing': From Napster to Mega

What's in a name?: Piracy and filesharing

Before launching into a history of 'filesharing', this chapter will take issue with the terminology used within its own heading while acknowledging that, despite the problematic association with the term 'filesharing' (and piracy more generally), a suitable alternative has yet to present itself.[1] While Ramon Lobato's term 'informal' is helpful as a general term that provides 'a loose way of *conceptualising* certain forms of film culture, which are incompatible with more familiar paradigms' (original emphasis; Lobato, 2007, p. 114), such terminology is too broad for the purposes of this chapter. That is, while Lobato suggests that piracy might come under this banner of 'informal' distribution, not all methods of informal distribution can be understood as piracy. While the umbrella terms 'informal' and 'formal' circumvent the negative associations of the more popular terms 'illegal' and 'legal', the question remains as to what terminology we must use to accurately describe the subcategories that exist beneath.

The study by the Organisation for Economic Co-operation and Development (OECD), *Piracy of Digital Content*, suggests that 'there is currently no specific legal definition of digital piracy, which would be more accurately described as "digital infringement of copyright"' (OECD, 2009, p. 7). Indeed, the UK's *Digital Economy Act 2010* uses 'digital infringement of copyright' rather than 'digital piracy' when discussing the issue (Digital Economy Act, 2010). However, 'digital piracy' continues to be the terminology of choice within popular discourse despite obvious drawbacks in terms of what specific piratical practices come under its heading. For instance, a DVD contains digital data yet the illegal distribution of DVDs is not perceived to be digital piracy. The aforementioned

OECD study provides an explanation for this inaccuracy by pointing out that the term 'digital', when discussed in relation to piracy, is not a direct opposition to analogue data but rather refers to 'infringements of intellectual property rights, that *do not* use physical "hard media" (such as CD, DVD flash drives etc.) for the reproduction and exchange of pirated material' (original emphasis; OECD, 2009, p. 17). Thus, digital piracy does not refer to whether the content that has been pirated is in digital form but instead refers to the medium through which the data is transferred, in other words, the Internet. As such, these practices might be more accurately described as online piracy.

Yet, while the problems associated with the 'digital' might be resolved by the use of such a revised term, as I have discussed elsewhere (Crisp, 2014), 'piracy' remains a predominantly pejorative term and so its continued use is problematic. However, filesharing, another favoured term, unnecessarily and inaccurately emphasises the *sharing* potential of certain aspects on informal online distribution and also presupposes that those *sharing* are uploading and downloading in equal measure. Thus, both terms are inadequate and misleading and the following chapter, through a detailed discussion of the historical development of the informal online distribution of films, highlights the inadequacies of both 'piracy' and 'filesharing' as catch-all terms for the sheer variety of copyright infringing practices that exist.

While many of the types of piracy described within this chapter will already have fallen out of use, and many others will rapidly become so due to the rate of change in this area, the chapter will provide an invaluable contextual overview of the development of online informal distribution practices and their variable manifestations thus far. By providing both an historical and typological account of the online informal dissemination of film texts, this chapter will consider that, while some methods of informal online film dissemination can be quite straightforward, other forms take place in closed communities and require the person downloading to have a reasonably detailed knowledge of numerous programmes and methods of encoding and decoding data, This is also the case for the filesharing forums that provide a focus in the following chapter.

Early developments

Although this is covered extensively in Chapter 3, in order to provide a context for the examination of informal online distribution, it is first necessary to consider the landscape of formal methods of online

distribution and consumption. Legal download services such as iTunes have been available in North America since 2006, but the process of major Hollywood films becoming legally available online to download or stream has been slow. Disney films were available as early as 2006 but the other major Hollywood studios only came on board in 2008, with Apple announcing that digital downloads would be available on the same day as DVD from May that year (McLean, 2008). Indeed, the film industry has been somewhat slow to exploit the Internet as a mainstream avenue for distribution and, as previous chapters have attested, still seems reticent to embrace online distribution on a global scale. However, film download and streaming services are beginning to take hold with Netflix dominating the market in the US. To take the UK as an example, online options can be roughly split into online subscription services (SVoD), like Netflix and Amazon Prime, or online PPV VoD companies, like Mubi or BlinkBox. Netflix seems to be emerging as the dominant SVoD service, having launched their streaming service in the US in 2008 before extending the service to the Caribbean, Central and South America, the UK, Denmark, Sweden, Norway, Finland and Ireland by 2012 (Netflix, n.d.). In the UK the main competitor to Netflix is Amazon, who rebranded their online streaming service Amazon Prime Instant having bought out the postal DVD rental company LoveFilm in 2011, after LoveFilm increased their service to include online streaming of films (from a restricted catalogue) in March 2010 (Halliday, 2011). As discussed in Chapter 3, Stuart Cunningham calls these new players in the game 'disruptive innovators' who are 'challenging the premium content and premium pricing mass-media model' (2013, pp. 68–69). The disruptive innovators control platforms that represent a form of media convergence. Thus, sites like Netflix offer both television and film content and, furthermore, they allow viewers to be freed from the shackles of television and film schedules. Within such a context the audience is theoretically free to engage with content in times and spaces of their own choosing. Through such services it is also possible to stream movies direct to a television through a games console, such as, Microsoft's Xbox One or Sony's PS4, or directly to specific makes and models of televisions.

However, before heralding the new dawn of an era of unprecedented choice, we must consider that not everyone has access to the same services, in the same way and under the same conditions. For instance, although a subscription model still applies when accessing Amazon Prime Instant's subscription catalogue, the major film studios previously requested through their distribution deals with LoveFilm that

recent and high-profile films are only available on a PPV basis (LoveFilm, n.d.). Furthermore, in the UK, 'Sky, the largest pay-TV operator, retains control of first subscription pay-TV window film rights from all six major Hollywood studios. As a result, Amazon Prime Instant, Netflix and other internet (SVOD) services have been limited to offering older titles' (Enders Analysis, 2012, p. 41). Thus, the deals made between the major studios and influential pay TV operators such as Sky mean that the titles available on Netflix are not as up to date as audiences may hope. Now, as Netflix becomes more powerful, the rules of the game may change, and Netflix and Amazon are already responding to such controls by producing their own original content. However, the extent to which these innovators will 'disrupt' content production as well as distribution remains to be seen.

'Download-to-own' services that allow users to keep digital copies of films are also available but, like many streaming services, most only offer a restricted catalogue. The main source for legal film downloads in the UK appears to be Apple, who launched the UK arm of their movie download service through iTunes in June 2008 and are able to offer films from all of the major Hollywood studios except Universal (Richards, 2008). Tesco's BlinkBox service offers users the option to purchase films online with the added perk that any DVD or Blu-ray purchased in a Tesco store also comes with a free download from BlinkBox. This can also be linked to an *Ultraviolet* account, where consumers who have purchased an Ultraviolet DVD or Blu-ray can also add that movie to their Ultraviolet cloud-based library to download or stream. What such a brief examination shows is that, despite some movements in this area, there is still no obvious quick and easy legal film download service that has grown to prominence as the market leader in the UK.

In contrast to the context of formal online distribution, the informal market offers a range of alternatives, varying in terms of ease of use and popularity. One of the earliest and most high-profile methods was Napster. Napster was 'the first easy to use filesharing programme to make mass distribution of music free' (Goldsmith and Wu, 2008, p. 107). Launched in June 1999, it was a phenomenal success with over 20 million users by summer 2000 (Cotton, 2001, p. 25). At first this sharing activity was confined to music MP3s but, in April 2000, an add-on programme called Wrapster was produced which enabled users to 'wrap' files in such a way that Napster identified them as MP3 files. 'Thus movies, pornography, and pirated software could be distributed taking advantage of Napster's popularity and reliability' (Alderman, 2001, p. 123).

Napster became synonymous with illegal downloading and 'filesharing'. Yet, Napster's system of having centralised servers to which each user connected, in fact, meant that it could not fall under the title of 'filesharing' proper (because files were being downloaded centrally rather than from peers) and also left it particularly vulnerable to attack from litigation. This was to be its downfall and Napster was eventually shut down in summer 2001 after legal wrangling in court with the RIAA. It is worth noting that Napster facilitated the sharing of files through a computer programme and, while there could be a social element to the process, such activities were not routed through a specific forum or social hub.[2]

After the fall of Napster, various other peer-to-peer (p2p) programmes competed to fill the void.[3] One such programme was Kazaa, which, 'unlike Napster, did not play a hand in facilitating music-swapping... [One] could thus maintain that Kazaa was no different than the VCR, photocopier, and any number of technologies that are used for both licit and illicit purposes' (Goldsmith and Wu, 2008, p. 111). This made Kazaa an even greater success than Napster. Downloaded more than 319 million times by early 2004, it was by then the most downloaded piece of software in history (Goldsmith and Wu, 2008, p. 109). Kazaa's main benefit, at least in legal terms, was that it did not have a centralised server; users searched the computers of other users and downloaded directly from them. This meant that Kazaa could not monitor the sort of files that their users shared and thus it was difficult to argue that the creators of the software could be held legally accountable for the files shared through their network. However, Kazaa's major benefit also turned out to be its undoing, because the fact that Kazaa did not have any way of controlling its users also meant that the network was not monitored or policed. Thus, 'by 2005, Kazaa users were weeding through a junkyard of corrupt files, deliberate fakes, and efforts to advertise porn sites that made the p2p experience a major chore' (Goldsmith and Wu, 2008, p. 119).

Networks and protocols

Alongside Kazaa, more programmes (for example, Limewire, Soulseek and Morpheus) were developed to enable informal online distribution that vied for prominence in a growing market. Such programmes typically connected to decentralised p2p networks, such as, eDonkey (eD2k) and Gnutella. Meanwhile, informal online distribution was being revolutionised by Bram Cohen's BitTorrent protocol (Thompson, 2005). This

protocol involves breaking down the original file into small chunks. Therefore, each person downloading any one file will, in fact, be downloading a series of smaller files from a number of other people (peers) at the same time. BitTorrent also involves an individual installing software on their computer, but in this instance the user then downloads tiny torrent files (of a few kilobytes) that contain information on how big the file is and where it is coming from (Rietjens, 2005). After the user has downloaded the torrent file, it can be opened using specific BitTorrent software[4] and the user can select the location on their hard drive to which they would like the file downloaded (Beginner's Guide, n.d.). The BitTorrent software must remain open on a user's computer even when they are not downloading to allow others to continue to access the files on that user's hard drive.

BitTorrent quickly caught on, with certain research claiming that in 2004 BitTorrent was responsible for 'one third of all traffic on the Internet' (Waldman, 2005). Indeed, the BitTorrent protocol was the download method of choice on high-profile sharing sites such as *The Pirate Bay*. It was at this point in the evolution of informal online distribution that the sort of networks discussed in the following chapter started to come to the fore and that it became common for informal online distribution to be routed through specific forums.[5] However, such forum-based distribution is by no means necessary and many sites that post links to downloadable files are not associated with a particular discussion forum (for example, *The Pirate Bay*).

Release groups and The Scene

'The Scene', sometimes referred to as the 'warez scene' is, according to *The Guardian*, responsible for 'pirating 90 percent of the world's music, computer software and DVD movies' (Thompson, 2004). 'The Scene' is made up of various 'release groups', that is, 'clusters of individuals who work secretly in teams to illegally distribute digital goods' (Lasica, 2005, p. 50). It has been estimated that there were over 140 release groups in 2005 and the way that these groups function is highly organised, although generally the members will have never met each other face to face (Lasica, 2005, p. 50). Groups often obtain movies from industry insiders that are then sent to the group's 'ripper' who strips out the copy protection. Either the 'ripper' or a separate 'encoder' then 'compresses and optimizes the video file into formats suitable for downloading and viewing on a computer or television screen' (Lasica, 2005, p. 54). Then a 'distributor' places the file on a 'topsite' (secure underground server)

before 'couriers' transfer the file to other 'distribution servers' (Lasica, 2005, p. 55). Finally 'channel operators' announce that the films are available on Internet Relay Chat (IRC) channels. Also instrumental in this process are 'administrators' and 'donators', who help by either purchasing or donating the necessary hardware or bandwidth, and 'group leaders' who run the entire operation. Once the films have been released on the IRC channels, they filter down to online distribution sites (Lasica, 2005, p. 55).

This form of informal online distribution often involves the online dissemination of theatrically released big-budget Hollywood movies and the MPAA are all too aware of this highly organised type of informal online distribution. However, it is important to remember that the circulation of films before or just after their release is not the only type of informal online distribution. That said, it is part of the nature of filesharing that Scene releases permeate many aspects of informal online distribution. Scene releases can be found through a variety of means and it is not uncommon for online distributors who are not members of Scene release groups to share Scene rips within their own communities and networks. As is explained in more detail in the following chapter, I have termed those who effectively 're-share' Scene releases as intermediary distributors. The practices of such individuals are distinct from what I have called the 'autonomous distributors': people who make the initial transfer from DVD/Blu-ray to a downloadable format.

Furthermore, it is important to keep in mind that a specific characteristic of downloading films (as opposed to music) is that, even if users are sharing what they download, they are invariably not actually increasing the range of films available online. Indeed, they are merely sharing those already being shared by others. In order for this sharing to take place, someone must make the initial conversion of the DVD into a format that others can download. The conversion of DVD (vob) files into a compressed format suitable for download is generally more complicated than converting the songs on a CD to MP3s. Not only are music files smaller, but also most computer music players have the capacity to change uncompressed audio files that exist on a bought CD into the compressed MP3 format.[6] DVD/Blu-rays, on the other hand, come in an encrypted format and cannot be copied directly or converted to another format easily. The Content Scrambling System (CSS) means that specialist software must be used to copy DVDs and convert the film into the compressed video format (typically avi), which is easy to download. Before DVD copiers became widely available (and affordable), films were often re-encoded to fit onto a CD-r (700 MB) so that the downloaded

files could be easily burned on to a disc.[7] Some very long films (or films where the image and sound quality were more of an issue) might be split into two CD-sized files, but it was (and arguably still is in some networks) relatively rare that films would be encoded to any other size. Owing to the greater bandwidth available now, there are some sites that are dedicated to sharing films in an uncompressed format.

Cloud storage and direct download links

Such developments show that informal online distribution is not a uniform activity and is not fixed to one method. Academic work on Napster (Giesler and Pohlmann, 2003) or *The Pirate Bay* (Andersson Schwarz, 2013) tells us about these particular methods of informal online distribution, but the context of such activities is rapidly changing and a more recent method of informal online distribution has evolved, *direct download links* (DDL). DDL refers to links to files hosted on the servers of legal cloud storage companies that are shared online. With one-click web-hosting services, people pay to host files on a company's servers. Although such services are in principle legitimate and above board, these servers are also used to host copies of copyrighted material.

Cloud-storage companies RapidShare and Megaupload have become the figureheads for this kind of downloading, but other examples of such services include MediaFire, Uploaded, FileFactory, Netload and Hotfile. While BitTorrent remains a prominent mode of filesharing, downloading movie files through DDLs to one-click web-hosting services like RapidShare or Megaupload is rising in prominence (Ernesto, 2011). Indeed, it has been claimed that in 2008 'RapidShare alone ... [was] ... responsible for 5 percent of ... worldwide Internet traffic' (Schulze and Mochalski, 2009, p. 12).

The growth in popularity of such informal methods of distribution might be attributed to the fact that each user downloads files directly from a server and not from others within a network (as with p2p). Such a system allows files to be downloaded very quickly and there are none of the problems associated with p2p (for example, other users going offline or only partial files being obtained). However, due to the existence of centralised servers where these links are hosted, such activities have not escaped the gaze of the industry and cloud-storage companies are coming under increasing pressure to pay more attention to the files that are available through their services. Indeed, although early criticisms of how such companies police the misuse of their services were not being upheld in court (Anderson, 2011), more recent legal battles have led

to DDL services such as RapidShare being banned in certain countries (Enigmax, 2011) and to the high-profile shutdown of Megaupload in January 2012.

However, Kim Dotcom, the controversial founder of Megaupload, seemingly undeterred by the legal battles surrounding Megaupload and the fact that the service had become synonymous with Internet piracy, returned to the cloud-storage business in January 2013 when he launched his new company, Mega. This new service allows users to easily 'share files' and so has been described in the media as a 'filesharing' service (Holt, 2013), but it is important to note that this company operates on a client-server model rather than a p2p one. Once a user has stored their files in the cloud, then they can easily share them with others through a link and an encryption code that allows access to the file. Indeed, it is by virtue of the fact that each file is encrypted that the executives of Mega can theoretically claim that they have no knowledge of (and thus no responsibility for) the files being stored and circulated using their service. This level of deniability is possible because this encryption code is known only by the user and not by anyone at Mega. Such an approach has been touted as a strategy to protect the user's files but undoubtedly has the added benefit of allowing Kim Dotcom and the other executives at Mega to claim that they cannot be held accountable for how their cloud-storage service is used.

Fansubbing

Any discussion of the global circulation of films through informal online channels must also consider the role of fansubbing in this arena. Fansubbing refers to the practice of producing subtitles for films informally shared and distributed online. Such practices are often particularly associated with Japanese anime and so research in this area has often focused on fansubbing amongst anime fans (Condry, 2007; Hatcher, 2005). Despite this, the term can be applied to any subtitles made by fans for use with fan-distributed content. The important factor to note about fansubs is that the creators often have no formal subtitling education and do not profit from their activities (Hatcher, 2005, p. 531). However, fansubbing groups may be quite professional while also developing and nurturing a strong brand identity.

> Fansub groups can get very sophisticated. Groups often have 'Help Wanted' sections where they advertise jobs with the group. Some groups maintain a certain level of brand identification and even

have 'subsidiaries' that release other genres of anime, typically adult-oriented material, often called *hentai*, under a different label.

(Hatcher, 2005, p. 520)

In forming their brand identity, fansubbing groups will often go far beyond simply translating what is being said on screen (Dwyer, 2009, p. 50). Some fansubs use different colours or spacing on the screen to indicate who is talking. They might also include information about yawning, background music and so forth. In certain releases, the fansubs go even further and provide footnotes to explain plotlines and cultural references (Dwyer, 2009, p. 50). There will often be fansubs available in a range of languages, and so the film files themselves will be in the original language without any subtitles, enabling various fansubs in various languages to be coupled with the release. Fansubs are created as a separate file (.sub or .srt) with the same name as the compressed video file (.avi) and, when burnt on to a disc together, or in the same folder on someone's hard drive, the film will play with subtitles.

The ethics of fansubbing is a contentious debate, with some arguing that the process allows access to previously inaccessible material, while others contest that fansubbing damages markets before they are even created. Furthermore, fansubbers themselves are renowned for having a specific ethical standpoint on their activities and adhering to codes designed to counteract the possible negative implications of the behaviour. Hatcher suggests that fansubbers consider ethics in an 'interesting twist on the stereotypical p2p "pirate" paradigm' (2005, p. 531). In other words, they admit they are doing something that is illegal but they also suggest that 'their fansubs help to build interest in a show and generate income for the show's producers: a "no harm, no foul" argument' (Hatcher, 2005, p. 531).

Indeed, there is a common myth that fansubbing groups adhere to strict ethical codes, most notably that shows should only be subbed if they had not been licenced for distribution in North America (Cubbison, 2005, p. 48). However, Rayna Denison has critiqued this, suggesting that 'the extent to which fansubbing groups follow, or care about, rules and guidelines for fansubbing is debatable' (2011, p. 12). Even Jordan Hatcher, who is quite positive about the potential of fansubbing to open up the anime market, suggests ethical guidelines are not always adhered to and that the work of fansubbers often makes its way on to counterfeit DVDs and VCDs and that therefore fansubbers may be supporting other forms of piracy (2005, p. 537). However, regardless of the potential effects of such activities, fansubbing has become an important part

of the wider online distribution ecosystem by allowing fans to circumvent language barriers that would have hitherto limited their experience of a wide range of films and TV programmes.

Conclusion

The brief (and admittedly selective) history of informal online distribution provided has illustrated that online forms of informal dissemination are varied and constantly developing. Indeed, the forum-based form of filesharing that will be discussed in the following chapter is only one of a range of methods of obtaining and distributing files over the Internet. Thus, these particular 'filesharing' forums also exist in relation to the wider historical context of informal online distribution and *The Scene*.

Indeed, this discussion has also demonstrated that *filesharing* cannot be applied as a universal term for all downloading behaviour. It is true that, due to the nature of p2p filesharing, anyone who downloads a film may also be sharing it at the same time. In this respect, one could argue that any member of a p2p network is in some ways also a distributor. However, it can no longer be claimed with any confidence that p2p represents the dominant form of downloading behaviour. Indeed, as far back as 2008, 'file hosting sites such as RapidShare and Megaupload generate[d] a substantial amount of Web traffic – between 12 percent in Southern Africa and 44 percent in South America – contributing up to 10 percent to the overall Internet traffic' (Schulze and Mochalski, 2009, p. 12).

6
Informal Distribution Networks: Fan 'Filesharing' and Imagined Communities

Introduction

This chapter outlines the findings of online ethnographic research carried out from 2006 to 2011 that explored the online dissemination of East Asian cinema through English-language filesharing forums. In doing so, it asks how these communities function and how filesharing activities are internally constructed and policed within these contexts. This examination indicates that such forums are about far more than just sharing *files*, and are imagined and constructed through the perceived existence of a shared ethos of sampling and reciprocity. During the process of imagining, the object of fandom itself fades into the background as the 'community' takes centre stage. Furthermore, these communities maintain ethical codes and belief systems that contribute to their process of imaging themselves as distinct from the 'pirates' who are constructed as solely concerned with the for-profit distribution of tangible goods.

Having considered in detail the process of community imagining, the chapter goes on to examine what motivates and shapes the acquisition decisions of the specific film distributors within these communities. Here, I make the distinction between the forum membership at large and those who might be more aptly described as informal online distributors in this context; that is, those who actually select, source and prepare films for release within their specific communities. While it is in the nature of certain forms of filesharing that a user will simultaneously share as they download, I would suggest that this (usually) enforced dissemination does not automatically qualify them as informal film 'distributors'. This is because, by engaging in such acts of automated 'sharing', users do not select films to add to the network; they only facilitate the circulation of what is already present. With this distinction

111

in mind, this chapter examines how the online distributors are moti-
vated to share films, not only because it raises their status within the
forum community, but also because they consider their actions to be
raising the profile of East Asian cinema more generally, thus furthering
the goal of the *wider* imagined community of East Asian cinema fans.
This chapter illustrates that the activities of the distributors themselves
are varied, as are the ethical and intellectual considerations of their own
actions. Despite the varied nature both within and across the forums,
these online distributors are not simply motivated by cost avoidance
(as the anti-piracy rhetoric would maintain), but exist within a complex
social community where many members *perceive* their activities to be
promoting the industry rather than competing with it.

Community imagining and symbolic power

The codes and conventions that govern these forums correspond to
Anderson's observation that 'communities are to be distinguished . . . by
the style in which they are imagined' (1991, p. 6). As such, the act of
imagining the communities in question is simultaneously born of these
rules and conventions and also shaped by them. That is, it is the pre-
sumed existence of a coherent ethical stance on specific issues on the
part of the forum members that allows them to imagine the bound-
aries of their community. In turn, it is the fact that the community is
imagined according to notions of shared goals that allows the imag-
ining of the community to transcend the confines of the registered
membership of the forums and extend to (theoretically) include anyone
whom the forum members deem to be engaged in active promotion and
distribution of East Asian cinema.

 However, it must be noted that it is those who have the ability to
shape the community rules and conventions that hold most of the
power within the forums. Thus, through invoking Pierre Bourdieu's
concept of symbolic power, this chapter examines how certain individ-
uals maintain their dominance within the community and dictate the
boundaries through which their community is imagined through acts
of 'symbolic violence' (1991, p. 167). According to Bourdieu, 'symbolic
power is that invisible power which can be exercised only with the com-
plicity of those who do not want to know that they are subject to it or
even that they themselves exercise it' (1991, p. 164). The *power* of sym-
bolic power lies in its ability to construct reality in its chosen image.
Symbolic power is enacted within symbolic structures or systems (art,
religion, language), which 'can exercise a structuring power only because

they themselves are structured' (Bourdieu, 1991, p. 166). So, art, religion and other 'symbolic systems' are 'structured structures', that is, they are able to govern the shape and appearance of the social world. Thus, drawing on Bourdieu's work on symbolic power and capital, it is necessary to establish what is, and is not, valued within the community as well as the amount of capital each individual holds, and the distribution of power and capital within the wider group.

In order to consider how power is enacted within these specific communities, what follows will include a detailed examination of how membership data is recorded and displayed within the forums under consideration in order to express how interactivity and participation are understood in each context. Kozinets's categorisation of forum members into tourists, minglers, devotees, insiders and lurkers[1] is employed to critically examine the variety of forms and levels of interaction that exist within both communities (1999, p. 254). These classifications are then used as a starting point to develop a new set of categories for the one of the forums, where each member's engagement is measured by the frequency with which they post and the user's join date; information that is prominently displayed each time the individual posts to the messageboard. The analysis of how members interact within each forum and how membership is constructed differently gives a sense of how these communities function, and how they are distinct from one another and other informal online distribution contexts. Furthermore, we can see how the more dominant forum members have the ability to 'structure the structure' of the forums, thus further reinforcing their own privileged positions within the community. The 'policing' of the activity of others (by restricting membership or exhibiting hostility towards new members) can be seen as acts of symbolic violence that effectively dictate the boundaries of acceptable and ethical behaviour within these forums.

Case study: *Chinaphiles* and *Eastern Legends*

This chapter concerns two forums that specialise in the informal dissemination and discussion of East Asian cinema. When referring to these communities, I shall focus on generic rather than specific features of the forums so as to protect the anonymity of the participants. Furthermore, so that the forums themselves cannot easily be identified, they are referred to by the pseudonyms *Chinaphiles* (*CP*) and *Eastern Legends* (*EL*) and all forum posts have been paraphrased because, if quoted verbatim, they would be locatable through standard Internet search engines.

These forums do not exist in isolation and are part of a range of informal online distribution practices that are particularly concerned with East Asian films and culture. Furthermore, they also intersect with other informal online distribution practices that have little to do with the circulation of East Asian cinema. In this respect, Bourdieu's concept of the 'field' allows us to understand these forums as 'social arena[s] within which struggles or manoeuvres take place over specific resources or stakes and access to them' (Jenkins, 1992, p. 52). Grenfell suggests that the exploration of any field should begin with an examination of how it relates to other fields (Grenfell, 2010, p. 22). Thus, the existence of the forums within wider online informal distribution networks as well as their relationship to other forms of piracy must be (briefly) considered.[2]

Online forums (or messageboards) operate as hubs for interaction over the Internet and they thus intersect with the multiple practices of informal online distribution that are arguably becoming normative cultural activities. Indeed, as far back as 2004, the MPAA claimed that 'nearly a quarter of the world's internet users have illegally downloaded a film at one time or another' (Staff and Agencies, 2004). Internet forums are ordinarily sections of a website where people come together to 'discuss' a variety of issues that are relevant to the focus of the website. It is often obligatory to create a membership account to participate in forum discussions, although non-members will generally be free to simply observe (lurk). Upon gaining membership, an individual chooses a username or 'handle' and is either given, or selects, a password. A user will then need to log in to their account in order to post (leave messages) within forum discussions (threads), start new threads, or send and receive private messages (PMs). However, as it is not always necessary to have a membership account in order to view the topics on the forum; many more individuals than those who actually participate in discussions often use such forums, and such people are typically referred to as 'lurkers' (Lindlof and Shatzer, 1998, p. 175).

A forum will generally have one or more administrators or moderators (commonly abbreviated to 'admins' and 'mods') who monitor the discussion threads and posts. Moderators are commonly very active members of the 'community' who are appointed by the admins to deal with the day-to-day running of the forum and have the power to move or delete conversation threads as well as edit, remove or comment on posts. Administrators can often be founder-members of the forum and they have the highest level of power; they have all the abilities of a moderator, but can also set permissions for other users, ban users or appoint moderators. Administrators and moderators will interject in

discussions if members are breaking the stated rules of the forum. Commonly they will move discussions that are 'off-topic' for one particular section of the forum to a more appropriate area or monitor offensive behaviour. There are five moderators and two administrators on the *EL* forum and these individuals are clearly indicated on an 'admins' page on the website. *CP*, on the other hand, does not advertise the identities of their admins and mods so explicitly, but such information is displayed under the user's avatar when they post to the forum. From examining such information, there appears to be one generic account named 'admin' followed by another user, Opilit, who holds the title admin; mods for the whole site, Luccio and Koil; and mods for each section of the site. Again, a combination of mods and admins on such forums is quite commonplace.

A 'filesharing' forum is a website, or part of a website, dedicated to posting links to downloadable files. Similar to other online forums, discussions can concern an assortment of topics relating to the focus of the website. In the case of the forums discussed within this book, both are split into sections, and more specific subsections, so the user can identify where to find and (if they wish) to participate in certain categories of discussion. First, both forums have a general discussion section that does not focus on any particular area of East Asian cinema. *CP* contains subsections under the 'general' discussion section, which allow users to discuss requests they have for movie releases or to request help and advice from other users when they are experiencing technical problems. *CP* has four further sections: 'release', 'subtitles', 'music' and 'miscellaneous'. The 'release' section is split into genres and is where links to specific movies are posted. The 'subtitles' section is split into two subsections: one for links to subtitles for particular films and another where users can request subs for particular releases or ask for fansubs in an alternative language to those already provided. The 'music' section has its own general music discussion subsection and also subsections for score and soundtrack releases, as well as East Asian pop music releases. The 'miscellaneous' section covers everything that does not fit into the focus of any of the other sections, such as, anime and manga, East Asian television shows and games and DVD extras and covers. *EL* has three further sections beyond its general discussion section: 'Asian media and entertainment', 'miscellaneous' and 'support'. The 'media and entertainment' section is split into music, movies, television, anime and manga, literature, games and reviews subsections. The 'miscellaneous' section is for mobile electronics, while the 'support' section contains requests and technical support subsections.

Such a setup can be observed on other filesharing sites where a 'general discussion' or 'introduction' thread is typically followed by sub-sections relating to specific media or topics depending on the focus of the forum. Indeed, forums will quite often act as the gateway to con-nect individuals with the files that they wish to download. However, this is not always necessary, and, as the previous chapter has already illustrated, there are a range of ways of downloading files from the Inter-net that do not involve accessing or participating in forums. However, for the *CP* and *EL* communities, the fact that their activities are routed through specific forums is significant because of the way these spaces are both structured by and structure informal distribution practices. In this respect, Pierre Bourdieu's notions of symbolic power and symbolic vio-lence are particularly informative when examining patterns and norms of behaviour within these forums.

Symbolic power and community norms

According to Bourdieu, 'Symbolic power, [is] a subordinate power, [it] is a transformed, i.e. misrecognizable, transfigured and legitimated form of the other forms of power' (1991, p. 170). The concept of symbolic power has links with the Marxist concept of ideology, in as much as it is 'subordinate' and 'misrecognised'. That is to say, the *power* of sym-bolic power comes in the fact that it is able to represent certain ideas or beliefs as 'natural', while serving particular interests (Bourdieu, 1991, p. 167). However, while ideology considers the political effects of sym-bolic systems. such as, religion, science or art, Bourdieu maintains it misses the significance of their ability to structure the social world. He suggests:

> It is not enough to note that relations of communication are always, inseparably, power relations which, in form and content, depend on the material or symbolic power accumulated by the agents (or insti-tutions) involved in these relations and which, like the gift or the potlatch, can enable symbolic power to be accumulated.
>
> (Bourdieu, 1991, p. 167)

Thus, for Bourdieu, the *power* of symbolic power is not born of its accu-mulation alone, but resides in its ability to structure the social world so that one group might dominate another. Indeed, while the enact-ment of symbolic power might be dependent upon the acquisition of high levels of symbolic capital, the accumulation of the capital alone

is not sufficient to produce an act of symbolic violence. As such, it is only those who draw the boundaries of symbolic systems who are able to enact power over those that exist beyond them. For instance, for Bourdieu, 'members of the laity... [are] *dispossessed* of the instruments of symbolic production', because it is the clergy who own the dominant discourse (1991, p. 167). Indeed, it is those who control the dominant discourse, that is, the 'structured and structuring medium' through which the status quo is presented as 'natural', who hold the power.

For Bourdieu, exercising one's symbolic power over others is an act of symbolic violence. However, that act of violence can only be achieved with the complicity of those upon whom it is enacted. As Bourdieu claims, 'what creates the power of words and slogans, a power capable of maintaining or subverting the social order, is the belief in the legitimacy of words and of those who utter them' (Bourdieu, 1991, p. 170). This concept is therefore helpful when examining the *CP* and *EL* communities because it is through such complicity that the more dominant members of the forums are able to maintain their mastery over the space. One of the most obvious ways in which they do this is through the regulation of community membership.

Registered membership is a prerequisite to posting on the sites or accessing the aspects of the forum that display links to downloadable files. When this research originally began in 2006, membership of each forum could only be gained by recommendation or applying during one of the infrequent rounds of open membership. The fact that these are largely closed communities sets them apart from other, less specialist, forums that facilitate informal online distribution that might be easily located after the most basic of Internet searches. Furthermore, the existence of a membership requirement also further structures the space as a closed 'member's club' with an explicitly social context that is furthermore carefully monitored, controlled and protected.

As such, the forums under examination could be understood as what Pierre Lévy calls 'knowledge communities' (cited in Jenkins, 2006, p. 27). That is, the forums are not for posting links alone, but also function as communities where individuals come together to discuss the object(s) of their fascination. They are places where members can learn about new releases, discuss preferences for particular films or genres, and engage in a whole host of other discussions related to East Asian cinema. In many respects, these forums are as much about the exchange of knowledge as they are about the circulation of films. Therefore, it could be argued that these forums are representative of a wider shift towards communities

formed around mutual interest rather than geographical proximity. As Henry Jenkins describes:

> New forms of community are emerging, however: these new communities are defined through voluntary, temporary and tactical affiliations, reaffirmed through common intellectual enterprises and emotional investments. Members may shift from one group to another as their interests and needs change, and they may belong to more than one community at the same time. These communities, however, are held together through the mutual production and reciprocal exchange of knowledge.
>
> (2006, p. 27)

The portrait that Jenkins provides of the emergence of these new forms of community fits the forums under examination in this research. Certainly individuals are brought together by a common interest. They also shift from group to group and maintain membership of multiple groups concurrently.[3] A prime example of this is Jo, who is a member of four separate East Asian filesharing forums and a host of related anime and subtitling forums (2007).

Furthermore, the knowledge that is exchanged within these forums is not only about the films themselves, but everything that surrounds them: the production, release[4], distribution company, release quality and more. Thus, in this context, knowledge acts as a form of symbolic capital and the deployment of that capital is how one gains and maintains status with the community. To a certain extent, this sets these practices apart from types of informal online distribution activities that involve downloading the latest Hollywood blockbuster. That is not to say that this necessarily makes the activity any more legal, ethical or acceptable, but it does mean that it is possible to argue that the context for these acts of informal online distribution is different for forum members when compared to the casual downloader. Participating in informal online distribution in this setting could be understood as a more complex, community-based activity. Posting releases, providing subtitles or answering the queries of other members all serves to increase the social status of the individual within the forum community. Such factors cement the importance of an approach to the study of informal online distribution that takes into account the social, emotional and affective aspects of the circulation of cultural commodities.

When Lévy originally conceived of the 'knowledge community', he saw it as representing freedom from the shackles of hierarchical and

canonical knowledge that exists in the 'real' world (1999, p. 112). However, this is where the forums under discussion here diverge from Lévy's conception of the knowledge community because, in many respects, these communities are particularly hierarchical. Jenkins has noted a similar phenomenon in his work on the website '*Survivor* sucks', which is a spoiler website designed to uncover behind-the-scenes information about the reality TV show *Survivor*. Within these websites Jenkins has noted 'brain trusts', or private cabals within the larger community, who hoard information. Jenkins suggests that these 'brain trusts' are strictly hierarchical and 'attempt to create an elite which has access to information not available to the group as a whole' (2006, p. 39). Furthermore, they position themselves as 'arbitrators of what it is appropriate to share with the community' (Jenkins, 2006, p. 39).

Although the *CP* and *EL* forums do not have specific groups that 'speak' in hushed tones and are password protected, similar methods of safeguarding and protecting specialist knowledge can be noted within *CP* in particular. For example, the technique of ridiculing newcomers for their lack of specialist knowledge (discussed at greater length further on in this chapter) is one example of how access to knowledge is protected. While there are sections on the forums designed to allow new members to ask basic questions, when they do, such requests are often met with sarcasm and derision (Help Request Discussion Thread, 2006; How Do I Download Asian Movies Discussion Thread, 2004). Such reactions demonstrate how the community members use their own high levels of symbolic capital as a weapon against new members in a bid to reinforce their own position as the arbiters of community rules and codes.

Since this research began, the fabric of these communities has changed and the *CP* forum has ceased being password protected. Arguably, the fact that the community was originally password protected and required an invitation to join provided the 'gated (knowledge) community' that Jenkins describes (2006, p. 27). Furthermore, the requirement to be recommended and/or approved for membership highlights the way the forums are both structured and structuring. The requirement that key community members 'approve' the addition of others serves to suggest that the approvers are in some manner 'special' and thus reinforces existing hierarchical arrangements. Indeed, even though membership rules have subsequently been relaxed (on the *EL* forum, you do still need an account to access the forum, but it is free and open for anyone to sign up for an account), there is still anxiety surrounding new members entering the community 'unchecked'. The

primary concern amongst the more prominent members is that allowing open membership has the knock-on effect that previously banned leechers can simply re-join under another name (New Membership Discussion Thread, 2010).

The *CP* community in particular is markedly hierarchical, with status dictated by length of membership and number of posts. For the online distributors, the number of posts is particularly important because it is often linked to the number of films the user has posted within the community. With this in mind it is imperative at this juncture to make a distinction between different *types* of distributor that exist across the forums.

The *EL* forum only allows 'releases' in the form of uncompressed DVD or Blu-ray files. This has the added effect that forum members specifically create 'releases' to distribute within this particular community. I have used the term 'autonomous' distributors to refer to those who create releases in this manner. The *CP* forum, on the other hand, does not have any technical requirements for the films circulated within their grouping. As such, on the *CP* forum it is common for films 'released' by forum members themselves to exist alongside links to films that users have found on other forums or networks and have gone on to post on the *CP* messageboard. I have designated the term 'intermediary' distributors to indicate users who pass on links in this fashion but do not in any other way contribute to the creation of the release (further details on the specifics of creating 'releases' comes later in this chapter). It is important to note that the links found elsewhere may have been created by what is sometimes referred to as the filesharing 'Scene'[5] (that is, a loosely affiliated collection of release groups that circulate files online) but that such releases were by no means commonplace.

These distinctions are significant because it is the autonomous distributors who garner more respect within the *CP* forum because the effort and expertise that has gone into actually creating a release (often called a 'custom rip'), rather than simply posting the links, is recognised and respected within the 'community'[6]. In this respect, autonomous distribution brings with it a higher level of symbolic capital. Such a distinction only really exists on the *CP* forum, because the *EL* forum, by focusing on sharing uncompressed DVD (and latterly Blu-ray) files only, precludes the sharing of 'Scene' releases because such files are not available in DVD format. However, within the *CP* forum, one's position as an autonomous, rather than an intermediary, distributor provides an individual with a higher and more respected social status within the 'community'.

While each forum protects the exclusivity and hierarchy of their com-
munity through strict membership requirements, these measures have
nonetheless still allowed membership numbers to expand into the tens
of thousands. While such numbers might initially seem quite extensive,
a more thorough examination of the membership data for each forum
reveals that the number of registered user is not necessarily indicative
of levels of what might be considered 'active' participation within each
community. An analysis of the membership data from each forum illu-
minates how key individuals are able to exert a considerable influence
upon the community at large.

Both forums provide detailed information on their members. How-
ever, providing this data is voluntary and so its accuracy has to be treated
with scepticism. When joining either forum the user provides a name
(which is generally their Internet handle rather than the name on their
birth certificate). They are also offered the opportunity to provide loca-
tion and basic contact information, but not everyone does. Membership
data is available for all members to view. In addition to the informa-
tion provided by the individual on joining, the membership list on
the *CP* forum also includes information on when the user joined and
how many times they have posted to the forum. The *EL* forum also
includes the user's ratio (this provides an indication of how much the
user has downloaded in relation to how much they have uploaded). This
is because *EL* functions using the BitTorrent protocol, whereas *CP* uses
the eDonkey network and as such does not record such information
about its users.[7]

CP prominently displays how *often* a member posts to the forum and
their *length of membership*, whereas the *EL* forum emphasises each mem-
ber's ratio. Highlighting particular types of information within the user's
profile and whenever they post to the forum suggests these factors are
prized highly by the community as indicators of an individual's com-
mitment to the forum; therefore, within *EL*, forum members who would
typically be referred to as 'lurkers' might be considered as much a part
of the community as those who regularly contribute to forum discus-
sions. In this environment, it is how much a member *shares*, rather than
how much they *'speak'*, that is understood to constitute their level of
involvement. In both cases, this concern about participation indicates
that membership is about more than just registering.

Indeed, conforming to both the actual and perceived rules and
guidelines of each forum is what grants membership over and above
registering one's details on the site. Furthermore, the existence of
both written and accepted guidelines for behaviour is exactly what

allows each community to exist and also dictates its shape and scope. Indeed, the community context then becomes the factor that moulds the filesharing experience. That might be through contributing to the social discussions privileged in the *CP* forum or by adhering to the strict uploading/downloading ratio guidelines within the *EL* community. In either instance, a sense of shared goals, rules and expectations both helps to shape the community and in turn dictates the boundaries and expectations pertaining to the informal distribution activities that are enacted within each forum.

Chinaphiles

The membership list for *Chinaphiles* is considerable, but the proportion of people who actually contribute to forum discussions through posting is minuscule when measured against the overall membership. As of July 2009, the *CP* board had 64,502 members. However, at that time, 59,175 users (91.74% of the total membership) had never posted a message to the forum and thus would be commonly termed 'lurkers'. While there are no universally recognised terms for other members of forums and their varying levels of involvement, Robert Kozinets has gone some way to categorising these individuals by applying the terms tourists, minglers, devotees and insiders.

> The first of the four types are the *tourists* who lack strong social ties to the group, and maintain only a superficial or passing interest in the consumption activity. Next are the *minglers* who maintain strong social ties, but who are only perfunctorily interested in the central consumption activity. *Devotees* are opposite to this: they maintain a strong interest in and enthusiasm for the consumption activity, but have few social attachments to the group. Finally, *insiders* are those who have strong social ties and strong personal ties to the consumption activity.
>
> (Kozinets, 1999, pp. 254–255)

Kozinets's categories are particularly useful as they provide a method of understanding the varying *levels* of interaction that individuals might demonstrate within any online community to which they claim membership. However, they are of limited use within the *CP* forum because, significantly, within this community, participation is assessed on the frequency of contribution to forum discussions rather than on the level of interest that an individual has in the 'consumption activity' (Kozinets, 1999, p. 255). As such, for the purposes of analysing the *CP* forum for

Table 6.1 Member categorisation by total forum posts (*CP* forum)

Total number of posts	Member type	Number of forum members	% of overall forum membership
>1000	Key poster	38	0.0589
500–999	Habitual poster	65	0.10
200–499	Consistent poster	112	0.17
100–199	Common poster	173	0.27
50–99	Occasional poster	234	0.36
10–49	Sporadic poster	477	0.74
<10	Minimal poster	4,228	6.55
0	Lurker	59,175	91.74

this research, a method of categorisation has been devised based on the frequency of posts to the forum.

This categorisation of members allows an overview of posting activity within the forums. As can be seen from the data (Table 6.1), very few individuals actually post to the forums on a regular basis. On the face of it, this would suggest that only a small percentage of the overall members are *active* members of the community. However, it may be that many of the lurkers, minimal and sporadic posters are 'active' in the sense that they share movies within the community regularly through the eDonkey network. In contrast, key, habitual, consistent and common posters may rarely share the movies they download (although this would be unlikely). From looking at Table 6.1, it is clear that the lurkers make up a majority of the population and so it is difficult to get a clear sense of how the posting members of the forum are distributed. Thus, if we ignore the lurkers for a moment, we have a total forum membership of 5,327. In this situation the key posters still only make up 0.71% of the posting population and it becomes obvious that the majority of forum members have only limited input in forum discussions (Table 6.2 and Figure 6.1).

Predictably, amongst forum discussions, frequency of posting is often cited as an indication of status with the community. Thus, the existence of forums surrounding the consumption activity mean that those individuals who choose/are able to contribute to forum discussions are more visibly able to shape the codes and conventions of the community through forum posts that, in turn, reference forum posting as an important facet of community membership. For instance, through the creation of topics where forum members are encouraged to 'introduce' themselves to the forum (Introduction Discussion Thread,

Table 6.2 Member categorisation by total forum posts (excluding lurkers) (*CP* forum)

Total number of posts	Member type	Number of forum members	% of posting forum members
>1000	Key poster	38	0.71
500–999	Habitual poster	65	1.22
200–499	Consistent poster	112	2.10
100–199	Common poster	173	3.24
50–99	Occasional poster	234	4.39
10–49	Sporadic poster	477	8.95
<10	Minimal poster	4,228	79.37
Total		5,327	

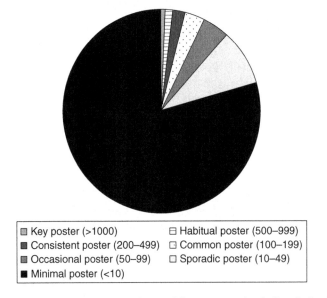

☑ Key poster (>1000) ⊟ Habitual poster (500–999)
■ Consistent poster (200–499) ☐ Common poster (100–199)
■ Occasional poster (50–99) ☐ Sporadic poster (10–49)
■ Minimal poster (<10)

Figure 6.1 Member categorisation by total forum posts (excluding lurkers) as a proportion of total forum membership (*CP* forum)

2008) or to show gratitude for links posted to the site (Thanks Discussion Thread, 2004). Thus, they legitimise their own preferred method of forum interaction and informal online distribution behaviour through posting to the forums. As such, the key posters must be considered to have control of the dominant discourse within the *CP* community. In such a privileged position, they are able to continue deliberately or

unwittingly structuring the forum space according to their own best interests.

Another method of accruing high levels of symbolic capital within the *CP* community is through length of membership. Indeed, each member's date of joining is prominently displayed next to their total number of posts whenever they post to the forum.[8] The foregrounding of frequency of posting and length of membership as primary indicators of status demonstrates that, within this forum, interaction (in the form of posting), is of utmost importance in the process of both structuring and imagining the *CP* 'community'. This then serves to reinforce the sense that this is a 'community' bound and shaped by textual communication (as opposed to the sharing of files) and, significantly, dominated by a number of key posters. In dominating the *CP* forum, these posters then establish knowledge of the forum and its rules as other routes to the accumulation of symbolic capital. Thus, in the process of imagining the bounds of the *CP* 'community', members must be possessed of an expert knowledge of not just the object of their fandom, but also the means of obtaining it through both formal and informal channels.

The most evident illustration of this in the *CP* forum is the mixed reactions that can be noted towards individuals trying to join the community, and in particular how key forum members react against those who are perceived to be bereft of the requisite knowledge needed to achieve full forum membership. Each new forum member (newbie, or 'n00b' in abbreviated form) is generally accepted as long as they are not seen to ask questions that are deemed to be overly 'stupid' or 'obvious'. There is no official 'introductions' thread (as there is on *EL*), but some 'newbies' nonetheless created a thread to introduce themselves to the community. Such was the case with Botem, who started a thread in the general section in order to introduce himself. Here, he gave away some personal information and expressed enthusiasm at joining the community. Key posters Burble, Mollow, Boser and Derven greeted this gesture warmly and reciprocated by sharing fond stories about Botem's hometown (Introduction Discussion Thread, 2008).

However, when another newbie, Carrel, requested help through the support forums, he was greeted rather less favourably by key poster Eleo and habitual poster Ferti (Help Request Discussion Thread, 2006). Although Eleo and Ferti answered Carrel's questions, they both made references to the fact that the newbie would probably not understand the technical language they used, while simultaneously criticising the new member for not *already* having an expert knowledge of the rules of the forum. If newbies ask generic or unspecific questions, then the

key posters will often respond with sarcasm or open hostility. On one such occasion a new forum member asked the rather blunt question 'how do I download Asian movies?'. At which point, key poster Burble responded to this initially by being sarcastic and then by referring to the individual as a 'dumbass n00b' (How Do I Download Asian Movies Discussion Thread, 2004). Thus, hostility towards new members can be seen as an act of symbolic violence whereby established members can reinforce their authority to define 'acceptable' community behaviour.

Indeed, when I originally joined the forum and introduced myself as a researcher investigating filesharing forums, I was accused by Ancient, a key poster within the community, of being a 'n00b' trying to break into 'The Scene' (Ancient, 2007). The term 'n00b' is not only a descriptive term for a new member but is also often used as a pejorative form of abuse to describe any forum member who makes any error that might suggest less than perfect knowledge of the forum's rules and conventions. Indeed, despite his/her own attack on newbies, when Burble (a key poster within the community) asked a 'stupid' question on a particular thread, he/she was called a 'n00b' by his/her fellow community members and also referred to his/her own 'stupidity' at asking for a film that could be easily found using the search facility on this site (*Three Monster* Discussion Thread, 2004). As was mentioned earlier, according to Bourdieu, acts of symbolic violence require that there is a consensus amongst both the powerful and powerless of the boundaries of acceptability and normality (1991, p. 170). Thus, by identifying this term with his/her own 'stupidity', Burble strengthens the status of the term 'n00b' as a form of abuse and promotes the idea that individuals joining the community are necessarily ignorant and naive. This, of course, in turn, consolidates the position of key posters as the rightful arbitrators of community standards of behaviour.

While theoretically anyone is free to post to any of the threads in the *CP* forum, new members are tacitly discouraged from contributing due to the dominance of certain key community members. Thus, if we return to Kozinets's categorisations, we could analyse the *CP* forum as comprised of a combination of minglers and insiders. However, lurkers, tourists and devotees (despite making up the bulk of the membership) are marginalised by the key posters due to their lack of contribution to forum discussions. Furthermore, the key community members control forum discussions to such an extent that new members are discouraged from contributing. Indeed, Helo, Ancient, Burble and Fishtank are some of the most avid and also hostile members of the community, and it is through their derisory attitude towards new members that they have

effectively secured their own position as the most 'vocal' members of the *CP* community. Furthermore, in doing so they are able to effectively frame and mould the way the larger community is structured and imagined.

Through their negative attitude to new members, they reinforce the convention within the group that those who have been members for the longest or who post more frequently, and thus are more likely to have an expert knowledge of the official forum rules and conventions, are somehow also 'representative' of unspoken community rules and moral guidelines. As such, they also put forward the point of view that their opinions are also indicative of a cohesive community position on various ethical and moral dilemmas related to their informal online distribution activities. Analogously to Anderson's argument that the rise of print capitalism contributed to the growth of nationalism, the key posters on the *CP* forum are able to use their domination of textual discussions to both foster and dictate an imagined community position on particular issues; for instance, whether there is a distinction between 'piracy' and 'filesharing', and whether the files available on the forum should be used as a replacement for legal DVD purchases or just as a sample. The specifics of these proposed ethical positions will be discussed in more depth later in the chapter.

Overall, posting regularly and possessing a longstanding membership are presented within forum discussions as elevating the status of the user within the *CP* community. However, these observations are primarily gleaned from observing forum discussions and as such reflect the opinions of those community members who actively contribute to discussions. Therefore, one might expect such respondents to privilege participation in forum discussions. Despite such a sampling drawback, this observation is also supported by the fact that the forum records information concerning the number of posts and length of membership, and displays such information when the individual posts to the forum, behaviour that is not mirrored within the *EL* forum. Furthermore, by having a long history of forum membership and posting regularly, such forum members are able to accrue the symbolic capital necessary to reinforce these conventions, thus marginalising new forum members and securing their own position as the community leaders.

Eastern Legends

On the *EL* forum, user information is recorded and displayed in a different way to that on *CP* and so tells a different story about the structure and priorities of this forum and how power operates within

it. Furthermore, due to the focus on how much data each member has *shared* rather than their contribution to forum discussions, this community also has a different manner of imagining itself. Rather than having key forum members who present a community position on moral and ethical dilemmas through forum discussion, the community position on the same issues can be understood as framed by the underlying emphasis on sharing through the importance placed on each user's upload/download ratio. That is not to say that key community members do not have the same levels of power as those within *CP*; it is simply that their power is enacted through methods other than the textual domination of forum discussions.

Unlike *CP*, the site does not openly display further information on its users such as location, length of membership or date of joining. However, the forum does record and display statistics for the top ten uploaders, downloaders, fastest uploaders, fastest downloaders, 'best' sharers and 'worst' sharers (Statistics Thread, 2009). As such, the site appears to designate a member's contribution to the dissemination of files within the community as paramount, and could be argued to be less concerned with their participation in forum discussions. In addition, rather than displaying the number of posts and length of membership with a user's name when they post, the forum includes their ratio: an indication of how much they have uploaded compared to how much they have downloaded.[9] A ratio that demonstrates that the member has uploaded more than they have downloaded is prized and respected within the community, and acts as an indicator of their levels of symbolic capital. Thus, as with Quiring et al.'s example of a *sharing* model of filesharing, a user benefits the more files they add to the filesharing community (2008, p. 435). However, in this case, individuals benefit through raising their standing within the community rather than through reaping a financial reward for their efforts.

When considering the *EL* community, Kozinets's categories become more applicable because, within this board, there are likely to be some 'tourists' who have come to the forum to, for example, find a particular film, but do not have a burning interest in East Asian cinema in general. There are also likely to be less 'minglers' on such a forum as *EL*, because the discussion barely deviates from East Asian cinema and this forum is more concerned with the circulation of films rather than the conversations surrounding them. 'Devotees', however, becomes a much more useful term, because it can be applied to many members of this forum who would use their membership as a means of obtaining

the films that they care for without demonstrating a strong inclination to contribute to the community discussion surrounding such films. A good example of such an individual within the *EL* community would be Dertoy. The member exists in both the list for the top ten 'uploaders' and the top ten 'fastest uploaders' but had only contributed to forum discussions four times in almost three years of membership (Statistics Thread, 2009). The 'devotees' on *EL*, as opposed to the *CP* forum, could be perceived as more integral to the community and may have significant levels of symbolic capital (through good ratios), while posting to the forums infrequently or even simply lurking. Indeed, in the top ten 'uploaders' list in December 2009, only one individual had posted to the forum more than a dozen times. One member had never posted at all, although all of the individuals listed had been members of the community for at least two years (Statistics Thread, 2009). 'Insiders', again, would be prominent members of the group who demonstrate a strong interest in both East Asian cinema and the discussions surrounding it within the *EL* forum. A significant example of this would be Usef, who regularly features in the top ten lists while also habitually contributing to forum discussions (Statistics Thread, 2009).

As this community is not explicitly drawn together through textual communication, the group is imagined in a different manner to that in the *CP* forum. The *EL* forum administrators have considerable amounts of symbolic power to dictate the parameters for membership by displaying user information so that ratio accompanies every post each member makes to the forum. Thus, forum posts become structuring structures that set the standard for how membership is discussed on the forums. This then manifests itself as a concern within the community of the damaging influence of individuals that might 'leech' from the community, that is, download more information than they upload (New Membership Discussion Thread, 2010).

What such observations tell us is that, even within the relatively specialised enclave of 'filesharing' forums for East Asian films, there is more than one community model. Furthermore, what distinguishes these forums from one another is the manner in which each community imagines itself. The *CP* forum is a textually focused community wherein key posters are able to dictate and police the imagining of the community through their control over, and privileging of, textual communication. In doing so, these individuals position themselves as arbiters of both the official and unofficial community rules, in a similar manner to the Brain Trusts observed by Jenkins on *Survivor Sucks*

(2006, p. 27). The *EL* forum on the other hand foregrounds the user's upload/download ratio as the primary indicator of their community status, thus imagining their community membership as bound by the written and implied forum rules dictated by the forum administrators.

It is important to note that the ways that certain modes of behaviour and certain members have become dominant within each community should not be viewed as naturally occurring events, but rather as directly resulting from the fact that those individuals are able to play a strong role in dictating the way the forums are imagined. Then, as they structure the forums so that their own preferred modes of behaviour (posting regularly or maintaining a good ratio) are the key routes to the accrual of symbolic capital, they perpetuate their cycle of control by implying that their own methods of interaction as the more 'natural' and in line with universal community values. Indeed, they further shape the sense that their own opinions are somehow representative of universal community values and ethics through the way that the ideas of reciprocity and sampling are discussed and enacted within the forums.

Reciprocity, sampling and the imagined filesharing community

Within both of the forums, there was much discussion of the questions surrounding 'piracy' and 'filesharing'. Some individuals questioned whether informal forms of film distribution were as damaging to the creative industries as those industries have suggested and such community members took a relatively hostile attitude towards the global film industry. However, many members from each forum saw their activities as very much in line with the interests of certain segments of the film industry and saw their distribution activities as promoting East Asian cinema more generally by bringing it to a wider audience. Thus, one of the underpinnings of such a perspective was the assumed presence of a 'sampling ethic': a community guideline that dictated that, rather than replacing traditional retail sales, downloading films from the forums should be used as a means to 'try before you buy'. This ethic played an important role in the process of imagining the communities on both forums, especially as it allowed the imagining of the community to transcend the registered membership of the forum and extend to anyone with a shared aim of disseminating East Asian films. However, whether there was consensus regarding the 'sampling ethic' is certainly debatable, and arguably the 'ethic' itself (if it could be said to exist) was largely dictated by the fact that certain key forum members had

a disproportionate amount of influence over the way each community was structured and imagined.

Beyond how the community is internally constructed and how social position is determined, a further observation can be made about both the *CP* and *EL* communities. In both cases, individuals contextualise and rationalise their informal online distribution and consumption behaviours by 'imagining' their community to extend *beyond* the enrolled membership of the forums. So, while it might be reasonable to claim that participation in the community is, on one level, defined by the contribution that one makes to the forum or by the files that one shares, membership is also 'imagined' to extend to fans of East Asian film that need not ever post, share movies or even visit the forums in question. Their membership is guaranteed by their shared interest and mutual fandom, and not by their actual 'presence' on or participation in the forums.

In addition, for members of the forum, the boundaries of their imagined community are not restricted to the individual online forums. Indeed, many forum members do not construct their identities surrounding membership of one online community because often individuals will be members of multiple forums that facilitate the dissemination of East Asian film (Forum Membership Discussion Thread, 2007). They will also often hold membership of other forums that are tangentially connected to, but not necessarily focused on, East Asian film (for example, subtitling forums, technical 'filesharing' forums, general 'filesharing' forums such as *The Pirate Bay*, anime forums and so on). As such, the imagined community is not bound by membership of one forum but is arguably constructed in the minds of the members of multiple forums. Furthermore, the forum members also do not restrict membership of their imagined community to *online* forum interactions. They perceive the net of membership to be far wider, and to even include members of the film industry itself. This conclusion can be made by examining how forum members discuss their relationship with the film industry, and how they debate the effect that their sharing and distributing activities might be having on the industries surrounding the production and distribution of East Asian films (discussed further in Chapter 7).

A particular way that the communities were able to imagine themselves beyond their registered membership was through reference to a sampling ethic. Thus, it was possible for forum members to understand their acts of 'sharing' as benefiting the wider imagined community (through promoting East Asian cinema), as well as the forum

community (through disseminating files). Within discussions on both forums, an emphasis is often put on the fact that downloading films through the forum *should* be used as a form of sampling. Thus forum discussions might be seen to indicate that the more 'vocal' members of the community do not view their activities as unethical or morally reprehensible, and that this might be in part attributable to the fact that they perceive their actions to be ultimately beneficial to the East Asian film industry. Such an observation is in line with the work of Aron Levin, Mary Conway and Kenneth Rhee who suggest that downloaders show 'a greater willingness to endorse ethically questionable acts, and that [they] ... are more likely to believe that downloading files does *not* harm the company or the artists' (2004, p. 48). In general, and across both communities, the online distributors could be understood as viewing their circulation activities as providing a service both to the forum community within which they interact as well as the larger population of East Asian cinema fans.

Even those forum members who proffer the more radical argument that all culture should be free, often boast large and expensive DVD libraries that contain a combination of legal, bootleg and downloaded copies of movies. *EL* forum member, Avves, goes so far as to list the films she/he has on order from various companies to illustrate her/his commitment to Asian film (eBay Discussion Thread, 2009). Avves is very clear that he/she supports the industry, and has respect for the filmmakers and copyright restrictions. He/she argues that he/she only uses the forum for sampling and nothing more. Within the same thread, other forum members offer support for Avves assertions by also listing their substantial DVD collections (Puulo, eBay Discussion Thread, 2009).

Indeed, when looking specifically at the informal online consumption of music, Levin, Conway and Rhee report that downloaders are more likely to have a larger overall music collection than other music consumers and to have paid for more music through legitimate channels in the last six months than people who do not download as much music (2004, p. 56). As such, they tentatively claim that 'downloading music is not always a substitute for purchasing. The qualitative data also indicate that for some downloading may actually be a form of product sampling' (2004, p. 57). However, the fact that keen downloaders are also likely to buy lots of music in addition to their informal online distribution/consumption activities does not mean that such actions are ultimately beneficial to the music industry at large. For example, Alejandro Zentner argues that people who download are the sort of people that are more likely to spend their money on music, but that using

p2p means that people buy 30% less music than they would if they did not partake of such activities. Based on such calculations, he argues that in 2002, with the absence of online informal distribution, music sales would have been 7.8% higher (2006, p. 66).

Furthermore, the studies by Zentner and Levin, Conway and Rhee concern music downloading, and so we must be sure not to extrapolate the findings from one medium to another uncritically. Indeed, one criticism of the sampling argument when applied specifically to films is that movies, unlike music or software, are often considered to be single-use items. Indeed, Bounie, Bourreau and Waelbroeck argue that music and movies differ in important ways (2007, p. 168). Not only are movies often perceived as single use, burning DVDs is more expensive and complicated that CD burning, and ultimately it results in a vastly different product from the bought DVD or cinematic experience. Furthermore, they suggest that watching a movie is often an exclusive and full-time activity. They claim that under such conditions the sampling effect is weaker for movies than it is for music.

With this in mind, we might also examine the other claim made by Bounie, Bourreau and Waelbroeck, that their respondents indicated that informal online distribution actually increased their demand for films, a finding in line with the perceptions indicated on the forums that this study is concerned with (2007, p. 168). However, in both this chapter and the work of Bounie, Bourreau and Waelbroeck it is imperative to note that, just because individuals *perceive* their behaviour to be beneficial, it does not necessarily mean that it actually is. Indeed, as Higgins, Fell and Wilson suggest, would we not largely expect those willingly engaging in the illegal circulation of content to view their activities as acceptable (2007, p. 344)? Surely if the 'filesharers' saw such behaviour as ethically dubious, then they would be considerably less likely to be members of 'filesharing' forums in the first place? However, what we have seen is a much more complicated engagement with the legal and ethical questions concerning their behaviour than Higgins, Fell and Wilson might acknowledge. As James Coyle et al. suggest, filesharers are more than capable of making their own distinctions between different forms of piracy and their own decisions about the ethical nature of each activity (2009, p. 1034).

One particular discussion on the *CP* forum that highlights these issues came after a BBC article about some anti-piracy raids (BBC News Article Discussion Thread, 2005). Here, Levin, Conway and Rhee's (2004) observation that downloaders do not see their activities as damaging to the industry was reflected in the comments of one sporadic poster,

Detset, who was angry at the excessive profits made by large companies whom, he/she felt, failed to recognise that ordinary people were not affluent enough to afford the inflated prices that were charged for rare DVDs (BBC News Article Discussion Thread, 2005). These sentiments were supported by occasional poster, Elegent, who made the claim that strict copyright enforcement was just greed on the part of people who were already rich (BBC News Article Discussion Thread, 2005). However, key poster Fishtank responded in support of the copyright owners and suggested that forum members often use the 'greed argument' to justify their activities but that in many respects 'filesharers' are just as 'greedy' by circulating files that they do not own (BBC News Article Discussion Thread, 2005). Consistent poster Garfeld countered this by arguing that the users were not 'greedy' – they just did not have the money to purchase very expensive DVDs. He/she also pointed to how many DVDs he/she personally owns and suggested that the majority of those would not have been bought had he/she not downloaded them first (BBC News Article Discussion Thread, 2005).

Such a comment highlights the common reference amongst forum members to a 'sampling ethic'. Many members of both forums proffered the suggestion that it would be beneficial to East Asian cinema as a whole if films were disseminated to as wide an audience as possible, thus increasing the total fan base. Far from viewing their activities as damaging to the industry, the forum members presented their role as beneficial because they viewed their behaviour as encouraging and enabling consumption of East Asian cinema in a similar manner to the respondents described by Cenite et al. (2009) and Condry (2004). This is linked in with an ethos that permeated discussions on the *EL* forum, which suggested that the forum was primarily for sampling and that individuals had a 'duty' to legally purchase films that they particularly enjoyed.

However, there was some debate on the *CP* forum about whether purchasing commercial DVDs actually assisted the industry at all. Consistent poster Murb suggested it was naive to think that money from commercial DVD sales goes back to supporting the East Asian film industries (Thanks Discussion, 2004). Furthermore, common poster Lesvel raised a specific criticism against the *CP* forum that so many of the films available on the forum were quite easy to purchase legitimately (Thanks Discussion, 2004). Lesvel suggested that, as such, the forum is not supporting Asian cinema, but he/she was careful to say that he/she did not want to denigrate the hard work of the people who share on the forum. Fishtank, a prominent member of the community, questioned how many people actually bought the films they had downloaded from

the forum (BBC News Article Discussion Thread, 2005). Fishtank then suggested that he/she both enjoyed something for nothing and getting one over on 'the rich guys'. He/she agreed that much media content is overpriced but questioned whether word of mouth was actually enough reward for the struggling artist.

In response to Fishtank, Helo – a key poster, one of the forum moderators and a staunch supporter of the sampling ethic – suggested that he/she always bought what he/she downloaded and he/she knew of many others who did this too (BBC News Article Discussion Thread, 2005). Helo suggested that if forum members really wanted to support East Asian cinema then they should purchase the 'overpriced' DVDs available through legitimate channels (Thanks Discussion, 2004). This sentiment was reflected in other threads where users were encouraged to show their support for the forum and the community at large by purchasing commercial DVDs (Kolmon, Thanks Discussion, 2004). Helo also suggested that if he/she had more money then many more legitimate purchases would be made, at which point Fishtank made the concession that if the company was small then people will want to support them (BBC News Article Discussion Thread, 2005). Such an attitude reflects those described by Condry that, when individuals have an emotional or community attachment to a particular artist, musician or type of music, they feel more inclined to seek out legal purchases and support the artist and the music scene to which they belong (2004, p. 353).

Referring to a 'sampling ethic' within forum discussions that specifically tackled the ethics of their activities was common on both forums. In the process of imagining the community it appeared to be important for forum members to be both seen to (and understand themselves as) aiding the community. As such, it could be argued that reciprocity was an important facet of community membership. This was particularly obvious in *EL*, where the user's 'ratio' was given as a key indicator on each post they made.

Through the observation of a sampling ethic, it is possible to perceive the *CP* and *EL* forums as exhibiting some of the traits of gift communities. However, as Giesler and Pohlmann suggest, within 'filesharing' networks, the reciprocity is not between two individuals (dyadic), but between individuals and the wider community (2003). Thus, in the context of filesharing forums, the need to repay the gift is not to an individual but to the network at large. Such an analysis provides important insight into how one might conceive of gift exchange operating within a networked context. Indeed, on both *EL* and *CP*, the principle of reciprocity is prized. Specifically in the case of *FL*, through the privileging

of a user's ratio as a sign of each member's contribution to the community, reciprocity can be seen to be central to the act of imagining the community.

However, Giesler and Pohlmann's analysis specifically relates to Napster and so differs in one fundamental way from the activities being considered in this chapter. This is particularly evident in their claim that the Napster gift economy is parasitic: 'In Napster's parasitic economy driven by gift exchange consumers enrich themselves; they assume the role of host, troublemaker and parasite at the same time' (Giesler and Pohlmann, 2003, p. 275). Napster's 'parasitic' gifting community is not based within a centralised hub that facilitates textual communication such as a forum. Thus, this form of community is distinct from those that are the concern of this study. Within Napster's community, it is possible to simply download material and not share the files that one has downloaded. In contrast, on the *EL* forum in particular, reciprocity is not only prized but also enforced. The moderators of *EL* will take steps to halt the activities of any community member who does not share as much as they download. This is because, in addition to including a member's download ratio on each post, the site also has a minimum ratio requirement for membership. If you have downloaded above a certain amount, then you are required to maintain a certain ratio. If this is not done, then you are sent a warning. Failure to respond to the warning results in download privileges being revoked (Forum Rules, n.d.). As such, sharing within the community is required, and solely downloading is viewed as a form of leeching and is neither permitted nor tolerated.

While positioning reciprocity as a central principle underpinning all other community interactions, community discussions on both forums also demonstrated that community members were acutely aware that this alone was not sufficient to address the wider ethical and legal concerns that surrounded their activities. Such issues were considered at length within the forums and, despite the comments of some individual members, the opinions expressed fell far short of representing a cohesive community perspective on the issue. There was much discussion of, and disagreement concerning, larger questions of ownership, copyright, and the free circulation of information and intellectual property. Such questions considered explicitly whether profit should be made from informal online distribution practices, whether and how their own intellectual labour could be protected, and generally whether information and cultural commodities should be freely available. Despite this, within discussions, members often presented their own points of view as though

they were in some way representative of a specific moral code that underpinned their particular community. Thus, despite the fact that a coherent ethical code was not observably present in either community, it was nonetheless *presented* as existing in both forums. Furthermore, this leads on to another interesting finding of this research, that forum members constructed their own community identity in opposition to what they perceived to be the revenue-stealing, for-profit pirates. I have discussed this particular example in detail elsewhere (Crisp, 2012); suffice to say that the differing opinions expressed regarding the actions of one forum member who took *EL* custom rips and sold them as bootlegs on eBay would suggest that cohesive ethical standpoint is not in evidence on the *EL* forum (eBay Discussion Thread, 2009). Nevertheless, it seems that forum members perceive such a code to exist and that this code is based on the presumption that forum members also believe that their sharing activities are distinct from the sort of for-profit physical piracy that they consider to be at odds with the aims of the industry. Thus, there is an acceptance that there is a sampling ethic within the community's moral code despite the fact that some forum members suggest that such an ethic is neither widely adhered to within the forum nor effective in routing revenue back to the artists.

Doing their bit (torrent): Sharing in the community

Moving on from how these communities are imagined and policed, the following section asks what shapes and drives the distribution process within informal distribution networks. Previous research on online piracy has often focused on why people *download* files from the Internet rather than asking why they might *share* those files with others.[10] In doing so, such studies have provided a description of informal online distribution that presumes selfish rather than altruistic motivations. That is not to say that I wish to present a rose-tinted perspective where those 'sharing' files are perceived as working for the greater good, rather I draw on the work of Giesler and Pohlmann to propose a 'participation' model of motivation, where motivations are neither purely altruistic nor selfish, but rather involve a wish to participate in, and contribute to, a 'community' (2003, p. 273). Second, while the motivation to 'share' might have been overlooked, filesharing is not a standardised activity with everyone uploading and downloading in equal measure. I therefore argue that the distribution process on the forums in question is collaborative and community-based, with a range of individuals contributing in a variety of ways. That being said, those I have specifically

identified as the online distributors in this context do more than simply share files that already exist within their network(s), they actively select and acquire films for release and in doing so they increase the catalogue of titles available within their community.

The online distribution cycle

Online distributors go far beyond just sharing the movies in their virtual collections: they dedicate a large part of their spare time, money and expertise to their community endeavours. Indeed, informal online distribution of *films* is not the same as most online informal music dissemination. It is not as easy as putting a CD in a computer, selecting 'convert to MP3', and then choosing to share the right folder on your hard drive. The process of making films available online and then disseminating them is far from straightforward and is a collaborative effort on the part of the entire community[11].

In the *CP* and *EL* forums, the online distribution process does not involve the online distributors alone, but also requires the input of some key community members and the wider forum community to contribute to some important parts of the distribution process. Facilitated by such contributions, the film then embarks on a cyclical distribution journey. From being located, then ripped and encoded by the online distributors, subtitled and finally shared by key community members, the community at large then reviews the release. Even following this process, the film may then be revised by the same (or another) autonomous online distributor before it then re-enters the distribution cycle (see Figure 6.2).

What this distribution cycle illustrates is that the process of distribution involves contributions from a range of community members. Thus, the sharing of files within such contexts cannot be considered a standard activity because contribution levels vary across the community. While those I have dubbed the online distributors are responsible for the selection of *which* films to release, they require other key community members to help them share and subtitle each release. Even those who are not involved in the sourcing, encoding and subtitling stages will still contribute to the wider process by both sharing and reviewing the release.

Before locating and distributing a film, distributors on *EL* or *CP* need to decide which film to acquire. In many ways, what influences the individual films selected for release is inextricably linked with why online distributors choose to share films in the first place: availability and quality. However, in some respects, the selection process is at once both more

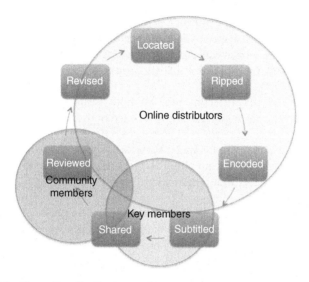

Figure 6.2 The online distribution cycle

subjective and in many ways more practical. Issues of quality and avail-ability are combined with practical concerns over what other people in the community are releasing or requesting and the personal preference of the releaser.

Starting with the practical considerations, it is clear even at this stage that the community plays a key role in shaping the acquisition process. First, online distributors tend to pay considerable attention to what others are releasing before choosing to distribute a particular film. This is because it is perfectly possible for two distributors to be working on the same release at exactly the same time. It is time consuming to encode a movie, so there is no point in two members of a community work-ing on the same release simultaneously. The community is not highly organised, but if someone is planning to create a release, they post on the forum what they intend to encode so others will not duplicate their efforts.

As Naxx points out when referring to the *EL* forum:

> We are a small community... so it really makes no sense to compete if you are going to release something with similar specifications. (2008)

As such, it is clear that at this stage of the distribution process the autonomous distributors are careful to work in collaboration rather than

in competition with one another. This is in stark contrast to the Scene, where specific release groups will often compete with one another for prominence and so several different versions of a film will be released simultaneously by a number of disconnected groups (p2p vs Scene Explained, 2009).

Another way that the community shapes acquisition decisions on a practical level is through request threads. On both *EL* and *CP*, sometimes films will be released because other members have requested them. More commonly, a film might be made available as a response to more general discussions on either forum about the lack of a quality release of a certain title, or the fact that a particular distribution company is releasing a newer version.

As well as these community-based considerations, personal preference plays a strong role in decision-making and distributors often chose to release films that they particularly enjoy. Some would pride themselves on providing the best 'quality' release of all of their favourite director's films. For instance, Jo, an autonomous distributor on both *EL* and *CP*, first chose to share the films of Wong Kar Wai because he was a 'big fan' (Jo, 2007). However, along with personal preference, the issue of whether the film would be ordinarily accessible to community members was also key in shaping the acquisition process.

Many of the films shared on the *CP* forum are originally sourced from bought DVDs, whereas on *EL* it is a specific requirement that only uncompressed DVDs and Blu-rays are shared. Before purchasing the original DVD, each distributor would conduct some research into the best version of a film available before purchasing it (Jo, 2007). For example, Jo would look at various DVD comparison sites before judging the best-quality release worldwide. The respondent would then purchase this particular release in order to share it. He commented that:

> The R4 (my DVD zone here in Argentina) versions of In The Mood For Love and 2046 are terrible. I bought the Criterion version of In The Mood For Love and the Korean version of 2046. 2046: the movie was released as DVD9 (DVD of aprox 9GB), but the R4 versions of 2046 was compressed and butchered into a DVD5 (aprox 5GB). there are some compression artifacts, blurred colors. When I bought them, these were the best versions available. and the spanish subtitles are not even good. so i bought the korean DVD. it comes with english subs which is fine by me.

(Jo, 2007)

As we can see from Jo's comments, quality was paramount for this distributor, but so was the issue of availability. As the best-quality release was invariably not the Region 4 release, he would quite often source a copy subtitled into English and then produce his own fansubs in his native language. His primary motivation for choosing a film was that he had enjoyed it, but that he knew it was difficult to obtain in Region 4. Thus, he would seek the 'best' release so as to be able to share it with people who might otherwise never have access to it.

Indeed, particularly on the *EL* forum, many of the DVDs used as 'originals' would not be available through traditional channels to the majority of community members. Many of the films will only be available in their country of origin. As such, unless the fan has the requisite language skills, then the film would be inaccessible. If the film is particularly rare, then downloads on the *CP* forum might be sourced from a VHS or recorded from television.[12] In such a case, the same language issues generally apply. In many cases, the process of acquisition can be somewhat laborious, although not always. Sometimes the online distributor may have gone to some effort to locate a film in order to share it within the community (Sollam, Park Chan-Wook Back-Catalogue Thread, 2009). That copy might be a rare (and often expensive) import and often the distributor will have spent a considerable amount of time and effort locating a good-quality version of the film. Therefore, the issue of whether films had been released in certain territories and thus would be inaccessible to the community through legitimate channels also served to shape acquisition decisions.

After the 'preferred' version of the film has been acquired, the film needs to be ripped and re-encoded into a format suitable for uploading and downloading by community members. As mentioned before, on *EL*, only uncompressed DVD or Blu-ray rips are permitted. On *CP*, the film will normally be compressed to a smaller file size in preparation for sharing on the forum (Naxx, 2008). The process of encoding the DVD into a compressed format for download may be time consuming, but it is not as complicated as recording from television or transferring from VHS. As such, this part of the process was generally completed by lone distributors and did not require the collaboration of other members of the community.

Possibly the most significant contribution that is made by community members to the overall distribution process is the provision of fansubs. As mentioned before, the films shared on the forums will often not have received a release outside of their country of origin and so will not have

any official subtitles in foreign languages. Then the role of the online distributor gives way to key community members who have the appropriate language and technological skills required to provide fansubs for each film. In the context of the *EL* and *CP* forums, the work of fansubbers is of utmost importance. Without the work of the forum fansubbers, the majority of forum members would never be able to understand the films released within their community. Although they do not necessarily select the films to distribute, the fansubbers play a key role in making the films accessible to the rest of the forum and thus are prominent members of the community.

In addition to the fansubbing process, the film needs to go through an initial sharing phase between key forum members before being released into the community at large. In order for community members to download the films quickly, the files need to be shared between specific members (who have high bandwidth) first. In the strictest definition of the term, filesharing requires peers to be both uploading and downloading for files to be disseminated quickly and successfully, and so each community member plays a vital role in the distribution process by hosting files on their computer. Such a fact might lead one to suggest that any member of a filesharing network is automatically a distributor. However, it is not necessarily the case that each peer will seed as much as they leech. Thus, it would be incorrect to assert that all filesharers are consumers and distributors in equal measure. Although hosting files is an important part of the process, this alone does not make each peer a distributor. As can be seen from the discussion above, the process of distribution is complex and involves a variety of contributions at varying stages and to varying degrees. However, while each community member's contribution should be understood as an important part of the process, I have reserved the use of the term 'online distributor' to refer to someone who originally selects and acquires the film for release within the community and, as such, the general forum members would not come under this label.

After its initial release, the film will begin a process of review, and this is where the wider community will start to take a more active and influential role. Notably, often the focus of the review is not the film itself but the quality of the release.[13] This might be the quality of the work of the online distributors, the fansubber or the original DVD transfer. Indeed, specific distributors or fansubbers will often develop a reputation within the community for producing work of a certain type. For instance, within the *CP* forum, Burble releases mainly martial arts films, whereas Mibit focuses on anime (Movie List, n.d.). On the *EL*

forum, Jo is particularly concerned with the films of Wong Kar Wai, Jufoy concentrates on anime, and Lopis only releases films from Japan (Release List, n.d.).

As well as having their own area of expertise, the distributors will develop a reputation for producing work of a particular standard or quality. This is similar to Rayna Denison's observations that fansubbing groups develop subcultural brand-like capital through the production of subtitles (2011, pp. 8–9). Although not operating in groups, the online distributors develop a reputation for producing work of a certain standard, and are thanked and respected for their contribution to the wider aims of the community (Thanks Discussion, 2004). However, the significance of the reviewing stage of the distribution process goes beyond developing the subcultural capital of the distributor and drives the next stage of the process: revision.

After the review process, the 'release' will often then be revised. If there are considered to be issues with the existing version, then the original uploader or another community member will often produce an alternative version of the release (Naxx, 2008). This might fix problems with the sound quality or the audio/video/subtitle synchronisation, or it might even be a new version of the film. The new release might be from another distribution company, another country, a longer cut or a different edition. This will then go through the same recommendation and review process, thus creating a situation where multiple versions of the same film are often simultaneously available for download within the forums.

The existence of multiple versions of the same film on the forums calls into question one of the common arguments raised in relation to the difference between movie piracy and other types of piracy: that films are a single-use item, whereas software (and music) are used again and again (Wang, 2005). This argument does not hold up to scrutiny when we examine the manner in which individuals on these forums engage with the films that they watch. The films are not only watched multiple times, but multiple *versions* of each film are watched multiple times. In fact, each different version of the film is considered as distinct, and is examined and reviewed in terms of its relationship to all of the others (*Fearless* Release Thread, 2006).

For instance, the first version of any film that is available on the forum might not necessarily be considered to be the 'superior' version. Initially, there may be no fansubs available and so members will have to weigh up their wish to watch the film as soon as possible with whether their enjoyment will be diminished if they cannot understand the dialogue

(*Fearless* Release Thread, 2006). This forms a major part of discussions on the forums. Often people will watch films without subtitles but then discuss at length about how they wish to watch the film with fansubs (Burble, *Fearless* Release Thread, 2006). Some users will also then watch the film when English subtitles are available (English being the dominant language on the forum), but before fansubs are available in their own languages (Helo, *Fearless* Release Thread, 2006). Even when fansubs are available, there will then often be some discussion about whether this particular version of the film is the best. In this case, the film will often have been released in a variety of countries. In each location, a slightly different cut of the film will have been made available (due to local censorship arrangements).

What this discussion of the distribution cycle shows is that the process of distribution is far from straightforward and involves contributions from a wide range of individuals and groups within the wider community. Thus, the process of preparing a film for release is not an individual effort. The distribution cycle demonstrates how autonomous distributors, key community members (especially fansubbers) and the population at large all contribute to a greater or lesser extent throughout the life of the online distribution process. Therefore, filesharing in these contexts is a distinctly social activity.

Pirates, piracy and gift economies

The complex community interactions described in the previous section would seem to contradict the claims of organisations like the MPAA who suggest that one of the major reasons why people illegally download movies via the Internet is because they are free (Timms, 2004). However, while my findings point towards the fact that there is more to informal online distribution practices than simply obtaining something for nothing, it cannot be denied that price is an influential factor in motivating people to download files illegally from the Internet (Cenite et al., 2009; Sandulli and Martin-Barbero, 2007). In fact, being unable to afford certain items at the price at which they are sold legally can be influential in encouraging individuals to seek what they desire through illegitimate means. Francesco Sandulli and Samuel Martin-Barbero suggest that there is some evidence that the current pricing of online music retailers deters individuals from making the leap from illegal to legal downloads (2007, p. 74).

As such, I would echo Condry's argument that we must 'unpack the overly simplistic image that people are sharing (in his example, music) "just to get something for free"' (2004, p. 345). In reference to informal online music distribution, Condry points out that our interest in

obtaining music may have as much to do with the relationship we have with other human beings as with the relationship that we have with music. For instance, Giesler and Pohlmann's work on Napster acknowledges that people sharing files in this manner might have either agonistic or altruistic motivations. Thus, they avoid the construction of informal online distribution practices as *intrinsically* selfish acts (Giesler and Pohlmann, 2003, p. 276). Leading on from this, the work of Cenite et al. on filesharers in Singapore found that individuals would engage in filesharing for a number of reasons: to avoid the long wait they would have before cultural imports would make their way to Singapore; to circumvent censorship restrictions; as a method of sampling; to find rare or obscure material; or simply because 'downloading is convenient and free' (Cenite et al., 2009, p. 206). Thus, while acknowledging that cost may be a motivating factor, Cenite et al.'s study also emphasises how community and availability can also shape the behaviour of filesharers.

Giesler and Pohlmann have attempted to classify the motivations of filesharers and in doing so have developed the following categorisations: 'realisation', 'participation', 'purification' and 'renovation' (2003, p. 273). According to them, filesharers motivated by 'realisation' are concerned with the act of consumption itself whereas their 'participation' model describes those who are more concerned with community rather than the act of consumption itself. A 'purification' motivation refers to individuals who use downloading as a method of escaping mainstream consumption, whereas those who are concerned with 'renovation' see downloading as a means to subvert and challenge the corporately controlled creative industries. Without wishing to reduce the activities on either forum to one single motivational model, it would seem that *participation* in the community is of particular significance within both forums.

While *realisation* also appears to be an important motivation, this is primarily in instrumental terms (aiding one's ultimate contribution to the community), rather than in the autotelic terms that Giesler and Pohlmann propose.

Within this broader 'participation model', while the main motivation might be participation, we cannot view this in purely agonistic or altruistic terms. Community members show a strong motivation to share with the community, but they are also concerned with *displaying* their generosity and skill, and receiving recognition for their pains. So, the aim of the distributor may be to assist the community by providing copies of previously inaccessible films but they in turn benefit, as this act of generosity improves their own standing within the community.

Through this model of 'participation' we can see other motivational factors emerge that are framed within the larger participatory model. The lack of legal, affordable or quality releases of certain films in certain territories or languages was a major motivational factor for the distributors within the *CP* and *EL* forums. However, it was whether films were available to the community at large that concerned them, rather than whether they as individuals could get hold of such films. As such, the distributors were primarily motivated by a wish to make East Asian cinema more accessible to their community, and cost, quality and poor distribution were considered significant barriers for fans that could be overcome by methods of online informal distribution. However, rather than acting as a means of 'renovation' or 'purification' for fans who wish to provide an alternative method of distribution, overcoming these barriers was a way of securing one's position within the community rather than subverting the industry.

In the case of the *EL* and *CP* forums, the fact that many films were simply not officially distributed in many territories were seen by some online distributors as important incentives to seek, and also distribute, films through alternative means. As one interviewee commented 'I got into filesharing because I couldn't get hold of the Asian films I wanted because of poor distribution or extreme prices' (Sills, 2009). It has been suggested by Lawrence Lessig that many of the files that are shared through p2p networks are no longer available through legitimate channels (2004, p. 113). Indeed, in examining how piracy enables access to cultural goods for individuals across Eastern Europe, Asia, Africa and Latin America, Tristan Mattleart also suggests that people turn to piracy because they are looking for an alternative to what is commercially available (2009, p. 316). Mattelart makes the argument that underground digital networks allow high-speed access to Western cultural goods to those in developing countries and that the importance of such access cannot be underestimated. It has further been suggested that accessing pirated materials allows the less affluent to feel as if they can in some way participate in a global culture or 'information society' from which they are so often excluded (Newman, 2012, p. 468; Ramasoota, 2003 cited in Mattelart, 2009, p. 319). Thus, Mattelart's analysis points towards a more sophisticated understanding of informal methods of film distribution, which recognises that obtaining pirated material is not only about avoiding cost but also about participating in a wider cultural sphere. However, it is nonetheless important to scrutinise the claim that the particular films available on the forums discussed here would be ordinarily unavailable through legitimate channels.

Up until 2008, the UK had two distributors with specific lines dedicated to Asian cinema (Tartan and Optimum) and a further selection of niche distributors who carried a selection of East Asian films (BFI, ICA, Eureka and Momentum). In addition, an English speaker from the UK would also have access to the further variety of East Asian films that are released in the US (where there is a larger market) and Hong Kong (where many films are given English subtitles). Yet Sills claimed that access to Asian cinema was difficult due to 'poor distribution' (Sills, 2009). As such, his/her claim appears, at first, difficult to support. It would thus seem reasonable to assume that finding films online might simply be more straightforward or cheaper than seeking out an English-language copy from Hong Kong or the US. However, it must be taken into consideration that, simply because there is an English or Hong Kong release, does not mean that this will be accessible to someone in the UK because of the region coding to which DVD releases are subjected.

According to J.D. Lasica, in 1996, 'like Allied powers carving up Europe and the Middle East as spoils of war, Hollywood moguls ... carved the world into six regions' (2005, p. 23). This action was taken to protect the existing system of sequential global release dates for films. Therefore, in terms of DVD sales, the world is split into Region 1 (Canada and the US), Region 2 (Europe, Japan, the Middle East and South Africa), Region 3 (South East Asia), Region 4 (Australia and South America), Region 5 (Africa, Russia and the Rest of Asia) and Region 6 (China). Thus, a DVD purchased from the US would not (at the time this research was conducted) usually play on a DVD player purchased in the UK.[14] That is, unless the purchaser is somewhat technically savvy, in which case there is often a way of removing region locking from a DVD player by entering a simple code. Various websites exist where a user can simply enter in the make and model of their DVD player and receive instructions on how to change the region settings on their machine.[15]

However, simply removing the region locking from a DVD player does not mean one can easily play a disc from another country. This is because there are also two technical standards for televisions:[16] PAL (25 frames per second) and NTSC (30 frames per second). The US, Canada, Korea, Japan and some South American countries use NTSC, while most of Europe, Africa, the Middle East and the Far East use PAL. If a person from the UK buys a Region 1 disc from the US, even if they have a DVD player that will play all region discs, the picture might not be correct if the disc is meant to play on an NTSC standard television. Buying a television that can handle NTSC as well as PAL is not difficult, and

obtaining a code to remove region locking from your DVD player would not take much searching online, but the presence of these obstacles in the way of fans of East Asian cinema frustrates their ability to legally purchase a DVD from another territory and watch it in a straightforward manner. Thus, there are many technological strategies designed to discourage individuals from buying import copies of movies, and this might make non-region-controlled pirate copies an even more attractive option (Sinha et al., 2010, p. 41).

Therefore, let us further examine Sills' claim that there is 'poor distribution' of the specific types of films that he/she wants to see. This respondent is from the UK and a member of four separate filesharing forums dedicated to East Asian cinema (Sills, 2009). The films available on each forum vary. However, if we are to assume that the respondent is interested in the types of films released on these various forums, then it is reasonable for him/her to suggest that the films he/she wishes to watch are unavailable because the majority of East Asian films are never released in the UK. For instance, in 2007, 407 Japanese films were released domestically (Statistics of Film Industry in Japan, 2000–2014, n.d.), while in the same year only two Japanese films received theatrical distribution in the UK (Research and Statistics Bulletin, 2007).

Furthermore, while both of the websites requested that all forum posts be in English, the forum members appeared to be from a range of countries around the globe. As English was the primary method of communication, the discussions tended to focus around releases of films in English-speaking countries, specifically the UK, the US and Australia. Although the membership was international, many discussions about DVD companies and expected release dates for specific films showed a distinct bias towards UK-based information.

However, what this decidedly international membership served to illuminate was how availability was arguably of even greater concern for individuals for whom English was not their first language, and so who did not even entertain the hope of importing films with English subtitles from the US or Hong Kong. This was illustrated by Jo from South America who described the process of sharing his first film as an online distributor: Wong Kar Wai's *Days of Being Wild* (1991). The respondent explained why he chose that particular film as his first release:

Jo: first i am a BIG fan of wong kar wai. i discovered him through P2P. emule to be more specific and after seeing a couple of his movies i bought all of them.

Interviewer: Are his film's readily available where you are?

Jo: Of all his movies, i think Days of Being Wild was the movie with
the worst releases. nope, none are available. no, i think In The Mood
For Love and 2046 are available.[17]

It is interesting to note that Jo claims to have discovered the films of
Wong Kar Wai thorough peer-to-peer download software. Indeed, the
fact that individuals have been introduced to films on the forums and
have subsequently bought official copies is often mentioned in support
of the aforementioned 'sampling ethic' and is often raised in defence of
the forum's activities. However, this perceived obligation to sample does
also raise the contradiction present in the combination of the sampling
and availability arguments raised on the forums. Although members
suggest that sharing should be predominantly used as a form of sam-
pling, they are also quick to bemoan the fact that official copies are often
not available. This poses an interesting question: how are the member-
ship at large expected to use sharing as a form of sampling if the majority
of the films they would wish to locate are not actually available to them
through legal channels?

To take Jo as an example: heralding from South America, the DVDs
that would have been commercially available to Jo would have been
Region 4. Wong Kar Wai is one of the most famous directors to come out
of Hong Kong and his films have received international critical acclaim,
but the majority his films were not released in Region 4 at the time
this individual started to share Wong's films online.[18] This distributor
suggested a justification for his actions on the basis that the films he
was sharing were not widely available within his region. Furthermore,
he suggested that he was fortunate because, as an English speaker, he
was able to source imports from abroad with English subtitles, whereas
many other individuals within his region would not have this option
available to them.

This highlights a related issue, that of the availability of a release
in the appropriate language. There are a number of ardent fans on
forums who take great pains to learn one or more of the languages
of East Asia in order to enjoy the object of their fascination without
being reliant on the accuracy of subtitles or dubbing. Therefore, certain
individuals might be able to purchase films directly from their coun-
try of origin and would have no need for an official release in their
first language. Furthermore, there is a reasonably large market for East
Asian cinema in the US, and (as mentioned earlier) many films from
Hong Kong come with English subtitles. Thus, for individuals who
can speak English as a second language, there is also the option of

sourcing an English language version of certain films. However, there was recognition amongst respondents that not all Asian cinema fans can necessarily speak English, let alone Japanese, Korean, Cantonese or other East Asian languages.

Ancient, an intermediate distributor on the *CP* forum, commented:

> I like to share my love for Asian movies. Online and offline. For example my father in law likes Asian cinema a lot but he can't read English. So he enjoys Asian movies with 'fansubs', and, while i am at it, I can share the effort with many people online. (2009)

Fansubs themselves are not circulated on either the *EL* or *CP* forums. Generally, links to other websites that specialise in fansubs are posted by individuals to accompany their releases or by other helpful forum members. There is often more than one set of fansubs available for each release and consequently there is often some discussion about the preferred fansubs for a particular release and which fansubbers are known for their quality.

Another factor that contributes to a distributors' choice to share films within the community is a concern for the quality of existing releases, formal and informal. The fact that the official version available in their territory was perceived to be of inferior quality was given particular preference by one respondent, but was mentioned by all participants and frequently discussed on both forums. An example was the release of Wong Kar Wai's *Days of Being Wild* (1991). As an ardent Wong Kar Wai fan, Jo noted a particular problem with the release:

> Cristopher Doyle (sic), Wong Kar-Wai's cinematographer gave the whole movie a greenish tone. the people releasing the DVDs thought it was an error and 'corrected' it. so most edition don't stay true to Christpher Doyle's (sic) vision. (2007)

Jo considered this a serious issue. He had taken great pains to try and track down a copy of the movie that had not been 'corrected'. This was both for himself and so he could share this edition online. It was considered of utmost importance that the film was experienced as the director and cinematographer had meant it to be seen, and so Jo saw it as his duty to share a copy of the movie that was of optimum quality. Such attention to detail was one of the reasons that this particular individual was held in high regard across both forums.

The forum members' concern with quality might indicate something about the particular *type* of online distributors that this study is examining. These respondents are more than casual moviegoers. They are fans, aficionados and highly concerned with quality and 'authenticity' in their movie consumption. Furthermore, a concern with quality acts as currency within the community because, by producing high-quality releases, an individual distributor can raise their standing within the community.

However, it should be noted that, as it is within gift communities, sharing films within *CP* and/or *EL* is not only motivated by benevolence and a belief in reciprocity, but is also driven by the sharer's wish to *display* their expertise and skill (Castells, 2002, p. 47). In this case, the primary manner in which individuals demonstrate their expertise is through producing and distributing quality releases of East Asian films. Indeed, gaining respect and praise for distributing requested or quality releases is a very important factor for online distributors within both communities. If a distributor posts a link to a movie, then other members post thanks and reviews of the release. One distributor stated that getting thanks from other users for quality releases was 'part of the fun!:)' (Sills, 2009). Also, there are discussions within the forums as to the proper etiquette involved in providing thanks to the online distributor once a film has been 'released' (Thanks Discussion, 2004).

Distributors are ultimately driven to share by a wish to participate in the community, but an important part of that motivation involves being *seen* to participate by other forum members. One manifestation of this was forum threads where members boasted about their film libraries. Indeed, many of the forum members had extensive DVD collections and ownership of such impressive libraries elicited respect within the community. In fact, a thread was started by Gouy on the *EL* forum so that members could post pictures of their DVD collections as evidence of their commitment to their fandom (DVD Collections Thread, 2009). Accompanying these images were annotations giving titles of films with an indication of their rarity. Indeed, discussions around the cost of DVDs were not generally used as a justification for illegal downloading or distributing activities, but often concerned the 'disapproval' that the members had to endure from their respective partners about the amount of money that they spent on their passion for rare import DVDs (*Tai Chi Master* Thread, 2005). Indeed, the distributors did not complain about the cost of DVDs but would actually boast about the financial outlay required to keep up with their fandom when the East Asian films that

were released on DVD were invariable quite expensive (*Tai Chi Master* Thread, 2005).

For instance, the average price of a DVD in the UK was just under £10 in 2007 (Allen, 2007), whereas import DVDs can be considerably more expensive. It is the rarity of these films, and the fact that they are imported from other territories, that can contribute to the generally high prices of such films. For instance, Jo mentioned that he hoped to buy Wong Kar Wai's *Happy Together* (1997) soon but that the only edition that he believed worthy of purchase was priced at US$182.99. Even though the respondent found this price expensive, he did indicate that it merely *delayed* his purchase of the DVD rather than discouraging it altogether (Jo, 2007). Similarly, Kolo (2009) mentioned the prohibitive expense of buying foreign import DVDs, but did not cite this as a reason to download films rather than pay for them.

Thus, while cost was obviously a consideration for forum members, this was only in relation to how it enabled them to boast about how much money they had spent on their DVD collections. As such, considerations of the price of DVDs were not generally of importance to individuals, but only gained significance when forum members could use the high price of DVDs as a method of quantifying and displaying their dedication to their fandom within their community. So, although participation can be seen as a significant motivation for online distribution, a drive to share rare films within the community cannot be viewed as a purely altruistic act. This is because being an online distributor attracts respect within the community in recognition of the time, cost and effort that is required to distribute films online.

Conclusion

This chapter has shown that the informal dissemination of movie files may be routed through a social hub that may to a greater or lesser extent provide (or even prescribe) a certain level of community interaction in order to access the files the user desires. On the *CP* and *EL* forums, interaction is imagined in different ways, but both communities are 'imagined' as bound by a shared set of codes and conventions. Beyond Anderson's claim that to a certain extent 'imagination' is a prerequisite to any community, these particular communities imagine themselves through reference to the idea that they are bound by explicit and implicit goals and ethical codes. That is, their activities should be exclusively non-profit, used as a method of sampling rather than as a replacement for commercial products, and underpinned by an ethos of

reciprocity. It is through the belief in a shared ethical code that the communities are able to imagine their boundaries, but it is also through the same process that they are able to extend themselves beyond their 'gated' online existence and see themselves as sharing goals and aims with the industry as well as each other.

However, it must be acknowledged that a few key individuals are able to exert a considerable influence on the way these communities are imagined and structured by presenting their own actions, opinions and beliefs as somehow representative of the wider community. It is their ability to dictate the structure of the forums that gives them power within the communities and allows them to maintain their dominant position. By privileging their own patterns of behaviour as the markers of 'true' community participation they effectively create a self-perpetuating cycle whereby, as they accumulate more symbolic capital through their normal practices, they attain yet more power to suggest that such patterns of behaviour represent the only route to community status. This in turn cements the idea that the current forum structure, with all its associated hierarchies, represents the forum in its 'true' and 'proper' state.

Furthermore, examining the distribution cycle within these forums reveals that there is an important collaborative and community aspect to online distribution. It shows that the films themselves are not the primary focus, but act as the facilitator to community participation. Therefore, online informal distribution can be a complex process that is facilitated by a range of individuals who contribute at various stages of the process and to lesser and greater degrees. As such, we must acknowledge that not all practices of informal dissemination are equal and that, in this context at least, the act of sharing films online is a complex and community-based process. Thus, as Marshall attests, we should not look at filesharing as 'an *economic* activity when it is actually a *social* one' (2004, p. 195).

7
Intersections: Pirates Meet Professionals

While this book has previously considered the activities of formal and informal distributors in a number of discrete chapters, it is my central contention that we must examine the activities of these disseminators as inextricably intertwined and interdependent. As such, this chapter draws from the examples of formal and informal distribution practices examined within the preceding chapters to consider the interconnections and intersections between such activities. Such an approach reveals that despite 'common sense' perceptions inflamed by the anti-piracy rhetoric, the 'pirates' and 'professionals' from this book's title are not as opposed as one might presume. Approaching informal and formal distribution from the theoretical position that these varying practices should be perceived as intertwined rather than oppositional, this chapter proposes the metaphor of 'symbiosis' to understand the relationship between the differing types of formal and informal distribution under consideration here.

Interconnected circuits of distribution

This book has hitherto made some arbitrary, but necessary, distinctions between different forms of film distribution. This may have resulted in the impression that this book proposes that these practices do not intersect or interact. However, such a proposition is very far from my intention and these separations have been made in order to illustrate the startlingly diverse forms of informal and formal film distribution that exist. So, having disaggregated these practices in order to illustrate heterogeneity, this chapter will now turn to the many interrelations between formal and informal processes of film distribution and, in doing so, will illustrate how the boundaries between these categorisations are

far from clear. In order to do this, I shall turn to the work of Ramon Lobato, who notes the current bias within existing studies of film distribution towards examining the formal sides of such practices. As Lobato suggests:

> A great deal of research has operated with a fairly narrow view of the nature, boundaries and scale of the film economy. Within this script, film distribution is seen as a set of transactions between formal businesses – major studios, theater chains, broadcasters, sales agents – and changes to distribution process are typically understood through a discourse of crisis and disruption. This definition fails to capture many of the informal circulatory systems…which facilitate movie viewing for hundreds of millions of people every day. If we take such phenomena seriously and move them to the center of our analytical frame, we are left with a rather different image of what the film business is all about.
>
> (2012, p. 86)

In making this claim, Lobato highlights that we do not yet have the right 'analytical language for talking about informal distribution' (2012, p. 86). Indeed, he points out that in different contexts the film industry is discussed in a variety of ways; with a focus on policy in Europe and countries like Canada and Australia, while Hollywood tends to be discussed from a political economy perspective (Lobato, 2012, p. 86). I would further agree with Lobato that such an approach (one that positions power squarely with the formal side of the film industry) implies that there is an antagonistic relationship being enacted between the industry and the 'pirates'. However, if we consider the example of the Russian film industry, it becomes apparent that the boundaries between the formal and informal sites of film dissemination are far from straightforward (Lobato, 2012, p. 88). With such an example in mind, Lobato posits, how do we then consider the informal and formal in conjunction?

According to Lobato, the solution comes in developing new tools that allow us to examine film piracy as a part of an interconnected film economy rather than as a separate phenomenon that should be perceived as either at odds with or revolutionising the 'real' film economy. To do this he suggests that we should take a lead from economic anthropology, where it is acknowledged that 'economies are not simply bounded and pre-existing phenomena but also products of the particular modes of analysis through which we approach them' (Lobato, 2012, pp. 88–89).

In the case of the film industry, this particularly relates to how the specific systems of measurement that are commonly used (for example, box office receipts) shape our conceptions of the construction of the global film industry. Here, Lobato gives the example of which nation has the largest film industry and claims that, 'if our yardstick is formal industry capitalisation, then the answer would undoubtedly be the United States. If we go by the number of feature films produced annually, then Nigeria and India shoot to the top of the rankings' (2012, p. 89). He further suggests that the picture becomes even more confused if we ask a question like: 'How many jobs does the film industry generate?' In response to this question, he asserts, the focus is overwhelmingly on film production. Thus,

> The general picture that emerges from these accounts is of a production-driven locomotive pulling the rest of the film industry along behind it, dispersing money like a clown handing out candy at a child's birthday party. If we extend this logic and think about the generativity of distribution, a wider set of transactions and activities come into view. Finally, when we factor in distribution via informal channels it becomes clear that there are many more jobs connected to the circulation and distribution of movies that have never been counted in industry surveys.
>
> (Lobato, 2012, p. 89)

For this reason, Lobato turns to the work of J. K. Gibson-Graham, the cultural geographers Katherine Gibson and Julie Graham, and their theory of 'diverse economies'. That is, the idea there is not one 'real' economy but a reality that consists of an 'ecology of differentiated *economies*' (original emphasis; Lobato, 2012, p. 92). This theoretical perspective allows the capitalist economic system to be de-throned from its position as the 'real' and 'natural' form of economy, and allows for an analysis of economy that recognises 'not only corporations, companies and other institutions of capitalist enterprise but also a much wider array of economic formations, including community and household systems, barter, gift exchange and unpaid domestic labor' (Lobato, 2012, p. 91). In making these suggestions, Lobato also acknowledges that this theory in turn owes a debt to the work of Karl Polyani who had previously argued that there is no single entity that we should call 'the economy' because it is actually made up of many coexisting and intertwined systems. Thus, from the work of both Gibson-Graham and Polyani we must think of *economies* rather than of a singular economy.

Furthermore, in an extension of this argument, Lobato suggests there is also no 'one' *film* economy 'but a diverse series of overlapping and co-constitutive economies each comprised of different processes, transactions, currencies, materials, norms, values, and forms of labor' (2012, p. 91).

Taking a lead from Lobato's work, I would suggest these informal film economies (online filesharing, bootleg DVD sales and so on) are often judged to be problematic depending on the extent to which their actions might be *perceived* as having parasitic, promotional or instrumental effects. Within this framework, 'parasitic' effects can be judged in relation to the extent to which the piratical practices use the same distribution routes as formal products but do not route profits back to the intellectual property holder (for example, Nollywood). The potential 'promotional' effects of piracy are widely discussed and covered in detail in Chapter 4 and broadly linked to the 'sampling argument' referred to there. This argument contests that certain forms of piracy might allow people to 'try before they buy' and thus ultimately lead pirates to become future purchasers. 'Instrumental' effects, on the other hand, refers to the idea that certain forms of piracy will ultimately open up markets in new territories and thus are instrumental in paving the way for legitimate markets to develop.

In making such distinctions, I do not wish to provide further labels for particular acts of piracy based on *actual* effects. In contrast, I have provided such divisions so as to illustrate the extent to which certain forms of piracy are *perceived* to have certain effects; perceptions that are then used to judge their potential economic 'threat' to the media industries. Thus within such a framework, if certain copyright infringing practices are perceived to offer the potential to ultimately lead to legitimate business opportunities, then they are often discussed as though these ends (opening up new markets) somehow justify the means (piracy). Such a line of reasoning is connected to Tom O'Regan's argument that the 1980s witnessed a shift 'from piracy to sovereignty' within the VCR market, as piracy during this period actually enabled the growth of the VCR industry (O'Regan, 1991). Indeed, a similar argument has been made in relation to piracy of Indian films opening up international markets (Athique, 2008, p. 712) and piracy of Japanese anime in the US paving the way for the formal VHS industry to develop (Leonard, 2005).

While I would not dispute the validity of such arguments, I would suggest that they point to an attempt to justify certain forms of piracy on primarily economic grounds. For example, if we consider

Athique's argument in particular, we can see a focus on the 'utility' and instrumental potential of certain types of piracy:

> Indeed, since the ongoing shift from piracy to sovereignty is likely to remain restricted to a small number of export markets in the short to medium term, piracy may continue to have some utility in sustaining a market presence elsewhere. The longer-term benefits of maintaining a market presence in Pakistan or Indonesia, for example, may well indicate a continuing role for piracy in those areas prior to the emergence of more favourable conditions for the capitalization of intellectual property.
>
> (Athique, 2008, p. 713)

This potential to capitalise upon intellectual property is clearly positioned as *the* route to securing the health and longevity of the Indian film industry. If we refer back to Lobato's observation that European, Australian and Canadian discussions of the film industry tend to focus on policy, then we can see a very different understanding of how the health of any national film industry might be preserved and protected. Such a focus on policy would imply that the state plays a key role in protecting and nurturing national film industries. However, Athique's discussion of piracy in India would suggest that the market is the ultimate decider and that piracy might be seen as a 'necessary evil' that must be endured as long as it increases the audience for Indian films and thus ultimately enables economic reward at some point in time. A concern with such attempts to 'legitimise' certain forms of piracy is that distinctions can then be made between 'good' piracy and 'bad' piracy, and furthermore, such demarcations are made in purely economic terms.

I would argue (as I have done throughout this book) that we need to consider the social context of piracy and not let the economic dominate such discussions; however, in doing so I am not denying that there are economic realities that cannot be ignored. Rather, I would side with Brian Larkin who, when considering piracy in Nigeria, suggests that it is a decidedly 'ambivalent phenomena'; one with both considerable benefits and significant drawbacks for all concerned. On the one hand, piracy has enabled Nigerians to connect to 'the accelerated circuit of global media flows [so that] ... Instead of being marginalized by official distribution networks, Nigerian consumers can now participate in the immediacy of an international consumer culture' (Larkin, 2004, p. 297). On the other hand, there are concerns that piracy has reduced

the possibility for Nigerian musicians and filmmakers to make profits from intellectual property and thus for official industries to develop. So, while the drawbacks are primarily economic, the benefits are decidedly social and cultural. Again, in making this observation I do not seek to defend piracy but rather to highlight the problematic nature of formulating a defence predicated on the idea that the informal (and illegal) may potentially transcend into the formal, and thus legitimise previously maligned activities. Defending certain acts of piracy based on their presumed capacity for transformation again privileges the status quo, prioritises the economic and inadvertently presents a hierarchy of piracy based upon imagined financial consequences.

In the same way that pirates can be seen to be defended based on their entrepreneurial drive to capitalise upon untapped markets, we can also see Hollywood as lambasted for simultaneously failing to capitalise upon the markets opened up by the Internet. We can see such a criticism summed up by the quotation from Finney (also cited in Chapter 3) which suggests that, while it is clear that Internet distribution is the only 'growth area' for the film industry, 'the Studios are not servicing it proficiently to date' (Finney, 2010, p. 124). Such a quotation is exemplary of the popular argument that Hollywood has not sufficiently responded to market demand after the development of the Internet and the growth of online filesharing. The claim being, if only Hollywood could see the potential of online distribution then they would reap big rewards. Within such an argument it is hypothesised that any technological development that is initially seen as a threat by the film industry (for example, home video) must ultimately be understood as a business opportunity.

While such arguments might ostensibly seem a reasonable defence of instances when piracy has facilitated the growth of legitimate markets, we must question the desirability of the same conglomerates ultimately co-opting informal practices and seeking to monetise them for their own ends. While I would not deny that the duplication and circulation of a film owned by, for instance, Paramount Pictures, is certainly illegal under current copyright law and regulations, we should question the mechanisms by which that intellectual property is attributed to such an organisation in the first place and the manner in which they subsequently restrict access to the products which they 'own' in order to maximise their profits. Furthermore, to suggest that 'redemption' for the pirates comes through new business models and that capitalising upon a market when others did not might ultimately 'legitimise' their actions, speaks of a remarkably neoliberal ideology and again

foregrounds economic metrics as the ultimate arbiters of morality and fairness.

Furthermore, in rewarding those 'pirates' who have 'repented' and entered the legitimate side of distribution, the anxieties surrounding the blurred and messy nature of their previous endeavours is further highlighted. As Andersson Schwarz suggests, filesharing is considered an issue for a number of reasons but a significant concern is the way it blurs boundaries between accepted binaries of legal/illegal, producer/consumer and so on. Andersson Schwarz, drawing on Latour suggests that while hybrids are ubiquitous they are problematic because they challenge 'the ways modernity envisages society' and thus 'the hybrid ontology of the world is repeatedly underplayed, hidden from view, and unacknowledged' (Andersson Schwarz, 2013, p. 23). So, for Andersson Schwarz as a decidedly hybrid practice, filesharing challenges the dichotomies that Latour suggests are held as sacred by modernity. Thus, those informal distribution practices that might be understood as 'instrumental' (in the 'transitional' phase before being adopted into the formal industry) or 'promotional' (ultimately leading to legal purchasing) might be tolerated while actions that are considered 'parasitic' are an anathema to the binary thinking that underpins neoliberal modernity.

Thus, this chapter contests that we need to consider the intersections between the formal and informal while also resisting these categories. Although Lobato's categorisations have taken the debate forward because they have questioned the legal/illegal binary, his use of the terms formal/informal might be misunderstood as advocating an alternative yet equally dichotomous approach. Instead he proposes:

> to adopt a *both/and* kind of thinking, in which film distribution is imagined not as a zero-sum game of revenue capture, where pirates cannibalise producer profits, but as a space of economic plurality in which both formal and informal distribution systems interact – sometimes antagonistically, other times to mutual advantage.
>
> (Lobato, 2012, p. 93)

Thus, this chapter draws from Lobato's work and in doing so also adopts Ravi Sundaram's perspective on pirate modernity and denies the necessary opposition between piracy and the formal economy. As Larkin suggests, Sundaram's work points to the 'ambivalence of piracy, refusing the simple equation that piracy is an alternative or oppositional modernity' (Larkin, 2004, p. 298). With this theoretical context in

mind, the following section of this chapter proposes that the concept of symbiosis provides a useful metaphor through which to consider the connections between formal and informal practices of film distribution.

The use of the term 'symbiosis' in such contexts already has a precedent. Wu, in considering piracy in China, refers to Feldbrugge's (1989) work on the symbiosis between the first and second economies in Russian and, in doing so, suggests that a similar symbiotic relationship can be seen in China as well because 'cultural piracy not only supplements and replaces the deficiency of the official apparatus, but also serves as the very base of popular periodicals and cinema book publishing, since the content of these publications mainly concerns pirated films' (Wu, 2012, p. 511).

Overall, the concept of symbiosis is informative because it recognises that organisms (from single cell to complex mammals) are mutually dependent upon one another rather than self-sufficient. Symbiosis, rather than heralding from a natural world which focuses on survival of the fittest, brings to mind a reality where cooperation (rather than competition) allows life to flourish and develop. The term is synonymous with animal relationships and conjures up images of Nile crocodiles and Egyptian plovers living in balanced harmony on natural history programmes. However, beyond such famous relationships, in nature it is the multitude of symbiotic relationships that exist on a bacterial level that allow the global ecosystem to function at all (Hird, 2010, p. 55).

Broadly speaking, a symbiotic relationship is one that takes place between apparently dissimilar organisms. Furthermore, in biological terms, the concept of symbiosis also 'challenges the boundaries of the organism' (Keith Ansell Pearson quoted in Hird, 2010, p. 59), because it allows us to understand a *complex ecosystem of relationships*, rather than a series of distinct species competing with each other for survival in a world of scarce resources. In such a manner, the biological metaphor of 'symbiosis' enables us to see the multiple and heterogeneous practices of film distribution as all part of a complex ecosystem of relationships. Such a concept seeks to challenge the previously dichotomous discussions that have positioned an adversarial contest between 'pirates' and 'professionals' as both natural and inevitable.

Furthermore, while calling into question the distinct nature of those organisms, the term 'symbiosis' is generally used to describe a relationship that may be mutually beneficial but, importantly, does not necessarily indicate a dynamic where power resides equally with both parties. These features of the term 'symbiosis' serve as a reminder that the world is not easily split, demarcated and pigeonholed into

discrete categories. Furthermore, while there may always be a dominant side to the binary, 'revolutionaries, oppressors, pirates or victims, both producers and consumers depend on each other' (Denegri-Knott, 2004, p. 15).

Widening participation: Formal and informal distribution of East Asian film

According to Giesler and Pohlmann, within 'Napster's parasitic economy driven by gift exchange, consumers enrich themselves; they assume the role of host, troublemaker and parasite at the same time' (2003, p. 275). Giesler and Pohlmann suggest such a feature applies to how the community functions internally and also describes Napster's relationship to the wider music industry (2003, p. 275). However, this chapter goes beyond the parasitic gifting community model applied by Giesler and Pohlmann, where 'filesharers' are seen to 'leech' from both the industry and the wider community, and instead proposes that the metaphor of symbiosis is more applicable when examining the relationship between the informal online distribution forums discussed in Chapter 6, *Chinaphiles* and *Eastern Legends*, and the formal distribution companies, Tartan and Third Window Films, examined in Chapter 2. By drawing on Luca Molteni and Andrea Ordanini's principle of socio-network effects (2003) – that is, that the tastes of consumers usually organise themselves in clusters, and so an interest in one product normally encourages consumption of another similar and connected product – I make the argument that the relationship between theses 'pirates' and 'professionals' is inherently interdependent, and that any mutual benefits should be considered in both social and economic terms.

Therefore, an understanding of the relationship between online and offline distribution is developed that perceives the actions of both sets of distributors as potentially aligned rather than opposed. So, rather than perceiving informal online distributors to be parasitic 'pirates' illicitly benefiting from the creations of the cultural industries, we might understand their actions to be part of a complex symbiotic relationship. In order to contextualise the following examination, it is necessary to provide a brief discussion of network effects because this principle underpins the subsequent argument.

(Socio-) network effects

According to network effects (or externalities) 'the utility that a user derives from consumption of a good increases with the number of other

agents consuming the good' (Katz, 2005, p. 35). Thus, in certain circumstances, even if copyright infringement cannibalises profits in the short term, it actually increases the value of the network in the long term. The effect is usually described in relation to software and may work in one of two ways. First, if a user pirates a piece of software, they then form part of the user network and will theoretically be more inclined to purchase the software once they have the disposable income to do so (Reavis, Conner and Rumelt, 1991, p. 125). Thus, piracy potentially 'plays a dominant role in the generation of buyers over the software's life cycle' (Katz, 2005, p. 168). Second, the product's value is directly proportional to the number of users in the network. For example, Microsoft's *Word* software increases in value for both the end user and Microsoft, if more people use it. In many respects, applications like *Word* have become such a standard for all word-processing activities for PC users that people have little choice but to use it. To opt out of using Microsoft *Word* might put the user at a severe disadvantage because any documents produced using alternative software might not be compatible with the documents of others. As such, the major competitors to *Word*, namely Apple's *Pages* and the open source package, *Open Office*, make it possible to save documents created within their software in *Word*'s .doc(x) format. Documents created in *Word*, on the other hand, currently cannot be saved in the formats associated with *Pages* and *Open Office*. Thus, according to the principle of network effects, if individuals around the world download a copy of *Word* illegally and continue to use it without paying, they actually reinforce the overall dominance of *Word* as the word-processing software of choice. This creates an environment where companies across the globe choose (or are effectively left with little choice but) to pay Microsoft for licences to use their software because *Word* has become an industry standard.

It has been argued that software manufacturers are well aware of this phenomenon and actively capitalise on it when developing their approach to piracy (Katz, 2005, p. 192). Ariel Katz suggests 'that the failure to protect software is a conscious business profit-maximizing strategy' (2005, p. 156). Katz argues that having an initial tier of individuals obtaining the product for free is part of an overall strategy to generate a larger and more valuable user network, thus enabling the publisher of the software to become the dominant player in their field (2005, p. 166).

Katz (2005) further argues that strong copyright protection, rather than forcing the user to buy the legal version of the software, actually pushes the user out of the network and into the network of a competitor. If it is possible to protect software and reduce the rate of piracy, a

software publisher's decision not to protect their software is equivalent to a decision to price discriminate and let non-paying users copy the software for free. By doing so, the publisher may achieve the greatest network effects in the shortest time and thus win the race to become the monopoly provider of the software.

However, such discussions only pertain to software piracy and it has been argued that movies are not a network product (Higgins et al., 2007, p. 341). In contrast, Ian Condry argues that, even if music and movies are not network products, 'peer-to-peer systems follow the principles of network economics, which hinge not on supply-side economies of scale, but on demand-side economies of networks' (2004, p. 348). As such, 'the more participants, the more sharing, and the more distributed users and content, the more valuable the network is' (Condry, 2004, p. 348). So, regardless of whether we consider music and movies to be network products or not, it is reasonable to argue that the peer-to-peer networks *are* subject to the principle of network effects regardless of what content they are used to distribute.

However, I would go further than Condry's consideration of the technology of distribution and make the claim that both movies and music can be considered to be network products if one examines the social relations that exist around them. Films and music do not exist in isolation, but are part of wider networks of movie and music fandom, and the proliferation of individual movies and songs has the capacity to raise the value of other products created or circulated by the same artist, band, director, record label, film studio, distribution company or even online distributor. As Gilbert Rodman and Cheyanne Vanderdonckt argue, 'the worth of intellectual property – measured economically, culturally, politically, and/or socially – is often dramatically enhanced by the extent to which it circulates' (2006, p. 248). This is why the music industry wants their products to be played on the radio, on TV programmes and on advertisements: the more people hear the music, the more valuable it becomes. Although the argument seems less straightforward in the case of movies, as they are traditionally considered more of a single-use product, the argument becomes more convincing when taking into account the social context of film viewing and consumption.

As such, Molteni and Ordanini's amended concept of *socio*-network effects is particularly useful when considering film as a network product. Under the socio-network effects model, 'the social dimension of consumption is a further element of complexity and explains how tastes for cultural goods are essentially group-based and built around different clusters or profiles of consumption' (Molteni and Ordanini, 2003,

p. 391). Simply put, this is the idea that, in the absence of an objective marker of quality, people often tend to like what other people like and therefore are easily influenced by what other people think. Therefore, exposure to one film from a particular genre or director might encourage users to consume other films from the same genre or director. Furthermore, one only has to look at the consumption practices surrounding film fandom or the huge business that has built up around licenced merchandising (in the form of film TV-shirts, posters, lunchboxes, stationary sets and the like) to see how films might be perceived as network products.

It is the contention of this chapter that the relationship between practices of informal and formal distributors can be seen as mutually beneficial due to the principle of socio-network effects. This is because, for both the formal and informal distributors discussed in chapters 2 and 6, the level of cultural capital that they each have is tied to the overall profile of East Asian cinema. Thus, each distributor's cultural capital increases with each film they distribute themselves, but it also increases with each release from each other distributor (online and offline), because this raises the profile of East Asian film more generally. Conversely, if East Asian film languishes in obscurity, then being a distributor that deliberately deals in (and is knowledgeable about) that specific type of film does not carry the same cultural cachet. Therefore, I shall suggest that a symbiotic relationship is present if one looks beyond the financial alone and also considers the cultural associations surrounding film and the social motivations behind distributing it.

How the other half distributes

Despite popular representations of media 'pirates' as thieves who are unconcerned about the financial ramifications of their actions on the people who work within the cultural industries, members of both the *EL* and *CP* forums demonstrated considerable amounts of respect for the work of independent distributors. Furthermore, these informal online distributors expressed that they and the formal distributors shared a wider aim to promote East Asian cinema. In addition, rather than being concerned over the devastating effects that informal online distribution might be having on their livelihoods, the reaction of the formal distribution to such behaviour ranged from ignorance to indifference and even to active encouragement.

The fact that members of the *EL* and *CP* communities seem to have a positive attitude towards the film industry at first appears to contradict

the observations of theorists who have looked into music filesharing communities and have found that 'for the younger generation, the image of record labels is far from benign' (Huang, 2003, p. 49). In such studies, there is evidence of a general contempt for the industry and a perception that those in the 'business' are making record profits while the artists struggle. However, the picture within the *EL* and *CP* communities is much more complex because, although the members of both forums demonstrated a wish to actively support the small distributors and the 'struggling artists', they were quite hostile to any aspect of the film industry that they perceived to be primarily driven by commercial concerns. This observation can be demonstrated by analysis of the attitudes of forum members to the *business* of film, of which Hollywood appeared to act as the figurehead.

Within forum discussions, Hollywood was repeatedly represented as concerned only with profit, unnecessarily greedy and bereft of any sort of artistic integrity. The reaction to a *New York Times* article on co-productions between Hollywood and China was illustrative of some of the extreme reactions to Hollywood and the US film business by the forum members (*New York Times* Article Discussion Thread, 2010). One member of the *CP* forum, Mybit, criticised Hollywood for being largely ignorant of the size and power of other film industries, such as Hong Kong and Bollywood (*New York Times* Article Discussion Thread, 2010). Another member of the same forum, Boser, was concerned that any intervention by Hollywood in the Chinese film industry would effectively 'ruin' Chinese film (*New York Times* Article Discussion Thread, 2010). Which prompted another user, Carfort, to express that monetary investment would be fine as long as Hollywood was not able to 'influence' what films were made and how they eventually 'looked' (*New York Times* Article Discussion Thread, 2010). Overall, this discussion illuminated just how profit-driven Hollywood was perceived to be by forum members and the negative connotations they associated with such financial priorities. As such, it would seem that the forum members here made a distinction between the business of film and the 'artists' who work within in, as has been observed in some studies of music filesharing (Coyle et al., 2009; Huang, 2003).

However, this disdain towards Hollywood often contrasted starkly with how the forum members reacted to other (generally smaller) distributors. The reaction towards these niche distributors was more favourable, suggesting that the relationship between the informal online distributors and the industry was not as straightforwardly oppositional as it might at first appear. On the *EL* and *CP* forums there

seemed to be a recognition that specialist distribution is not necessarily a profitable pursuit, and that small distributors are doing a good job in the face of conditions that make the release of certain films in particular territories economically unviable. Indeed, while forum members were hostile towards some aspects of the film 'business', they were careful to make distinctions between those sections that they perceived as needing their support and those that were considered unworthy of it. As such, a generally favourable attitude was only present towards the artists (directors, actors, cinematographers) and the small distributors. Other facets of the industry were seen as a concern, if they allowed commercial priorities to take precedence over aesthetic ones. This was presented as a specific concern if the 'money men' were seen to have taken liberties with individual films.

For instance, on the *CP* forum in February 2006, there was a discussion about a release of the film *Fearless* (Ronny Yu, 2006). One member, Burble, suggested that this was likely to be a great film considering the previous form of the director and the stars, and so he/she urged other forum members to wait for the quality official release (*Fearless* Release Thread, 2006). Fickle also suggested that the film was brilliant, but said that, despite having seen both the Cantonese and Mandarin versions on downloads, he/she was eager to purchase the official release too (*Fearless* Release Thread, 2006). At this point, Mashup contributed by saying that the film was indeed very good but that someone had obviously instructed the director to make the film conform to an action-movie formula (*Fearless* Release Thread, 2006). Burble agreed with this assessment and said he/she would wait for an uncut version before downloading or purchasing this film (*Fearless* Release Thread, 2006). The focus of concern within this discussion surrounded the perceived interference of commercial priorities in the artistic vision of the director. It demonstrates that the forum members were markedly hostile towards any economically motivated activity that was perceived to weaken the 'quality' or 'artistic' merit of a film. Thus, the opposition that might appear to exist between the 'industry' and the 'pirates' might be reinterpreted as a distinction between those primarily concerned with the 'quality' of the film (and its release), and those perceived to have other (usually profit-driven) concerns.

This issue of the 'quality' of official releases was a constant theme within the *Fearless* discussion thread, which was added to intermittently for almost a year. The conversations generally concerned the range and quality of the versions available commercially, and also the quality and length of the rips that were obtainable through the forum (*Fearless*

Release Thread, 2006). As this discussion took place on the *CP* forum, links to a range of Scene and 'homegrown' releases were provided within the same discussion thread. Despite this variety, the community releases (those sourced and prepared for release by forum members themselves – see Chapter 6 for further details) were deemed to be of superior quality and sourced from 'better' original versions that the Scene releases (Burble, *Fearless* Release Thread, 2006). The Scene releases were perceived to have been created by individuals who lacked a specific interest in East Asian cinema and so would generally not include the DVD extras or 'respect' the high quality of the original transfer to DVD. According to Burble, the specific issue with the Scene releases was that they were invariably available as 700 MB downloads so they could fit on to a CD; as such, Burble suggested that quality was compromised in favour of competing priorities (*Fearless* Release Thread, 2006). He/she acknowledged that some of the Scene releases might be acceptable but only if they produced three CD versions which managed to maintain what he/she suggested was an acceptable level of quality from the original DVD (*Fearless* Release Thread, 2006). This would add weight to the argument that the suggested opposition between industry and informal online distribution is misleading, because forum members also reacted with hostility to specific filesharers who were not considered to share their overriding concern with quality.

Indeed, the issue of quality was of paramount concern on the *CP* forum in particular, and official distribution companies were subject to high levels of scrutiny concerning the perceived 'quality' of their products. In a discussion specifically concerning Tartan on the *CP* forum, one particular forum member, Tate, warned other users to avoid Tartan releases because of their poor quality (Tartan UK Discussion Thread, 2003). On this same thread, another user, Fester, raised specific complaints against Tartan's releases, suggesting the subtitles were always 'hardcoded'[1] and the transfers always too dark (Tartan UK Discussion Thread, 2003). Fester went as far as to suggest that any of the releases available on the *CP* forum were of much better quality that the Tartan ones. However, despite these rather negative comments, the discussion itself was brief; no further members joined in with the criticism nor did anyone attempt to defend the distributor. Furthermore, Tate had actually praised the *high* quality of Tartan's version of *Battle Royale* (Kinji Fukasaku, 2000) in a different thread seven months previously (*Battle Royale* Release Thread, 2003). As such, criticisms of Tartan on the basis of producing bad-quality releases might be perceived as localised to a couple of individuals, but the discussions do illustrate that attitudes towards

the smaller distribution companies were often centred around questions of quality.

Other distributors were discussed in more favourable terms, but quality was referenced again as key when assessing their output. Criterion releases were particularly respected, with Simpson suggesting that the Criterion label indicated that both the film and the release would be of good quality. However, he/she also felt that this quality always came with a high price tag (*Youth of the Beast* Release Thread, 2005). Kinsky indicated a preference for more films to get the 'Criterion treatment', but also suggested that their wish was probably not very 'realistic' (Hollywood Discussion Thread, 2002). On the *EF* forum, the downloader Niku directly compared different releases of Ozu's *Tokyo Story* by both Tartan and Criterion (*Tokyo Story* Release Thread, 2011). Moons then contributed to the comparison by stating that he/she owned both copies and could confirm that the picture quality of the Criterion edition was superior, but that there were many more and much better extras available with the Tartan version. Indeed, such discussions indicate that, if the formal distributors were perceived within the community to produce DVD releases of good quality, then they were generally mentioned in favourable terms.

There was little evidence of criticism levelled at Tartan on the grounds of quality on the *EL* forum. A range of Tartan films were available on the forum and were shared precisely *because* they were Tartan releases with specific extras or cuts of films that no other distribution company provided. For instance, there was general praise for the user who shared the extras disc from the Tartan edition of Wong Kar Wai's *In the Mood for Love* shortly after it was released in October 2001. Further thanks were then provided each time it was re-seeded until February 2011 (*In the Mood for Love* Extras Release Thread, 2011). Furthermore, during a discussion of *Warm Water* in November 2010, Kadar remarked that the passing of Tartan was a great shame because this meant it would now be even more difficult to get hold of so many of their old titles, like *Warm Water*. Kadar further stated that Tartan was responsible for promoting East Asian cinema in the UK and that their demise was a significant blow for fans of East Asian films (*Warm Water* Release Thread, 2010). Such comments underline that members of the *CP* and *EL* forums took a kind view of the distributors that brought them a range of 'quality' East Asian releases.

The respect shown towards small distribution companies on the forums is even more favourable in relation to the other distributor considered in Chapter 2, Third Window Films, as the company was actively promoted on the *EL* forum as well as being praised for the quality of

their releases (*PTU* Release Thread, 2007). The Third Window version of *Confessions of a Dog* came with a specific request from the uploader, Sass, to support Third Window (*Confessions of a Dog* Release Thread, 2011). The request even came with a link to the Third Window website and details of special features available with the first thousand purchased copies of the film. Votid and Assis both posted to the discussion to second this request and to suggest that UK audiences should support their small distributors. Both users also expressed regret that they did not have equivalent companies in their respective regions (*Confessions of a Dog* Release Thread, 2011). Zuzu responded to the uploader's request by noting that he/she had already pre-ordered the Third Window version of the film and urged others to do the same (*Confessions of a Dog* Release Thread, 2011). Xant boasted that their copy of the film had just arrived and Kader added to the discussion by saying that Third Window really 'care' about their customers, and that they are always friendly and polite (*Confessions of a Dog* Release Thread, 2011). Interestingly, Third Window was not discussed directly on the *CP* forum and none of the editions shared on this forum were sourced from this particular distributor.[2]

The reaction on the *EL* forum to both Third Window and Tartan demonstrates a keen respect for and wish to support smaller distributors. While members of the *CP* forum could be quite critical of distributors who did not meet their exacting quality standards, those distributors that did were actively respected and supported. I argued in Chapter 6 that online distributors saw themselves as part of a wider imagined community when examining their own downloading behaviour. Here, a more nuanced version of that argument must be developed when considering the attitudes expressed upon the board towards distribution companies and the film industry more generally. Distributors are considered favourably if they demonstrate a respect for, and knowledge of, the films they distribute by producing what the community members perceive to be 'quality' releases. However, they are viewed less kindly if they are seen to prioritise monetary considerations or to in any way interfere with the quality or aesthetics of the individual films.

Perhaps unsurprisingly, the formal distributors I considered did not unilaterally demonstrate enthusiasm or respect towards informal distribution activities. However, the manner in which the formal distributors sought to distance themselves from the online activities of the informal distributors was not as straightforward as expressing contempt for the people who might be perceived as jeopardising their livelihood. In fact, the attitude towards informal distribution ranged from indifference on

the part of some Tartan employees and even enthusiasm from Third Window Films. This, again, illustrates that while the fight against film piracy is undoubtedly spearheaded by the 'industry', the individual professionals within that industry cannot be seen to unquestioningly adopt the anti-piracy rhetoric that is circulated on their behalf.

Interestingly, none of the respondents from Tartan (with the exception of Torel) had any significant level of knowledge about informal online distribution practices and none of them were aware of the community-based forms of circulation that take place within forums like *CP* and *EL*. Perhaps as a response to a deficit of company knowledge in this area, Hoile suggested that, when he first started working at Tartan as an intern, he was asked to do some research into which films from Tartan's catalogue were easily available through online channels (2009). Hoile mentioned that during his research it came to light that some of the films available on video-streaming websites might be films that Tartan had the rights to distribute in the UK, but that the viewable version of the film might not be the edition to which Tartan actually owned the rights (Hoile, 2009). As such, despite the fact that it was ostensibly the same film, Tartan would have found it difficult to combat such an instance of potential copyright infringement. Such an example raises the issue of the decidedly difficult nature of enforcing copyright law in a global context when the Internet is not bounded by the confines of national legal jurisdictions. Any number of 'versions' of a film that Tartan had the rights to distribute in the UK might be circulating online, but their ability to address such an issue was seriously impeded by the simultaneous existence of multiple versions of the same film. Indeed, almost all of Tartan's releases were available on either the *CP* or *EL* forums, but these films were not always originally sourced from the Tartan versions unless, as was the case with *In the Mood for Love* mentioned earlier, the DVD extras were of particular interest.

With the exception of this one case, the general response to the issue of piracy and downloading at Tartan appeared to be ambivalence or indifference routed in a lack of specialist knowledge of informal consumption/distribution practices. Each of the respondents was aware of downloading and some even suggested they had watched an illegally downloaded film, but they were careful to clarify that this was just a statistical likelihood considering the widespread nature of the activity rather than something they were consciously aware of having done. While one would expect people within the industry to wish to distance themselves from any suggestion of involvement in filesharing, they also showed only a cursory level of awareness of informal online distribution

activities. For instance, Hoile rather non-committally suggested that illegal downloading was undoubtedly a big issue, but was also quick to point out that actually most of what he said was conjecture and he was not really sure what impact downloading was having on the industry (2009). He used the example of the fact that there might be two to three years between the domestic release of some East Asian films and their release in the UK to indicate that anyone who watched the film illegally in that time was probably very unlikely to want to watch the official version when it was eventually released. However, he then quickly provided a counter example of TV film showings stimulating DVD sales to suggest that downloads might not necessarily be so harmful. He summed up his discussion by suggesting he was basing most of his ideas on 'assumptions' and, while his response did show some concern over the effects of downloading, it certainly did not represent the sort of distress or anger that one would expect of someone whose career and livelihood were perceived to be significantly under threat.

On the other hand, at Third Window, Torel was very familiar with fan-based informal dissemination activities and perceived it as something that was actually beneficial for the wider profile of East Asian cinema. Torel suggested that he was not concerned if people were sharing films that they could not access through legal channels. He did admit to getting a bit 'mad' if he discovered his films were being bootlegged, but he also suggested that this was not a major issue because of the extras available with each of his films (Torel, 2009). Torel described the fans of East Asian cinema as 'collectors'. As such, he saw their motivation as the acquisition of as many quality titles as possible. He suggested 'collectors liked features' and that this was a major reason why the fans would still buy the films. He felt that the extra features disc was not usually available through the pirate networks and so his copy of the film would always have an edge over the film-only online release (Torel, 2009).

As mentioned earlier, some of the Tartan films were shared specifically because of their extras, and so Torel's belief that the extras provided protection against piracy might be somewhat optimistic. However, the sharing of DVD extras appeared to only be popular on the *EL* forum and was not very common within the *CP* community. Indeed, forum member Burble identified the fact that they often did not include the extras as one of the major problems with releases found within the *CP* community (*Fearless* Release Thread, 2006).

So, while the online distributors appear to be generally sympathetic towards and supportive of the small distributors, the formal distributors themselves show varying levels of engagement with the activities

of their informal counterparts. Third Window actively supports the activities of fan communities online, even if this brings with it some accompanying copyright infringement. Tartan, despite some cursory investigations into bootlegging and illegal streaming of their films, appeared to be generally unaware of the type of complex communities that exist online and actively disseminate films that Tartan might have the right to distribute in the UK or US.

Doing their BitTorrent: Socio-network effects

With these examples in mind, I would argue that the relationship between small distributors of East Asian cinema and the members of the *CP* and *EL* forums could be said to be mutually beneficial if the principle of socio-network effects is applied. As mentioned in the chapter introduction, the network effects argument suggests that the value of an individual product increases proportionally with the size of the network of users. By extending this idea, the socio-network effects proposal suggests that, because people's interests and tastes tend to cluster, the more popular a cultural item is, the more attractive similar items become to potential audiences. Using such a proposition, it is possible to claim that, through their promotional activities, distributors both online and offline contribute to enhance the value of East Asian films.

Furthermore, it is possible to link the profile of East Asian film in general to the value of the cultural capital that the formal and informal distributors are able to trade on in their respective professional and online communities. As both groups are engaged in the promotion and distribution of East Asian cinema, then their online/offline dissemination activities can be understood to be mutually beneficial because, as the films distributed gain more acclaim, so both sets of distributors benefit from the resulting increase in their own status within their particular distribution contexts.

The single-use issue

One issue with proposing such an argument is the fact that it is often claimed that the principle of network effects cannot apply to films because they are considered to be single-use products (Higgins et al., 2007, p. 341). However, the idea that films are single-use items was critiqued in Chapter 6 on the grounds that within the *CP* and *EL* forums not only are films often multiple-use, but often manifold versions of the 'same' film will be available through these forums. To take one example, the aforementioned *Fearless* release thread involves a number of *CP*

forum members discussing the relative merits of a variety of releases of the 'same' film (*Fearless* Release Thread, 2006). Indeed, for the members, they are not only aware of the differences between each version, but will also often experience the film in all or many of these multiple incarnations. For instance, one member of the *CP* forum, Coco, suggested that he/she had watched the unsubtitled version that was already available, but was actively anticipating viewing the film again with subtitles and then watching the three-hour version of the film to see how it compared to the 100-minute version that he/she had already watched (*Fearless* Release Thread, 2006). Indeed, the general consensus amongst members contributing to this discussion was that it was great that they had seen *a* 'version' of the film now, but that they all were looking forward to a variety of other 'versions' as they became available (with a particular zeal for the director's cut) (*Fearless* Release Thread, 2006).

Another issue that questions the 'single-use' argument is that it is common practice for different 'cuts' of films to be available from different distributors or in different countries. One example is the Korean film *Sympathy for Lady Vengeance* (Chan-wook Park, 2005), where two distinct versions of the film are available, the standard version and the 'fade to black and white' version (Daniel, 2005). The discussion of this film on the *CP* forum explains that the Tartan version is the fade to black and white version, and that this version is preferable because it was the director's intention for this to happen (*Sympathy for Lady Vengeance* – Tartan Edition Release Thread, 2007). Within the *Fearless* release thread there is also a rather lengthy debate about the Thai version of the film and the fact that it includes a deleted scene that no other versions of the film have (*Fearless* Release Thread, 2006). Furthermore, there may be alterative versions of a film available in different countries where the censorship rules are different. For instance, the UK version of Kim Ki Duk's *The Isle* (2000) was censored by the British Board of Film Classification (BBFC) for animal cruelty. This was discussed when the film was released on the *CP* forum and members were keen to watch both the censored and uncensored versions to see how they compared (*The Isle* Tartan Edition Release Thread, 2007).

Indeed, many film distributors cater to (and arguably produce) this wish to see multiple versions of the film by releasing various editions of the same movie, so as to encourage repeat purchase and repeat viewing. In this respect, films (in the form of DVDs and Blu-rays) are frequently presented and packaged as collectible products. These collectibles then proliferate, so multiple editions and cuts of a single film are available with various special features and different packaging; not to mention

the multiple formats that are available (Blu-ray, DVD, VoD and so on). The fact that different cuts of a film might be released sequentially rather than simultaneously also suggests that this strategy is designed to encourage multiple viewings rather than cater to varying preferences. Such strategies would then suggest that the film industry at large certainly does not wish films to be perceived as 'single-use' products but wishes them to be consumed during as many windows and on as many platforms as possible.

Furthermore, I would contest that the principle of network effects can just as readily apply to films as software because the networks associated with movies are not the network of users of an individual product, but the network of users of sets of associated products. For instance, each new Disney film that appears solidifies Disney's status as a quality provider of animated movies for all ages. Thus it is the network surrounding Disney films in general that we should concern ourselves with, not the network surrounding, for instance, *Frozen* (Chris Buck and Jennifer Lee, 2013) in particular. Therefore, both movies and music can be considered to be network products if their social context is considered. As Rodman and Vanderdonckt argue, 'the worth of intellectual property – measured economically, culturally, politically, and/or socially – is often dramatically enhanced by the extent to which it circulates' (2006, p. 248). In this respect, the more people see *Frozen*, the more it becomes a 'must see' movie. As such Molteni and Ordanini suggest:

> Cultural preferences emerge following a *social contagion* process, where individual tastes are subject to continuous interactions with others', often by means of institutions that facilitate social intercourse and cohesion, such as, for instance, music fanzines, clubs or Internet user groups.
>
> (2003, p. 391)

Thus, this chapter applies the principle of socio-network effects to consider how tastes cluster, not just around genres of film or films by the same directors, but also around the filmmaking output of entire regions. Taking Hollywood as an example, Zhu and Wang argue that 'even though piracy has cut into the profit margin of the Hollywood majors, it has also reinforced Hollywood dominance in global image markets by circulating Hollywood products and consequently cultivating and creating an environment and demand for more of these products' (2003, p. 118). To take our earlier example, pirate copies of *Frozen* available online might cannibalise Disney's profits in the short term, but they

also may cultivate a future audience for Disney's subsequent films (not to mention their merchandising, theme parks, stores and so forth that circulate around the *Frozen* film brand).

The cultural capital of distributors both online and offline is inextricably linked with the value of the films that they distribute. Thus, if the profile of those films is raised, then the cultural capital that each distributor enjoys increases proportionally with the visibility of the film. Furthermore, if the films are not considered in isolation but are positioned within taste clusters, then the circulation of a range of East Asian films both offline and online increases the profile of East Asian films more generally. Thus the relationship between the formal and informal distributors can be said to be mutually beneficial, because what each distributor trades upon (either economically or socially) is their cultural capital. Regardless of whether there are direct economic benefits for each distributor from each film that is distributed (online or offline), there are indirect benefits through the corresponding increase in their cultural capital as the profile of East Asian cinema more generally is raised. However, while it could be argued that in many respects the relationship is mutually beneficial, it is nonetheless decidedly unequal. The informal online distributors may benefit by gaining access to the films that they want to see and by raising their social standing within their particular online communities, but their dissemination activities are also ultimately shaped by the actions of the formal distributors.

Formal distribution companies: The locus of power

At first glance, it might seem that online channels of distribution could facilitate a utopian exchange network. Informal online distribution exists outside of the market and is therefore not tethered by the necessities of securing financial returns for films distributed through its channels. It might appear that the 'free' exchange of goods online allows the criteria for distribution to be based solely on the aesthetic 'quality' of the film and its perceived 'critical success', rather than its likely box office figures and associated financial reward. Indeed, many of the films that are shared online can be difficult to find through traditional channels; they may have only been released in their country of origin, often have no subtitles, or may have been deleted so that copies are extremely difficult to come by. Filesharing communities function on the basis that, while it would be difficult for each individual to track down every film, as a collective they share the spoils of their cumulative searching powers. In addition, even if each individual were able to track down each film,

they would need to speak multiple languages in order to enjoy all of them. In contrast, within the community, there are teams of fansubbers who are able to provide subtitles in most major world languages.

This seemingly 'utopian' exchange network may facilitate the circulation of a variety of hard to access films but the following discussion will demonstrate that the informal distributors are dependent upon their formal counterparts in some fundamental ways, thus revealing the inherently unequal nature of this symbiotic relationship. Indeed, the professional film distribution sector is able to influence what films are released, which 'cut' of the film is available in certain territories, the technical quality of that released version and sometimes even which films get produced in the first place. In this respect, we must keep in mind the metaphor of symbiosis to illustrate that all practices of film distribution exist within an ecosystem and thus the actions of any single party may have particular ramifications for others within that system.

A particular illustration of the interdependence of these networks of distribution can be seen in how films are sourced to make 'releases' within these filesharing forums. On the *CP* forum there is a mix of Scene releases and releases made by forum members, so the source of those 'originals' used to make individual 'rips' varies. Scene releases might come from screeners, VHS copies, DVDs or recordings from theatrical exhibition. Releases made by forum members will almost exclusively be made from DVD or Blu-ray copies that the members themselves have purchased. It is a specific requirement of the *EL* forum that only DVDs and Blu-rays may be used as 'originals' to make releases. This is because, on the *EL* forum, each film must be shared in an uncompressed format. As such, all online distributors that exist outside the 'Scene' rely on a constant supply of officially released DVDs in order to share films. This reliance on authorised DVD/Blu-ray production serves as a neat illustration of how symbiosis operates in this context. However, as with many symbiotic relationships, it is a decidedly unequal affair and, in this case, the professionals exist at the dominant end of the power relationship because they control the supply of officially released DVDs/Blu-rays.

Not only do professional distribution companies have the power to decide which films are worthy of a commercial release, but they are also able to dictate the quality of the initial transfer to DVD. As discussed earlier in this chapter, quality appears to be a serious concern for members of the both the *CP* and *EL* communities. Some individuals will go to great lengths to obtain a copy of a film that meets their quality requirements or is in some manner considered to be artistically 'authentic'. This can be seen with the previously mentioned examples of *In the*

Mood for Love (Jo, 2007) and *Sympathy for Lady Vengeance* (Tartan Edition Release Thread, 2007) where standard versions released commercially had in some manner 'corrected' colour issues with the print that were actually deliberate stylistic decisions on the part of the director and/or cinematographer. While it was possible in both of these instances for the forum members to locate their preferred versions, they did have to wait a considerable amount of time or spend effort researching different releases to do so (Jo, 2007). Indeed, there are many discussions on both the *CP* and *EL* forums that concern the quality of releases, the varying cuts of films available and which of these are considered 'best'.

The final issue that illustrates the potential dominance of the formal distributors within the larger symbiotic ecosystem of film distribution more generally is the role that distributors often play in film financing. This issue did not specifically relate to the film distributors under consideration here because most of the films on their books are acquired as negative pick-ups, meaning films had already been made before the distribution rights were sold. However, it is often considered preferable for a distribution deal to be arranged even before a film goes into production because this makes it easier to secure funding to cover production costs (Film Distributor's Association Website, n.d.). As guarantees of distribution deals are so important to the initial financing of a film project, the role that professional distributors play in dictating which films are produced in the first place cannot be underestimated.

Conclusion

This chapter has outlined why the metaphor of 'symbiosis' might be apt to describe the interlinked ecosystem(s) of film distribution. Although popularly perceived to be at odds, through an examination of the attitudes of online informal distributors and formal distributors towards each other, some interesting conclusions can be established. The members of the *CP* and *EL* forums have the utmost respect for distributors that they feel share their concern with quality but are sceptical of the influence that economic considerations have on the 'artistic vision' of the filmmakers. On the other hand, the formal distributors are not particularly knowledgeable about the type of informal distribution practices represented by the *CP* and *EL* forums, and seem less concerned about the effect that piracy might be having on the film industry than one might imagine. In fact, the attitude of Adam Torel of Third Window was rather positive towards the activities of informal online distributors, but also indicated that he thought the 'extras' provided with his products

offered an added incentive to pay for his releases rather than just download them.

The proposed symbiotic relationship is not as straightforward or conscious as a transactional 'I'll scratch your back if you scratch mine' arrangement. As formal and informal distributors are able to trade on the cultural capital they accrue by both having access to and knowledge about East Asian cinema, the fact that the films are circulated (whether officially or not) only serves to increase the value of that cultural capital. As such, utilising Moltani and Ordanini's principle of socio-network effects, the relationship between the two sets of distributors can be understood as symbiotic rather than parasitic. However, it is important to reiterate that the mutually beneficial aspect of this relationship should be viewed in social and cultural terms and not primarily perceived of in relation to any potential economic benefits.

Rather than judging informal practices against whether or not they will inevitably translate into formal ones, we should view the informal and formal as already interlinked and thus representative of the messy nature of content creation, distribution and consumption. I would contest that the impetus to see a separation between the formal and informal is linked to a neoliberal doctrine that requires that individuals be marked as authors for marketing purposes and publishers/distributors are designated as owners for intellectual property reasons. This also positions the audience as consumers, active in the sense of making meaning but not in terms of production. However, as recent technological developments have abounded and prosumption has become a household term, companies have had to react quickly to ensure that user-generated content is another revenue stream rather than a competitor. Thus, piracy and other forms of informal distribution are positioned as highly problematic and can only be seen as acceptable if they have the capacity to ultimately transform into formal practices that elicit revenue.

Conclusion: Ecologies of Distribution and Shifting Gatekeepers

The book has argued that the interlocking ecosystem(s) of media distribution must be considered holistically and culturally if we are to truly understand the transnational flows of media texts. While many of the practices described within this book may bring into question the ontology of film in an era of digital distribution, the main interest of this volume does not lie in considering what film *is*, but rather what it does, how it moves, who controls that circulation, and how the varying networks of its distribution come together to form a complex ecosystem.

The varying methods of distribution that have been discussed herein present a picture of film distribution that demands we consider both the micro and macro contexts of dissemination practices. While the Hollywood formal mode(s) of distribution examined within Chapter 1 present(s) an image of an impenetrable industry configuration that perpetuates the dominance of a few key players, the subsequent discussions of both the 'disruptive innovators' and multiple methods of media 'piracy' would suggest a chink in that armour. While for the time being the Hollywood majors are able secure their pre-eminence (through lucrative PFD deals, by maintaining intellectual property rights and by creating a market where only companies bankrolled by multinational conglomerates can afford the inflated marketing costs that accompany the tent-pole blockbusters), the primary protector of their status quo, the sequential release window structure, is being challenged. While we must be careful not to assume that such 'disruptive' innovations represent an all out revolution, the manner in which new mechanisms of VoD have not simply been absorbed into the release window hierarchy represents a significant development within the film distribution ecology.

However, such a shift is not attributable to the disruptive innovators alone but is both cause and consequence of a number of interlocking

factors. For instance, arguably many parts of the world are now experiencing an on-demand culture where audiences increasingly wish to engage with media content in a manner, time and place of their own choosing. Furthermore, informal distribution networks are often more nimble and flexible than formal sequential systems of dissemination, and so provide a proliferation of opportunities to circumvent the carefully scheduled programming of film releasing. Furthermore, the current predominant mode of Hollywood production (one that creates multibillion-dollar films with similarly extensive marketing costs) has created a situation where those not supported by rich parent companies struggle to compete in a saturated marketplace. In such a context, releasing films simultaneously on multiple platforms becomes an attractive option for 'independent' distributors because it means that advertising costs are concentrated at a particular point and are thus not duplicated across each different stage of the windowed release system. So rather than any individual party (pirates, disruptive innovators, consumers or 'independent' distributors) singlehandedly changing the game, what can be witnessed is the complex intertwining influence of a number of groups simultaneously.

Furthermore, trying to designate individuals as exclusively members of any one of these groups (consumers, distributors, pirates and the like) reminds us that the distinctions between such labels are far from clear. To take the example of 'independent' distribution discussed within Chapter 2, this particular term can at once be an industrial designator, an economic category, a branding label and a matter of aesthetic judgement. In this manner, there is a significant blurring of distinctions between the 'independent' distribution sector and the major Hollywood studios. Such a situation again points to a complex picture of an industry that cannot be analysed by recourse to dichotomous thinking.

In a similar vein, the varying acts of informal distribution examined within this book suggest that piracy is not a monolithic activity but it comprised of a number of heterogeneous practices. As can be seen from the brief history of online informal distribution within Chapter 5, even these relatively recent sets of practices are remarkably varied. On an even more specific level, when considering the codes and conventions of informal distribution practices routed through filesharing forums, a range of practices are revealed. Such examinations have shown that the actions of distributors within these informal networks involve complex social and cultural interactions rather than purely economic considerations. However, while the process of preparing films for release within such forums is a complex and collaborative activity, only a few

individuals within each community actually 'select' and 'acquire' which films to release. As such, while the whole community may play a role in circulating files, only a few key players actually *add* to the overall catalogue of available films. Therefore, these forums cannot be viewed as utopian non-hierarchical spaces because, in reality, they are carefully guarded and policed by those who wish to reinforce their own prominent status within each community.

Such attempts at control point to the fact that, within piracy, as with acts of formal distribution, there are invariably gatekeepers who dictate which films are circulated and which are not. In these respects we must pay close attention to the way that acquisition decisions are made by such intermediaries. This book has made some headway in this regard by considering how 'independent' distributors (in the industrial sense that they are not financially or institutionally connected with Hollywood) make such acquisition decisions. This work has demonstrated that in such contexts, acquisition decisions are not, as one might expect, based upon subjective judgements of quality drawn out of the actual experience of watching films. In contrast, by assessing the existing critical and commercial success of prospective acquisitions as well as their potential marketability, a strategic acquisition plan is developed.

Such recourse to external indicators of critical and commercial success serves to remind us that in order to understand film distribution we must consider both the macro and micro contexts within which acquisition decisions are made. As the loosely geographical discussion of piracy from Chapter 4 illustrated, the specific political, economic, social and cultural contexts for distributors must be examined in relation to their intersections with the wider ecosystem of global film circulation.

For example, the acquisition decisions of the informal distributors discussed within Chapter 6 are clearly informed by their existence within a specific community, but such selections are also influenced by the formal film industry. In particular, the reliance upon officially released DVDs due to their perceived 'quality' means that the criteria for selection employed by the formal distributors is then unwittingly reproduced within such informal settings.

So, while such examples suggest that the majority of gatekeeping power still resides in the hands of traditional formal distribution companies, the 'pirates' and 'disruptive innovators' are undoubtedly augmenting the ways that films reach audiences. Nonetheless, such changes do not translate into universal and unlimited access for film spectators. At present, video on demand services are unevenly distributed around the globe and, even when the likes of Hulu and Netflix are available,

there can be practical, technical and financial barriers to consumer engagement with such platforms. In a similar way, while there are more and more examples of films being released using simultaneous multi-platform release strategies, such an approach is still a novelty rather than the norm. All this would suggest that while the traditional distribution status quo might have been disrupted to a certain extent, it has not been completely overturned. So, instead of witnessing a process of dis-intermediation (whereby intermediaries are removed entirely), we can see new gatekeepers (in the form of online distributors and disruptive innovators) rising to the fore.

In considering the political, social and cultural contexts of media distribution, this book has largely not concerned itself with the question of whether or not piracy is ultimately economically damaging to the film industry. Not only has such a question been covered quite comprehensively already, but it is also based upon a number of problematic assumptions. Firstly, it aggregates acts of piracy together as though it were possible to talk about all the varying forms of piracy as being equivalent acts. Secondly, such a debate further presupposes that informal distribution mechanisms *should* be measured primarily based upon their perceived economic effects on the formal industry. As was suggested in Chapter 7, to defend certain forms of piracy based upon their presumed eventual economic benefits presents a neoliberal world view where moral absolution can be achieved if illegal means are seen to produce certain economic ends. While it is undoubtedly important to ensure the continued production of cultural life, it is reductive to restrict 'culture' to tangible goods that can be sold for profit or to imagine that 'artists' will only be motivated to produce such goods if they receive the appropriate financial reward. As such, it is imperative to move beyond such attempts to quantify the damage inflicted upon the film industry by informal methods of distribution. Indeed, to that end, this book raises some questions and avenues for further research.

Firstly, distribution needs to be considered in broader terms and should not be confined to strict distinctions between professional distribution and illegal piracy. Further work is needed that examines the multiple channels and networks through which films might circulate transnationally. Such work needs not only to consider the multiple channels of distribution, but also how the process of dissemination itself shapes, positions and problematises the act of film consumption. As both formal and informal online distribution of media content becomes the norm rather than the exception, there is a continued need

for research and scholarship in the field to keep pace with the rapidly developing digital environment.

Secondly, although this book has mentioned the filesharing Scene in relation to the *CP* forum, this was only a passing reference. Future research into filesharing and digital piracy needs to tackle the Scene because, aside from the work of J.D. Lasica (2005), there is very little academic scholarship that concerns this area of activity. It would be particularly interesting to consider how these groups are organised and how they intersect with other informal distribution practices. Further work is also needed to consider the range of informal downloading activities that exist online and, in particular, the specific implications of the growth of direct download links from file-hosting services and the corresponding reduction in peer-to-peer traffic. It would be of particular interest to consider such a shift in light of the fact that the subscribers to such services actually pay for their membership. Thus, if illegal downloading is actually something that users are willing to pay for directly through subscriptions to hosting sites (rather than indirectly through their Internet subscription), then any remaining questions surrounding the economic impact of piracy on the cultural industries should perhaps be centred on how revenue has shifted into other industry sectors rather than how it has disappeared altogether.

Thirdly, as formal film download and streaming services become established in the market, how will informal online distributors adapt and develop? It is worth considering that the initial development of online filesharing was during a distinct period of time in which legal services had yet to be established. In the current on-demand climate, it is possible to download and stream films with ever-increasing ease and speed. As the entire film distribution ecology faces new challenges and new possibilities, this area of study warrants further attention.

Fourthly, the practices of film distribution must be examined in such a way that acknowledges the level of convergence between media forms and their associated process of production, distribution and consumption. While this book chose to specifically examine film distribution, such a focus was not meant to imply that the networks of dissemination for film texts are in any way distinct from those that are used to circulate other media forms. In this respect it is important to explore how the film distribution ecology intersects with the associated ecologies of production, distribution and consumption surrounding games, TV programmes, books, newspapers and other media content.

Finally, even though the dominance of Hollywood has clearly been established, how acquisition decisions are made in this context has yet to be thoroughly examined.

Films circulate in ways that are mediated by individuals who operate in social and professional contexts, and these environments then shape how film distributors see themselves and the films they circulate, and ultimately dictate which films are made available to audiences. In this respect, there is a particular need to consider in detail how acquisition decisions are made because such judgements have significant power to dictate which films are widely seen and which are not.

What all of these lines of enquiry indicate is that there is still much to be learnt about media distribution. This might be through a detailed examination of how further developments in digital technology will impact on potential and existing channels of distribution, or by supplementary work that considers, as this book has done, the relationship between different aspects of the wider distribution ecology. What remains certain, for the time being at least, is that film distribution is rapidly developing and cannot be restricted to its traditional characterisation as a link in the chain between industrial film production and exhibition. While concepts like the 'prosumer' question the boundaries between production and consumption, professionals and amateurs, and the economic and the social, we must be mindful of the interconnected complexity of cultural life and acknowledge that the Internet may not, in fact, be breaking boundaries but rather drawing into sharp focus the fictitious basis of such distinctions.

Notes

Introduction

1. For example, see Jeffrey S. Podoshen, "Why Take Tunes?: An Exploratory Multinational Look at Student Downloading," *Journal of Internet Commerce*, 7, no. 2 (2008); Twila Wingrove, Angela L. Korpas and Victoria Weisz, "Why Were Millions of People Not Obeying the Law?: Motivational Influences on Non-Compliance with the Law in the Case of Music Piracy," *Psychology, Crime and Law*, 17, no. 3 (2011): 1.
2. For example, see Mark Cenite, Michelle Wanzheng Wang, Chong Peiwen and Germaine Shimin Chan, "More than Just Free Content: Motivations of Peer-to-Peer File Sharers," *Journal of Communication Inquiry*, 33 (2009); Ian Condry, "Cultures of Music Piracy: An Ethnographic Comparison of the US and Japan," *International Journal of Cultural Studies*, 7, no. 3 (2004).
3. These distributors are (in order of market percentage) Warner Bros, 20th Century Fox, Paramount, Walt Disney, Universal, Sony Pictures, eOne Films, Lions Gate, Entertainment and Optimum.
4. 'The Scene' refers to a form of organised filesharing that involves individuals coming together to form 'release groups,' which then split the tasks of sourcing, ripping, encoding and sharing amongst the group. A more thorough discussion is provided in chapter 5 and also in J.D. Lasica, *Darknet: Hollywood's War against the Digital Generation* (2005).
5. 'Leeching' is a term commonly applied when someone downloads a file through a peer-to-peer network but does not subsequently share that file with other users. Much peer-to-peer software has options that allow the user to dictate whether they wish to share their own files, and from which folders on their computer. As such, each individual who downloads a file from a filesharing forum is not automatically or technologically obliged to share the file with others. However, amongst many filesharing communities, 'leeching' is considered antisocial behaviour.

1 Formal Film Distribution

1. For instance, Alisa Perren points out that, within television studies, there is some informative work on how acquisition decisions are made (2013, p. 166) and the issue of how news stories are selected for publication has been of interest since the publication of David Manning White's influential work 'The 'Gatekeeper': A Case Study in the Selection of News' in 1950.
2. That is, whereby individuals are either employed by the very small number of multinational media conglomerates (at the centre of the hourglass) or within the vast array of small companies that make up the rest of the cultural industries.

3. The organisation of such deals is explained in basic form here but for a detailed explanation see the chapter on distribution in *How Hollywood Works* by Janet Wasko.
4. A 'first-dollar' deal is relatively rare and refers to a situation where the gross participant's share is received *before* the distributor's fee has been paid but after the exhibitor has had their costs covered.
5. See Chapter 3 for a discussion of how this windowed system of releasing has been changing during recent years.

2 'Independent' Distributors

1. Releasing a new film to DVD no longer has the stigma attached to it that may have occurred in the past and, furthermore, is quite commonplace for an organisation like the BFI, where their main remit is to release 'classic' cinema.
2. In this case, released in the UK in 2003 by Contender Entertainment Group, *IMDB*, accessed 4 May 2009, http://www.imdb.com/company/co0106236/.

3 Disruptive Innovators

1. For instance, Hulu is only available in the US and Netflix is available throughout North, Central and South America, the UK, Ireland, the Channel Islands, Scandinavia, France, Germany, Switzerland, Luxembourg, Belgium and Austria.
2. See Cunningham and Silver (2012) for an extensive breakdown of the varying services that have tried to enter this market over the last two decades.
3. As of February 2015, these were Australia, Austria, Belgium, Canada, France, Germany, Ireland, Luxembourg, The Netherlands, New Zealand, Switzerland, the UK and the US.
4. It is necessary to include both film and TV in this discussion as the platforms referred to typically house content from both mediums. However, for the purposes of this volume, films, as in feature-length moving pictures that typically enjoy a theatrical release at some point, will remain the focal point.

4 Informal Distribution: Discs and Downloads

1. The actual size of a downloadable music or movie file is variable. For music, the size of the file depends on the rate at which the MP3 is encoded. In the early days of informal online distribution, films were encoded so they could be easily burnt on to a CD-r; as such, they would be below 700 MB. As data storage has evolved, the need to reduce the size of a movie to something that can easily fit on a CD has lessened.
2. A particular gifting relationship within tribes in the Pacific North West that did not replace other forms of exchange but took place on specific special occasions.
3. It is important to point out that Giesler and Pohlmann's research was conducted from October 2000 to February 2001 and so the 'version' of Napster they refer to pre-dates the law suit in March 2001 that saw the company lose

their battle with the RIAA (Giesler and Pohlmann, 2003) and before the software company Roxio bought out the platform in November 2002 (BBC, 2003). Admittedly, a deal had already been signed between the German conglomerate Bertlesmann and Napster in 2000 (Capella, 2001), but Napster was still a 'free' service when Giesler and Pohlmann's research was carried out.

5 A Brief History of Film 'Filesharing': From Napster to Mega

1. The term is used within the chapter heading because it is a recognized term. While the chapter highlights its inadequacies, the term is in common usage and 'informal online distribution' would be less recognisable for the reader.
2. For a discussion of the social side of Napster, see Markus Giesler and Mali Pohlmann (2003).
3. p2p filesharing involves installing a program on a computer that allows users to search the files available on the computers of other people in the network. It is then possible to locate specific files and initiate a download directly from any other person in the network.
4. Examples of software include Azureus, BitComet, BitTornado and μTorrent. Each different piece of software has different functions but all allow users to download files using the BitTorrent protocol. There is also a BitTorrent plugin (something that allows additional functions within software) available with eDonkey.
5. The *Chinaphiles* forum provides links to files available on the eD2k network and *Eastern Legends* deals exclusively with torrents.
6. Although MP3 is the most recognised, there are actually other standards for music compression. Sony has its own standard (AAC) as does Microsoft (WMA). However, the MP3 format has become standard because most software will usually convert into MP3.
7. Some DVD players are capable of recognising certain compressed video (avi) files and, as such, the burnt disc can sometimes be put directly into a DVD player and played back on a normal television. Furthermore, the compression of files to this size meant that they could be further shared on burnt disc. This capping of files to 700 MB has continued despite the fact that memory sticks of various sizes have largely replaced CDs as the transport method of choice.

6 Informal Distribution Networks: Fan 'Filesharing' and Imagined Communities

1. As well as being one of Kozinets's categories, 'lurker' is a commonly used term to describe individuals who are members of forums or message boards but do not contribute to the discussions.
2. The following provides a brief introduction but should be read in conjunction with Chapter 5 to give a fuller picture of informal online distribution practices.
3. On the EL forum, there was a specific discussion of cross-forum membership and many members reported having simultaneous membership of

five to seven forums, with some regularly visiting as many as 28. "Forum Membership Discussion Thread," *Eastern Legends Forum*, February 2007.

4. Discussions will quite often concern which cut of the movie is available. Notable examples are the releases on *Chinaphiles* of *Fearless* in February 2006 and *Kung Fu Hustle* in February 2005.

5. Scene releases did not represent a significant contribution to either forum under discussion here but more detailed information on the 'filesharing' Scene can be found in Chapter 5.

6. Sills, as an intermediate and an autonomous distributor, makes a point of indicating in his posts the releases that are his own, and those that are from Scene release groups.

7. See Chapter 5 for a discussion of the differences between eDonkey and BitTorrent.

8. Displaying such information with each post is commonplace on forums.

9. Displaying ratio is something peculiar to filesharing forums but it is not typical to display a user's ratio each time they post. While such information is recorded for each user, it is not always displayed in such a manner.

10. One notable exception is Mark Cenite, Michelle Wanzheng Wang, Chong Peiwen and Germaine Shimin Chan (2009).

11. This examination specifically considers the distribution process for releases provided by autonomous distributors on both forums. The process for the intermediate distributors has not been examined here because it is not as complex as the autonomous process and does not form the main method of films entering either forum.

12. If a film has never been released on DVD, then in exceptional cases it can be released on *EL*, but permission must be sought in advance from one of the admins (Forum Rules, n.d.).

13. There are many such discussions of this type (for instance, *Battle Royale* Release Thread, 2003; *Fearless* Release Thread, 2006; Tartan UK Discussion Thread, 2003).

14. In recent years this has changed and it was at the time of writing more commonplace for some major manufacturers to produce DVD players that are not region locked.

15. One example is the DVD Hacks website, http://www.DVDhacks.co.uk/.

16. There is actually another standard, SECAM, which is used in France, Russia and some countries in West and Central Africa. However, SECAM standard televisions can actually play DVDs in the PAL format, so I have excluded an explanation of this standard from my discussion.

17. Owing to the nature of IRC conversations, some questions/comments/ responses will appear to be in the wrong order but this is simply because the often people type at the same time as each other and conversations can become a little confused. All conversations are reproduced as they appeared on my computer screen, due to the nature of such conversations, it is possible this is not identical to that of the respondent.

18. It appears that as of 2009 only the following Wong Kar Wai films are released in Region 4: *In the Mood for Love* by Magna in 2002, *Magna Pacific Website*, accessed 12 June 2009, http://www.magnapacific.com.au/index.cfm?action= dsp_title&catnumber=DVD05510, *2046* by Madman in 2004, *Madman.com*, accessed 12 June 2009, http://www.madman.com.au/actions/catalogue.do?

releaseId=5978&method=view; *As Tears Go By* and *Days of Being Wild* on Roadshow in 2005, *HopscotchFilms.com*, accessed 12 June 2009, http://www .hopscotchfilms.com.au/flash.html; and *Fallen Angels* on Accent in 2004, *AccentFilm.com*, accessed 12 June 2009, http://www.accentfilm.com/product .cfm?id=MTAwMDAwOA%3D%3D&cat=MQ%3D%3D. The respondent was interviewed in January 2007 and said that he had started sharing about 18 months previously. Consequently, As *Tears Go By* and *Days of Being Wild* had not yet been released in Region 4 when he began.

7 Intersections: Pirates Meet Professionals

1. Hardcoded subtitles are part of the file that contains the film and play automatically, whereas softcoded subtitles must be downloaded as a separate file.
2. It is not clear why this is the case but the absence of the distributor from forum discussions would suggest that Third Window is unknown on the board rather than indicating a dislike or disinterest in the company's releases.

Bibliography

A Field in England, n.d. *Draft Films*, [online] Available at: http://drafthousefilms .com/film/a-field-in-england [Accessed 23 November 2014].

About, 2010. Third Window Films, [online] Available at: http://thirdwindow films.com/about [Accessed 16 January 2015].

About Palisades Tartan, 2009. [online] Available at: http://www.palisadestartan .com/AboutUs.asp [Accessed 23 March 2015].

Abraham, R., 2013. A Battle for Screen-Time. *FT.com*, [online] 6 September 2013. Available at: http://www.ft.com/cms/s/2/ed233298-1552-11e3-b519 -00144feabdc0.html#axzz3JtxtIEFQ [Accessed 23 November 2012].

Alderman, J., 2001. *Sonic Boom: Napster, P2P and the Battle for the Future of Music.* London: Fourth Estate.

Allen, K., 2007. DVD Retailers Singing in the Rain. *The Guardian*, [online] 25 July 2007. Available at: http://www.theguardian.com/business/2007/jul/25/ citynews.media [Accessed 21 February 2015].

Ancient, 2007. Research Discussion Thread. *Chinaphiles Forum.*

Ancient, 2009. ICQ Interview with Author.

Anderson, B., 1991. *Imagined Communities: Reflections on the Origins and Spread of Nationalism.* London: Verso.

Anderson, N., 2011. Atari's Copyright Attack on RapidShare Unplugged. *Ars Technica*, [online] 6 January 2011. Available at: http://arstechnica.com/ tech-policy/news/2011/01/ataris-copyright-attack-on-rapidshare-unplugged .ars [Accessed 21 February 2015].

Andersson, J., 2010. *Peer-to-Peer-Based File-Sharing Beyond the Dichotomy of "Downloading Is Theft" vs. "Information Wants to Be Free": How Swedish File-Sharers Motivate Their Action.* PhD Thesis Goldsmiths College (University of London).

Andersson Schwarz, J., 2013. *Online File Sharing: Innovations in Media Consumption.* New York: Routledge.

Athique, A., 2008. The Global Dynamics of Indian Media Piracy: Export Markets, Playback Media and the Informal Economy. *Media, Culture & Society*, 30 (5), 699–717. DOI:10.1177/0163443708094016.

Azumi 2 Release Thread, 2005. *Chinaphiles Forum.*

Balio, T., 2013. *Hollywood in the New Millennium.* London: Palgrave.

Balsom, E., 2014. *Exhibiting Cinema in Contemporary Art.* Amsterdam: Amsterdam University Press.

Battle Royale Release Thread, 2003. *Chinaphiles Forum.*

BBC, 2003. Napster Gets a New Lease of Life. *BBC*, [online] 24 February 2003. Available at: http://news.bbc.co.uk/1/hi/business/2795967.stm [Accessed 28 March 2015].

BBC, 2006. Web "first" for Guantanamo film. *BBC*, [online] 13 February 2006. Available at: http://news.bbc.co.uk/1/hi/entertainment/4708148.stm [Accessed 23 March 2015].

BBC News Article Discussion Thread, 2005. *Chinaphiles Forum.*

Beginner's Guide, n.d. MOOters Bittorrent Guide, [online] Available at: http://www.bittorrentguide.co.uk/bittorrent-help/beginners-guide/ [Accessed 21 February 2015].

Berney, B., 2006. Independent Distribution. In: J. Squire, ed. *The Movie Business Book*. Maidenhead, Berks: Open University Press, 375–383.

BFI, 2011. *BFI Statistical Yearbook*. London: BFI.

BFI, 2014. *BFI Statistical Yearbook*. London: BFI.

Bielby, W.T. and Bielby, D.D., 1994. "All Hits Are Flukes": Institutionalized Decision Making and the Rhetoric of Network Prime-Time Program Development. *American Journal of Sociology*, 99 (5), 1287–1313.

Bloomberg, 2007. Blockbuster Acquires Movielink. *New York Times*, [online] Available at: http://www.nytimes.com/2007/08/09/business/09movie.html [Accessed 17 December 2014].

Blume, S.E., 2006. The Revenue Streams: An Overview. In: J. Squire, ed. *The Movie Business Book*. Maidenhead, Berks: Open University Press, 332–359.

Bounie, D., Bourreau, M. and Waelbroeck, P., 2007. Pirates or Explorers? Analysis of Music Consumption in French Graduate Schools. *Brussels Economic Review*, 50 (2), 167–192.

Bourdieu, P., 1984. *Distinction: A Social Critique of the Judgement of Taste*. Cambridge, MA: Harvard University Press.

Bourdieu, P., 1991. *Language and Symbolic Power*. Cambridge: Polity.

Boyle, B., 2006. The Independent Spirit. In: J. Squire, ed. *The Movie Business Book*. Maidenhead, Berks: Open University Press' 174–181.

Capella, P., 2001. Napster to Charge Online Song Swappers. *The Guardian*, [online] 30 January 2001. Available at: http://www.theguardian.com/technology/2001/jan/30/business.newmedia [Accessed 28 March 2015].

Carroll, N., 2006. Defining the Moving Image. In: N. Carroll and J. Choi, eds. *Philosophy of Film and Motion Pictures: An Anthology*. Oxford: Blackwell Publishing, 113–114.

Castells, M., 2002. *The Internet Galaxy: Reflections on the Internet, Business, and Society*. Oxford: Oxford University Press.

Cenite, M., Wang, M.W., Peiwen, C. and Chan, G.S., 2009. More Than Just Free Content: Motivations of Peer-to-Peer File Sharers. *Journal of Communication Inquiry*, 33 (3), 206–221. DOI:10.1177/0196859909333697.

Chiang, E. and Assane, D., 2010. Copyright Piracy on the University Campus: Trends and Lessons from the Software and Music Industries. *The International Journal on Media Management*, 4 (3), 145–149.

Child, B., 2012. Time Warner CEO Predicts Release Date Shift to Combat Piracy. *The Guardian*, [online] 11 May 2012. Available at: http://www.theguardian.com/film/2012/may/11/release-date-piracy-time-warner [Accessed 12 February 2015].

Chin, D., 1997. Festivals, Markets, Critics: Notes on the State of the Art Film. *Performing Arts Journal*, 19 (1), 61–75.

Chin, D. and Qualls, L., 2002. "Here Comes the Sun" Media and the Moving Image in the New Millennium. *PAJ: A Journal of Performance and Art*, 24 (2), 42–55.

Choi, J. and Wada-Marciano, M., 2009. *Horror to the Extreme: Changing Boundaries in Asian Cinema*. Hong Kong: Hong Kong University Press.

Clift, T., 2014. "Your End Is Not Happy." From Karlovy Vary, Director Ben Wheatley Talks Pessimism, Film Distribution and "A Field in England." *Movie Mezzanine*, [online] 8 July 2013. Available at: http://moviemezzanine .com/your-end-is-not-happy-from-karlovy-vary-director-ben-wheatley-talks -pessimism-film-distribution-and-a-field-in-england/ [Accessed 23 March 2015].

Condry, I., 2004. Cultures of Music Piracy: An Ethnographic Comparison of the US and Japan. *International Journal of Cultural Studies*, 7 (3), 343–363. DOI:10.1177/1367877904046412.

Condry, I., 2007. The Shift from Ratings to Relevance: Intimacy, Youth Media and Nationalism in Contemporary Japan. *Asia–Pacific Journal: Japan Focus* [online] Available at: http://japanfocus.org/-Ian-Condry/2403 [Accessed 12 May 2014].

Confessions of a Dog Release Thread, 2011. *Eastern Legends Forum*.

Conner, K.R. and Rumelt, R.P., 1991. Software Piracy: An Analysis of Protection Strategies. *Management Science*, 37 (2), 125–139. DOI:10.1287/mnsc.37.2.125.

Cotton, M.B., 2001. *Futurecasting Digital Media*, London: ft.com.

Coyle, J.R., Gould, S.J., Gupta, P. and Gupta, R., 2009. "To Buy or to Pirate": The Matrix of Music Consumers' Acquisition-Mode Decision-Making. *Journal of Business Research*, 62 (10), 1031–1037. DOI:10.1016/j.jbusres.2008.05.002.

Crisp, V., 2012. "BLOODY PIRATES!!!* shakes fist*": Reimagining East Asian film Distribution and Reception through Online Filesharing Networks. *Journal of Japanese and Korean Cinema*, 3 (1), 65–72. DOI:10.1386/jjkc.3.1.65_1.

Crisp, V., 2014. To Name a Thief: Constructing the Deviant Pirate. In: M. Fredriksson and J. Arvanitakis, eds. *Piracy: Leakages from Modernity*. Sacramento, CA: Litwin Books, 39–53.

Crisp, V. and Gonring, G.M., eds., 2015. *Besides the Screen: Moving Images through Distribution, Promotion and Curation*. London: Palgrave.

Cubbison, L., 2005. Anime Fans, DVDs, and the Authentic Text. *Velvet Light Trap*, 56 (1), 45–57. DOI:10.1353/vlt.2006.0004.

Cubitt, S., 2005. Distribution and Media Flows. *Cultural Politics*, 1 (2), 193–213.

Culkin, N. and Randle, K., 2003. Digital Cinema: Opportunities and Challenges. *Convergence: The International Journal of Research into New Media Technologies*, 9 (4), 79–98. DOI:10.1177/135485650300900407.

Cunningham, S., 2013. *Hidden Innovation: Policy, Industry and the Creative Sector*. Brisbane: University of Queensland Press.

Cunningham, S. and Silver, J., 2012. On-line Film Industry: Its History and Global Complexion. In: S. Cunningham and D. Iordanova, eds. *Digital Disruption: Cinema Moves On-line*. St Andrews: St Andrews Film Studies, 33–66.

Cunningham, S. and Silver, J., 2013. *Screen Distribution and the New King Kongs of the Online World*. London: Palgrave Pivot.

Daily Mail Reporter, 2011. Film Industry in Crisis as Movie Audiences Plummet to Lowest Level in 16 Years. *Mail Online*, [online] 29 December 2011. Available at: http://www.dailymail.co.uk/news/article-2079582/Film-industry-crisis -movie-audiences-plummet-lowest-level-16-years.html [Accessed 12 February 2015].

Daniel, R., 2005. Sympathy for Lady Vengeance Review. *Far East Films*, [online] Available at: http://www.fareastfilms.com/reviewsPage/Sympathy-For -Lady-Vengeance-1744.htm [Accessed 15 March 2011].

Danto, A.C., 2006. Moving Pictures. In: N. Carroll and J. Choi, eds. *Philosophy of Film and Motion Pictures: An Anthology*, Oxford: Blackwell Publishing, 100–112.

Debruge, P., 2013. Film Review: "A Field in England." *Variety*, [online] 7 April 2013. Available at: http://variety.com/2013/film/reviews/film-review-a-field-in -england-1200511319/ [Accessed 23 November 2014].

Dekom, P., 2006. Movies, Money and Madness. In: J. Squire, ed. *The Movie Business Book*. Maidenhead, Berks: Open University Press, 100–116.

Denegri-Knott, J., 2004. Sinking the Online Music Pirates: Foucault, Power and Deviance on the Web. *Journal of Computer-Mediated Communication* 9 (4). [online] Available at: http://jcmc.indiana.edu/vol9/issue4/denegri_knott .html [Accessed 28 July 2010]. DOI:10.1111/j.1083-6101.2004.tb00293.x.

Denison, R., 2011. Anime Fandom and the Liminal Spaces between Fan Creativity and Piracy. *International Journal of Cultural Studies* 14 (5), 449–466. DOI:10.1177/1367877910394565.

Deuze, M., 2007. Media Work. London: Polity.

Digital Economy Act, 2010. [online] Available at: http://www.legislation.gov.uk/ ukpga/2010/24/contents [Accessed 21 December 2014].

Donoghue, C.B., 2014. Death of the DVD Market and the Rise of Digital Piracy: Industrial Shifts in the Spanish Film Market Since the 2000s. *Quarterly Review of Film and Video*, 31 (4), 350–363. DOI:10.1080/10509208.2012.660443.

Doyle, G., 2013. *Understanding Media Economics*. London: Sage.

DVD Collections Thread, 2009. *Eastern Legends Forum*.

DVD Hacks, n.d. Available at: www.DVDhacks.ac.uk [Accessed 17 June 2008].

Dwyer, T. and Uricaru, I., 2009. Slashings and Subtitles: Romanian Media Piracy, Censorship, and Translation. *Velvet Light Trap*, 63 (Spring), 45–57. DOI:10.1353/vlt..0026.

eBay Discussion Thread, 2009. *Eastern Legends Forum*.

Enders Analysis, 2012. Digital Europe: Diversity and Opportunity, *Enders Analysis* [online] 8 May 2012. Available at: https://www.letsgoconnected.eu/fileadmin/ Events/Brussels_2012/Studys/Lets_go_connected_Brussels_090512_FINAL _REPORT.pdf [Accessed 24 January 2015].

Enigmax, 2011. Turkey Bans RapidShare and FileServe. *TorrentFreak*. [online] 30 May 2011. Available at: http://torrentfreak.com/turkey-bans-rapidshare -and-fileserve-110530/ [Accessed 21 February 2015].

Ernesto, 2011. File-Sharing Traffic Predicted to Double By 2015. *TorrentFreak*, [online] 03 June 2011. Available at: http://torrentfreak.com/file-sharing-traffic -predicted-to-double-by-2015-110603/ [Accessed 21 February 2015].

European Audiovisual Observatory, 2014. Cinema Admissions in the European Union Down by 4.1% in 2013. *EAO*, [online] 14 February 2014. Available at: http://www.obs.coe.int/documents/205595/3477362/PR_Berlin_2014_ EN.pdf/86a37423-7c60-406b-b172-0a0186481f77 [Accessed 25 January 2015].

Fearless Release Thread, 2006. *Chinaphiles Forum*.

Fellman, D.R., 2006. Theatrical Distribution. In: J. Squire, ed. *The Movie Business Book*. Maidenhead, Berks: Open University Press, 362–374.

Festival de Cannes, 2014. Comparative Table for Film 1994–2014, *Festival de Cannes Website*, Available at: http://www.festival-cannes.com/assets/ File/WEB%202014/PDF/Chiffres-Films-1994-2014-EN.pdf [Accessed 28 March 2015].

Film Distributor's Association, n.d. Film Distributor's Association Website. [online] Available at: http://www.launchingfilms.tv/acquisition.php [Accessed 25 April 2011].

Finney, A., 2010. *The International Film Business: A Market Guide Beyond Hollywood.* London: Routledge.

Forum Membership Discussion Thread, 2007. *Eastern Legends Forum.*

Forum Rules, n.d. *Eastern Legends Forum.*

Frater, P., 2008. Tartan Admits Financial Problems. *Variety,* [online] 20 May 2008. Available at: http://www.variety.com/article/VR1117986153.html?categoryid=13&cs=1&query=Tartan+video [Accessed 1 June 2008].

Friedman, R.G., 2006. Motion Picture Marketing. In: J. Squire, ed. *The Movie Business Book.* Maidenhead, Berks: Open University Press, 282–299.

Garey, N., 2006. Elements of Feature Financing. In: J. Squire, ed. *The Movie Business Book.* Maidenhead, Berks: Open University Press, 117–127.

Gayer, A. and Shy, O., 2003. Internet and Peer-to-Peer Distributions in Markets for Digital Products. *Economics Letters,* 81 (2), 197–203.

Giesler, M. and Pohlmann, M., 2003. The Anthropology of File Sharing: Consuming Napster as a Gift. *NA – Advances in Consumer Research,* 30 (1), 273–279.

Giles, J., 2008. Interview with Author. 17 October 2008.

Goldsmith, J. and Wu, T., 2008. *Who Controls the Internet?: Illusions of a Borderless World.* Oxford: Oxford University Press.

Grenfell, M., 2010. Working with Habitus and Field: The Logic of Bourdieu's Practice. In: E. Silva and A. Warde, eds. *Cultural Analysis and Bourdieu's Legacy: Settling Accounts and Developing Alternatives.* London: Routledge, 14–27.

Guback, T.H., 1969. *The International Film Industry: Western Europe and America since 1945.* Bloomington: IN: Indiana University Press.

Hall, G., forthcoming. *Pirate Philosophy.* Cambridge, MA: MIT Press.

Halliday, J., 2011. Amazon Takes Full Control of Lovefilm. *The Guardian,* [online] 20 January 2011. Available at: http://www.theguardian.com/technology/2011/jan/20/amazon-buys-lovefilm [Accessed 06 February 2015].

Harbord, J., 2002. *Film Cultures.* London: Sage.

Harbord, J., 2007. *The Evolution of Film: Rethinking Film Studies.* Cambridge: Polity.

Harrington, C., 1952. Film Festival at Cannes. *Quarterly Review of Film, Radio and Television,* 7 (1), 32–47. DOI:10.2307/1209756.

Hatcher, J.S., 2005. Of Otaku and Fansubs: A Critical Look at Anime Online in Light of Current Issues in Copyright Law. *Script-ed,* 2 (4) [online] Available at: http://www2.law.ed.ac.uk/ahrc/SCRIPT-ed/vol2-4/hatcher.asp [Accessed 22 March 2015]. DOI:10.2966/scrip.020405.514.

Hearn, G., Ninan, A. and Rooney, D., 2008. Knowledge: Concepts, Policy, Implementation. In: D. Rooney, G. Hearn and A. Ninan, eds. *Handbook on the Knowledge Economy.* Cheltenham: Edward Elgar Publishing Ltd, 1–16.

Help Request Discussion Thread, 2006. *Chinaphiles Forum.*

Hennig-Thurau, T., Henning, V., Sattler, H., Eggers, F. and Houston, M B., 2007. The Last Picture Show? Timing and Order of Movie Distribution Channels. *Journal of Marketing,* 71 (4), 63–83.

Higgins, G.E., Fell, B.D. and Wilson, A.L., 2007. Low Self-Control and Social Learning in Understanding Students' Intentions to Pirate Movies

in the United States. *Social Science Computer Review*, 25 (3), 339–357. DOI:10.1177/0894439307299934.

Hird, M.J., 2010. Indifferent Globality: Gaia, Symbiosis and "Other Worldliness". *Theory Culture Society*, 27 (2), 54–72.

Hoile, P., 2009. Interview with Author, 14 January 2009.

Hollywood Discussion Thread, 2002. *Chinaphiles Forum*.

Holmlund, C. and Wyatt, J., 2004. *Contemporary American Independent Film: From the Margins to the Mainstream*. London: Routledge.

Holt, R., 2013. Kim Dotcom Launches Mega File-sharing Website a Year after Arrest on Megaupload Piracy Charges. *The Telegraph*, [online] 21 January 2013. Available at: http://www.telegraph.co.uk/technology/news/9815148/Kim-Dotcom-launches-Mega-file-sharing-website-a-year-after-arrest-on-Megaupload-piracy-charges.html [Accessed 30 March 2015].

Holt, T.J. and Morris, R.G., 2009. An Exploration of the Relationship between MP3 Player Ownership and Digital Piracy. *Criminal Justice Studies*, 22 (4), 381–392. DOI:10.1080/14786010903358109.

"How Do I Download Asian Movies?" Discussion Thread, 2004. *Chinaphiles Forum*.

How to See the Film, 2014. *A Field in England Website* [online] Available at: http://www.afieldinengland.com/screenings/#dvd [Accessed 25 March 2015].

Huang, C.Y., 2003. File Sharing as a Form of Music Consumption. *International Journal of Electronic Commerce*, 9 (4), 37–55.

Huddleston, T. and Jenkins, D., 2008. A Farewell to Tartan Films. *Timeout*, [online] 03 July 2008. Available at: http://www.timeout.com/film/features/showfeature/5133/a-farewell-to-Tartan-films.html [Accessed 15 September 2008].

In the Mood for Love Extras Release Thread, 2011. *Eastern Legends Forum*.

Introduction Discussion Thread, 2008. *Chinaphiles Forum*.

Iordanova, D., 2010. The Rise of the Fringe: Global Cinema's Long Tail. In: D. Iordanova, ed. *Cinema at the Periphery*. Detroit, MI: Wayne State University Press, 30–65.

Iordanova, D., 2012. Digital Disruption: Technological Innovation and Global Film Circulation. In: D. Iordanova and S. Cunningham, eds. *Digital Disruption: Cinema Moves On-line*. St Andrews: St Andrews Film Studies, 1–31.

Iordanova, D. and Cunningham, S. eds., 2012. *Digital Disruption: Cinema Moves On-line*. St Andrews: St Andrews Film Studies.

Jaglom, H., 2006. The Independent Filmmaker. In: J. Squire, ed. *The Movie Business Book*. Maidenhead, Berks: Open University Press, 49–57.

Jenkins, H., 1992. *Textual Poachers: Television Fans and Participatory Culture*. London: Routledge.

Jenkins, H., 2006. *Convergence Culture: Where Old and New Media Collide*. London: NYU Press.

Jenkins, R., 1992. *Pierre Bourdieu*. London: Routledge.

Jo, 2007. ICQ Interview with Author. January 2007.

Katz, A., 2005. A Network Effects Perspective on Software Piracy. *University of Toronto Law Journal*, 55 (2), 155–216. DOI:10.1353/tlj.2005.0007.

Kemp, S., 2014. Director Ben Wheatley's "A Field in England" Preps Innovative Rollout Plans. *Hollywood Reporter*, [online] 8 May 2014. Available at: http://www.hollywoodreporter.com/news/director-ben-wheatley-s-a-519474 [Accessed 23 November 2014].

Kerrigan, F., 2013. Film Choice in the Digital Age. Presented at: *World Cinema On Demand: Film Distribution and Education in the Streaming Media Era*, Belfast, UK, 26 June 2013.

Kerrigan, F. and Özbilgin, M., 2002. Educating Rita or Freeing Willy. Presented at the Academy of Marketing Conference, Nottingham, UK, 2–5 July 2002.

Kini, R.B., Ramakrishna, H.V. and Vijayaraman, B.S., 2003. An Exploratory Study of Moral Intensity Regarding Software Piracy of Students in Thailand. *Behaviour & Information Technology*, 22 (1), 63–70. DOI:10.1080/01449290301784.

Klinger, B., 2010. Contraband Cinema: Piracy, Titanic, and Central Asia. *Cinema Journal*, 49 (2), 106–124. DOI:10.1353/cj..0180.

Knight, J. and Thomas, P., 2008. Distribution and the Question of Diversity: A Case Study of Cinenova. *Screen*, 43 (9), 354–365.

Knight, J. and Thomas, P., 2012. *Reaching Audiences: Distribution and Promotion of Alternative Moving Image*. Bristol: Intellect.

Kolo, 2009. ICQ Interview with Author, September 2009.

Kozinets, R.V., 1999. E-Tribalized Marketing?: The Strategic Implications of Virtual Communities of Consumption. *European Management Journal*, 17 (3), 252–264. DOI:10.1016/S0263-2373(99)00004-3.

Kravit, S.M., 2006. Business Affairs. In: J. Squire, ed. *The Movie Business Book*. Maidenhead, Berks: Open University Press, 194–206.

Kretschmer, M., Klimis, G.M. and Wallis, R., 2001. Music in Electronic Markets: An Empirical Study. *New Media and Society*, 3 (4), 417–441. DOI:10.1177/14614440122226164.

Larkin, B., 2004. Degraded Images, Distorted Sounds: Nigerian Video and the Infrastructure of Piracy. *Public Culture*, 16 (2), 289–314.

Lasica, J.D., 2005. *Darknet: Hollywood's War against the Digital Generation*. Hoboken, NJ: Wiley.

Lau, J.K.W., 1998. Besides Fists and Blood: Hong Kong Comedy and Its Master of the Eighties. *Cinema Journal*, 37 (2), 18–34. DOI:10.2307/1225640.

Leonard, S., 2005. Celebrating Two Decades of Unlawful Progress: Fan Distribution, Proselytization Commons, and the Explosive Growth of Japanese Animation. *UCLA Entertainment Law Review*, 12 (2), 189–266.

Lessig, L., 2004. *Free Culture: The Nature and Future of Creativity*. London: Penguin.

Levin, A.M., Dato-on, M.C. and Rhee, K., 2004. Money for Nothing and Hits for Free: The Ethics of Downloading Music from Peer-to-Peer Websites. *Journal of Marketing Theory and Practice*, 12 (1), 48–60.

Levi-Strauss, C., 1969. *The Elementary Structures of Kinship*. Boston, MA: Beacon Press.

Lévy, P., 1999. *Collective Intelligence: Mankind's Emerging World in Cyberspace*. Cambridge, MA: Perseus Books.

Lewis, J., 2007. "If You Can't Protext What You Own, You Don't Own Anything": Piracy, Privacy, and Public Relations in 21st Century Hollywood. *Cinema Journal*, 46 (2), 145–150. DOI:10.1353/cj.2007.0015.

Lindlof, T.R. and Shatzer, M.J., 1998. Media Ethnography in Virtual Space: Strategies, Limits, and Possibilities. *Journal of Broadcasting and Electronic Media*, 42 (2), 170–189. DOI:10.1080/08838159809364442.

Lobato, R., 2007. Subcinema: Theorizing Marginal Film Distribution. *Limina: A Journal of Historical and Cultural Studies*, 13 (2007), 113–120.

Lobato, R., 2008. The Six Faces of Piracy: Global Media Distribution from Below. In: R.C. Sickels, ed. *The Business of Entertainment (Vol. 1): Movies*. Westport, CT: Greenwood Publishing Group, 15–36.

Lobato, R., 2009. The Politics of Digital Distribution: Exclusionary Structures in Online Cinema. *Studies in Australasian Cinema*, 3 (2), 167–178. DOI:10.1386/sac.3.2.167/1.

Lobato R., 2012. *Shadow Economies of Cinema: Mapping Informal Film Distribution*. London: BFI.

LoveFilm, n.d. Watch Online – General Questions. *Lovefilm.com*, [online] Available at: http://www.lovefilm.com/help/dyn_faqs.html?faq_cat=watch_online&editorial_id=9336 [Accessed 27 April 2011].

Macnab, G., 2008. Death of a Salesman. *The Guardian*, [online] 04 July 2008. Available at: http://www.guardian.co.uk/film/2008/jul/04/filmandmusic1.filmandmusic1 [Accessed 15 September 2008].

Malin, J. and Fowers, B.J., 2009. Adolescent Self-control and Music and Movie Piracy. *Computers in Human Behaviour*, 25 (3), 718–722. DOI:10.1016/j.chb.2008.12.029.

Malinowski, B., 1922. *Argonauts of the Western Pacific: An Account of Native Enterprise and Enterprise in the Archipeligoes of Melanesian New Guinea*. London: Routledge.

Maras, S. and Sutton, D., 2000. Medium Specificity Re-Visited. *Convergence: The International Journal of Research into New Media Technologies*, 6 (2). 98–113. DOI:10.1177/135485650000600207.

Marich, R., 2005. Marketing to Moviegoers: A Handbook of Strategies Used by Major Studios and Independents. Oxford: Focal Press.

Marshall, L., 2004. Infringers. In: S. Frith and L. Marshall, eds. *Music and Copyright*. Edinburgh: Edinburgh University Press, 189–208.

Mattelart, T., 2009. Audio-Visual Piracy: Towards a Study of the Underground Networks of Cultural Globalization. *Global Media and Communication*, 5 (3), 308–326. DOI:10.1177/1742766509346611.

Mauss, M., 1954. *The Gift: Forms and Functions of Exchange in Archaic Societies*. Mansfield Center, CT: Martino Fine Books.

McAlpine, H., 2004. A Personal Foreword. In: M. Pilkington *The Tartan Guide to Asia Extreme*. London: Startlux.

McDonald, P., 2007. *Video and DVD Industries*. London: BFI.

McLean, P., 2008. Apple Announces Same Day as DVD Release iTunes Movie Sales. *Apple Insider*, [online] 5 January 2008. Available at: http://appleinsider.com/articles/08/05/01/apple_expected_to_announce_new_movie_sales_in_itunes [Accessed 6 February 2015].

McQuire, S., 2000. Impact Aesthetics: Back to the Future in Digital Cinema?: Millennial Fantasies. *Convergence: The International Journal of Research into New Media Technologies*, 6 (4), 41–61. DOI:10.1177/135485650000600204.

Miller, T., Govil, N., McMurria, J. and Maxwell, R., 2001. *Global Hollywood*, London: BFI.

Miller, T., Govil, N., McMurria, J., Maxwell, R. and Wang, T., 2004. *Global Hollywood: No. 2*. London: BFI.

Molteni, L. and Ordanini, A., 2003. Consumption Patterns, Digital Technology and Music Downloading. *Long Range Planning*, 36 (4), 389–406. DOI:10.1016/S0024-6301(03)00073-6.

Motion Picture Producers Association of Japan, n.d. Statistics of Film Industry in Japan, 2000–2014. [online] Available at: http://www.eiren.org/statistics_e/index.html [Accessed 8 March 2011].

Movie List, n.d. *Chinaphiles Forum*.

MPAA, 2014. Theatrical Market Statistics 2013. *Motion Picture Association of America*, [online] Available at: http://www.mpaa.org/wp-content/uploads/2014/03/MPAA-Theatrical-Market-Statistics-2013_032514-v2.pdf [Accessed 25 January 2015].

Naxx, 2008. ICQ Interview with Author, December 2008.

Netflix, n.d. How Does Netflix work? *Netflix Help Centre*, [online] Available at: https://help.netflix.com/en/node/412 [Accessed 06 February 2015].

Newman, M.Z., 2012. Free TV: File-Sharing and the Value of Television. *Television and New Media*, 13 (6), 463–479. DOI:10.1177/1527476411421350.

New Membership Discussion Thread, 2010. *Eastern Legends Forum*.

New York Times Article Discussion Thread, 2010. *Eastern Legends Forum*.

NME. n.d. Apple iTunes become Biggest Music Retailer in USA. *NME.com*, [online] 4 April 2008. Available at: http://www.nme.com/news/itunes/35669 [Accessed 28 February 2015].

OECD, 2009. Piracy of Digital Content. *OECD Publishing*, [online] Available at: http://www.keepeek.com/Digital-Asset-Management/oecd/science-and-technology/piracy-of-digital-content_9789264065437-en#page9 [Accessed 21 December 2014].

O'Neill, P., 2014. A Field in England – Giving away the Whole Plot. *The Guardian*, [online] 7 April 2014. Available at: http://www.theguardian.com/film/filmblog/2013/jul/04/a-field-in-england-giving-away-the-plot [Accessed 23 November 2014].

O'Regan, 1991. From Piracy to Sovereignty: International VCR Trends. *Continuum. Australian Journal of Media and Culture*, 4 (2), 112–135.

Op den Kamp, C., 2015. Audiovisual Archives and the Public Domain: Economics of Access, Exclusive Control and the Digital Skew. In: V. Crisp and G.M. Gonring, eds. *Besides the Screen: Moving Images through Distribution, Promotion and Curation*. London: Palgrave, 147–161.

p2p vs Scene Explained, 2009. *ExtraTorrent.com*, [online] Available at: http://extratorrent.com/article/69/p2p+vs+scene+explained.html [Accessed 18 July 2011].

Pardo, A., 2015. From the Big Screen to the Small Ones: How Digitization is Transforming the Distribution, Exhibition and Consumption of Movies. In: V. Crisp and G.M. Gonring, eds. *Besides the Screen: Moving Images through Distribution, Promotion and Curation*. London: Palgrave, 23–45.

Park Chan-Wook Back-Catalogue Thread, 2009. *Eastern Legends Forum*.

Peitz, M. and Waelbroeck, P., 2006. Why the Music Industry may Gain from Free Downloading: The Role of Sampling. *International Journal of Industrial Organization*, 24 (5), 907–913.

Perren, A., 2013. Rethinking Distribution for the Future of Media Industry Studies. *Cinema Journal*, 52 (3), 165–171. DOI:10.1353/cj.2013.0017.

Petley, J., 1992. Independent Distribution in the UK: Problems and Proposals. In: D.J. Petrie, ed. *New Questions of British Cinema*. London: BFI, 83–94.

Petrie, D.J., 1991. *Creativity and Constraint in the British Film Industry*. London: Palgrave.

Picker, D.V., 2006. The Film Company as Financier-Distributor. In: J. Squire, ed. *The Movie Business Book*. Maidenhead, Berks: Open University Press, 167–173.

Pilkington, M., 2004. *The Tartan Guide to Asia Extreme*. London: Startlux.

Pillay, H., 2008. Knowledge and Social Capital. In: D. Rooney, G. Hearn and A. Ninan, eds. *Handbook on the Knowledge Economy*. Cheltenham: Edward Elgar Publishing Ltd, 80–90.

Podoshen, J.S., 2008. Why Take Tunes? An Exploratory Multinational Look at Student Downloading. *Journal of Internet Commerce*, 7 (2), 180–202.

PTU Release Thread, 2007. *Eastern Legends Forum*.

Pykäläinen, T., Yang, D. and Fang, T., 2009. Alleviating Piracy through Open Source Strategy: An Exploratory Study of Business Software Firms in China. *Journal of Strategic Information Systems*, 18 (4), 165–177. DOI:10.1016/j.jsis.2009.10.001.

Qualls, L. and Chin, D., 1998. To Market, to Market. *PAJ Journal of Performance and Art*, 20 (1), 38–43.

Quiring, O., Walter, B.V. and Atterer, R., 2008. Can Filesharers Be Triggered by Economic Incentives? Results of an Experiment. *New Media Society*, 10 (3), 433–453. DOI:10.1177/1461444808089417.

Radford, I., 2014. A Field in England: The Future of Film Distribution? *VODzilla.co.*, [online] 5 July 2014. Available at: http://vodzilla.co/blog/features/a-field-in-england-the-future-or-folly/ [Accessed 23 November 2014].

Release List, n.d. *Eastern Legends Forum*.

Research and Statistics Bulletin, 2007. *UK Film Council*, [online] Available at: http://www.ukfilmcouncil.org.uk/theatrical [Accessed 3 August 2011].

Richards, O., 2008. UK Finally Gets Apple Movie Downloads. *Empire Online*, [online] 4 June 2008. Available at: http://www.empireonline.com/news/story.asp?NID=226833 [Accessed 3 November 2011].

Rietjens, B., 2005. Give and Ye Shall Receive! The Copyright Implications of BitTorrent. *Script-ed*, 2 (3), 327–344. DOI:10.2966/scrip.020305.327.

Rodman, G.B. and Vanderdonckt, C., 2006. Music for Nothing or, I Want My Mp3. *Cultural Studies*, 20 (2), 245–261. DOI:10.1080/09502380500495734.

Rosenbaum J., 2010. *Goodbye Cinema: Hello Cinephilia: Film Culture in Transition*. Chicago: University of Chicago Press.

Rosser, M., 2013. A Field in England Figures Revealed. *Screen Daily*, [online] 8 July 2013. Available at: http://www.screendaily.com/news/a-field-in-england-figures-revealed/5058103.article [Accessed 23 November 2014].

Sandulli, F.D. and Martin-Barbero, S., 2007. 68 Cents per Song A Socio-Economic Survey on the Internet. *Convergence: The International Journal of Research into New Media Technologies*, 13 (1), 63–78. DOI:10.1177/1354856507072857.

Schulze, H. and Mochalski, K., 2009. Ipoque Internet Study 2008/2009. Ipoque.com, [online]. Available at: http://www.ipoque.com/resources/internet-studies/internet-study-2008_2009 [Accessed 31 March 2011].

Scott, A.J., 2004. *On Hollywood: The Place, The Industry*. Princeton, NJ: Princeton University Press.

Screen Daily, 2008. Tartan Films Goes into Administration, *Screen Daily*, [online] 28 June 2008. Available at: http://www.screendaily.com/ScreenDailyArticle.aspx?intStoryID=39611 [Accessed 19 July 2008].

Shin, C.Y., 2008. The Art of Branding: Tartan "Asia Extreme" Films. *Jump Cut* 50, [online]. Available at: http://www.ejumpcut.org/currentissue/TartanDist/index.html [Accessed 4 May 2009].

Sills, 2009. ICQ Interview with Author, August 2009.

Sinha, R.K., Machado, F.S. and Sellman, C., 2010. Don't Think Twice, It's All Right: Music Piracy and Pricing in a DRM-Free Environment. *Journal of Marketing*, 74 (2), 40–54. DOI:10.1509/jmkg.74.2.40.

Slater, D., 2002. Capturing Markets from the Economists. In: P. du Gay and M. Pryke, eds. *Cultural Economy*. London: Sage, 59–77.

Smith, M.D. and Telang, R., 2008. Competing with Free: The Impact of Movie Broadcasts on DVD Sales and Internet Piracy. *MIS Quarterly*, 33 (2), 221–338.

Squire, J.E., 2006. *The Movie Business Book*. Maidenhead, Berks. Open University Press.

Staff and Agencies, 2004. MPAA Says 24% of Internet Users Download Pirated Movies. *The Guardian*, [online] 9 July 2004. Available at: http://www.theguardian.com/film/2004/jul/09/piracy.news [Accessed 21 February 2015].

Staff and Agencies, 2005. Internet Piracy Fails to Sink Film Profits. *The Guardian*, [online] 3 May 2005. Available at: http://www.theguardian.com/film/2005/may/03/news2 [Accessed 28 February 2015].

Stafford, R., 2007. *Understanding Audiences and the Film Industry*. London: BFI.

Statistics Thread, 2009. *Eastern Legends Forum*.

Stelter, B., 2013. Blockbuster, Outdone by Netflix, Will Shut Its Stores and DVD Mail Service. *New York Times*, [online] 6 November 2013. Available at: http://www.nytimes.com/2013/11/07/business/media/internet-kills-the-video-store.html [Accessed 17 December 2014].

Stoddart, B., 2008. Interview with Author, 28 October 2008.

Strangelove, M., 2005. *The Empire of Mind: Digital Piracy and the Anti-Capitalist Movement*. Toronto: University of Toronto Press.

Stringer, J., 2001. Global Cities and the International Film Festival Economy. In: M. Shiel and T. Fitzmaurice, eds. *Cinema and the City: Film and Urban Societies in a Global Context*. Oxford: Wiley-Blackwell, 134–144.

Swart, S., 2008. Tartan Library to Palisades. *Variety*, [online] 8 July 2008. Available at: http://variety.com/2008/film/news/tartan-library-to-palisades-1117988641/ [Accessed 28 July 2009].

Sympathy for Lady Vengeance – Tartan Edition Release Thread, 2007. *Chinaphiles Forum*.

Tai Chi Master Thread, 2005. *Chinaphiles Forum*.

Tartan Films, n.d. *Tartan Films MySpace Page*, [online] Available at: http://www.myspace.com/Tartanfilms [Accessed 1 May 2009].

Tartan UK Discussion Thread, 2003. *Chinaphiles Forum*.

Tartan Video Catalogue: Issue One, 2005.

Taylor, S.A., Ishida, C.and Wallace, D.W., 2009. Intention to Engage in Digital Piracy: A Conceptual Model and Empirical Test. *Journal of Service Research*, 11 (3), 246–262. DOI:10.1177/1094670508328924.

Thanks Discussion, 2004. *Chinaphiles Forum*.

The Cinema Exhibitor's Association, 2012. *The Cinema Exhibitor's Association*, [online]. Available at: http://www.cinemauk.org.uk/key-issues/32 [Accessed 12 February 2015].

The Isle Tartan Edition Release Thread, 2007. *Chinaphiles Forum.*
The Scotsman, 2008. Tartan Films into Administration. *The Scotsman,* [online]. Available at: http://thescotsman.scotsman.com/6500/Tartan-Films –into-administration.4232541.jp [Accessed 05 January 2009].
The World Bank, 2015. Internet Users (per 100 people). *worldbank.org*, [online]. Available at: http://data.worldbank.org/indicator/IT.NET.USER.P2/countries/ 1W?display=default [Accessed 25 January 2015].
Third Window Films, n.d. Third Window Films MySpace Page, [online]. Available at: http://profile.myspace.com/index.cfm?fuseaction=user.viewprofile& friendid=154226245 [Accessed 10 March 2009].
Third Window Films, n.d. [online]. Available at: http://www.facebook.com/ thirdwindowfilms [Accessed 11 April 2011].
Third Window Films Discussion Board, n.d. Available at: http://thirdwindow .proboards.com/index.cgi [Accessed 3 October 2009].
Thompson, C., 2005. The BitTorrent Effect. *Wired.com*, [online]. 13 (1). Available at: http://www.wired.com/wired/archive/13.01/bittorrent.html [Accessed 21 June 2011].
Thompson, T., 2004. Online Pirates Revealed as Robbers, not Robin Hoods. *The Observer*, [online] 25 April 2004. Available at: http://www.theguardian.com/uk/ 2004/apr/25/arts.ukcrime [Accessed 21 February 2015].
Three Monster Discussion Thread, 2004. *Chinaphiles Forum.*
Timms, D., 2004. Online Piracy Dogs Movie Industry. *The Guardian*, [online] 9 July 2004. Available at: http://www.theguardian.com/media/2004/jul/09/ newmedia.business [Accessed 23 December 2014].
Ting, O., 2007. Pirates and the Orient: China, Film Piracy, and Hollywood. *Jeffrey S. Moorad Sports Law Journal*, 14 (2), 399–444.
Tokyo Story Release Thread, 2011. *Eastern Legends Forum.*
Torel, A., 2009. 12 March 2009.
Ultraviolet, n.d. Frequently Asked Questions. *Ultraviolet Website*, [online] Available at: https://www.myuv.com/en/gb/faq [Accessed 28 March 2015].
UNESCO Institute for Statistics, 2012. From International Blockbusters to National Hits: Analysis of the 2010 UIS Survey on Feature Film Statistics. *UNESCO*, [online] Available at: http://www.uis.unesco.org/culture/Documents/ ib8-analysis-cinema-production-2012-en2.pdf [Accessed 16 January 2015].
Vogel, H.L., 2006. Analyzing Movie Companies. In: J. Squire, ed. *The Movie Business Book*. Maidenhead, Berks: Open University Press 138–145.
Waldman, S., 2005. Simon Waldman: Coming to a Hard Disk Near You. *The Guardian*, [online] 17 June 2005. Available at: http://www.theguardian.com/ film/2005/jun/17/netmusic.internet [Accessed 21 February 2015].
Walls, W.D., 2008. Cross-Country Analysis of Movie Piracy. *Applied Economics*, 40 (5), 625–632. DOI:10.1080/13504850600707337.
Wang, C.-C., 2005. Factors that Influence the Piracy of DVD/VCD Motion Pictures. *Journal of the American Academy of Business*, 6 (1), 231–237.
Wang, S., 2003. *Framing Piracy: Globalization and Film Distribution in Greater China*. Lanham, MD: Rowman & Littlefield Publishers.
Warm Water Release Thread, 2010. *Eastern Legends Forum.*
Wasko, J., 2002. The Future of Film Distribution and Exhibition. In: D. Harris, ed. *The New Media Book*. London: BFI, 195–208.
Wasko, J., 2003. *How Hollywood Works*. London: Sage.

Waters, D., 2004. Europe Launch for Apple's iTunes. *BBC*, [online] 15 June 2004. Available at: http://news.bbc.co.uk/1/hi/entertainment/3805565.stm [Accessed 28 February 2015].

Weedon, P., 2014. Risky Business? A Guide to DIY Distribution. *Little White Lies*. [online] 4 July 2014. Available at: http://www.littlewhitelies.co.uk/features/articles/risky-business-a-guide-to-diy-distribution-24223 [Accessed 23 November 2014].

White, D.M., 1950. The Gatekeeper: A Case Study in the Selection of News. In; Tumber, H., 1999. *News: A Reader*. Oxford: Oxford University Press, 66–72.

Wigley, S., 2014. *A Field in England* Marks UK Distribution First. BFI, [online] 23 April 2014. Available at: http://www.bfi.org.uk/news-opinion/news-bfi/features/field-england-marks-uk-distribution-first [Accessed 23 November 2014].

Wingrove, T., Korpas A. and Weisz, V. 2011. Why Were Millions of People Not Obeying the Law?: Motivational Influences on Non-Compliance with the Law in the Case of Music Piracy. *Psychology, Crime and Law*, 17 (3), 1–16.

Wu, Angela Xiao. 2012. Broadening the Scope of Cultural Preferences: Movie Talk and Chinese Pirate Film Consumption from the Mid-1980s to 2005. *International Journal of Communication*, 6 (2012), 501–529.

Yar, M., 2005. The Global "Epidemic" of Movie "Piracy": Crime-Wave or Social Construction? *Media, Culture and Society*, 27 (5), 677–696. DOI:10.1177/0163443705055723.

Youth of the Beast Release Thread, 2005. *Chinaphiles Forum*.

Zentner, A., 2006. Measuring the Effect of File Sharing on Music Purchases. *Journal of Law and Economics*, 49 (1), 63–90. DOI:10.1086/501082.

Zhu, J.J.H. and Wang, S., 2003. Mapping Film Piracy in China. *Theory Culture and Society*, 20 (4), 97–125. DOI:10.1177/02632764030204007.

Index